William Sidney Mount

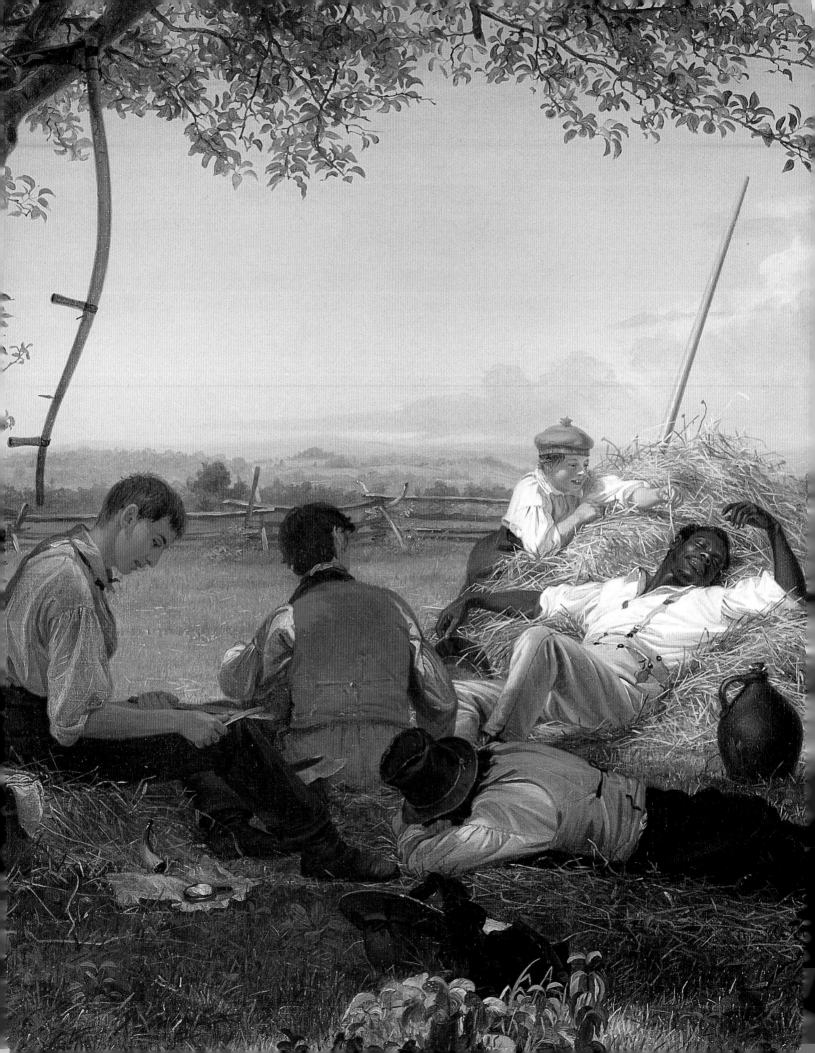

William Sidney Mount

PAINTER OF AMERICAN LIFE

Deborah J. Johnson

ESSAYS BY

Elizabeth Johns

Deborah J. Johnson

Franklin Kelly

Bernard F. Reilly, Jr.

THE AMERICAN FEDERATION OF ARTS

This catalogue has been published in conjunction with **William Sidney Mount: Painter of American Life**, an exhibition organized by The Museums at Stony Brook and The American Federation of Arts. The exhibition and catalogue are made possible in part by a generous grant from The Henry Luce Foundation, Inc. Funding has been received from the National Endowment for the Arts, the Institute of Museum and Library Services, and the New York State Council on the Arts. Additional support has been provided by The Brown Foundation, Inc., and the National Patrons of the AFA.

The American Federation of Arts is a nonprofit art museum service organization that provides traveling art exhibitions and educational, professional, and technical support programs developed in collaboration with the museum community. Through these programs, the AFA seeks to strengthen the ability of museums to enrich the public's experience and understanding of art.

Published in 1998 by The American Federation of Arts, 41 East 65th Street, New York, New York 10021.

Publication Coordinator: Michaelyn Mitchell
Designer: Katy Homans
Editor: Brian Wallis
Printed in Hong Kong

Photographs are supplied by the owners of the works and are reproduced by permission of the owners, except as indicated in the following additional credits.

Richard Caspole: Fig. 2.
Courtesy of Hirschl & Adler Galleries: Fig. 50.
Joshua McClure: Figs. 7, 44, 58, 77.
Jim Strong: Figs. 1, 3, 14, 20, 21, 40, 42, 64, 78.
Joseph Szaszfai: Fig. 23.

Unless otherwise indicated all works illustrated are by William Sidney Mount.

Front and back cover: *Dance of the Haymakers*, 1845 (fig. 51)
Half-title page: *Self-Portrait*, 1832
Frontispiece: *Farmers Nooning*, 1836 (detail, fig. 30)
Page 8: *The Truant Gamblers (Undutiful Boys)*, 1835 (detail, fig. 28)
Page 16: *Long Island Farmer Husking Corn*, 1833–34 (detail, fig. 22)
Page 108: *Bargaining for a Horse (Farmers Bargaining)* 1835 (detail, fig. 27)
Page 132: Alfred Jones, *Farmers Nooning*, 1843 (detail, fig. 84)

Exhibition Itinerary

The New-York Historical Society
New York, New York
August 14–October 25, 1998

The Frick Art Museum
Pittsburgh, Pennsylvania
November 19, 1998–January 10, 1999

Amon Carter Museum
Fort Worth, Texas
February 5–April 4, 1999

Library of Congress Cataloging-in-Publication Data
Johnson, Deborah J.
 William Sidney Mount : painter of American life / Deborah J. Johnson ; with essays by Elizabeth Johns . . . [et al.].
 p. cm.
 Catalog of an exhibition organized by the Museums at Stony Brook and the American Federation of Arts.
 Includes bibliographical references.
 ISBN 1-885444-08-7
 1. Mount, William Sidney, 1807–1868—Exhibitions. 2. United States—In art—Exhibitions. 3. Genre (Art)—United States—Exhibitions. I. Mount, William Sidney, 1807–1868. II. Johns, Elizabeth, 1937– . III. Museums at Stony Brook. IV. American Federation of Arts. V. Title.
N6537.M677A4 1988
760' .092—dc21. 98-9162
 CIP

Contents

Acknowledgments

As the foremost practitioner of American genre painting, William Sidney Mount is an artist who had a profound impact on nineteenth-century American art and culture, and we are delighted to be presenting this first major examination of his work. Bringing together finished paintings, preparatory sketches, prints, and ephemera, the exhibition documents Mount's artistic accomplishments, as well as his role in the popular culture of his time.

We first wish to acknowledge the dedication of Deborah J. Johnson, curator of the exhibition and president and chief executive officer of the Museums at Stony Brook, the premier repository of Mount's work and the institution from which most of the works in the exhibition are drawn. Ms. Johnson conceived the exhibition, wrote the lead essay in this publication, and secured the participation of Bernard F. Reilly, Jr., director of research and access at the Chicago Historical Society; Franklin Kelly, curator of British and American paintings at the National Gallery of Art; and Elizabeth Johns, Silfen Term Professor of American Art History at the University of Pennsylvania. Each of them has made a valuable contribution.

We are most grateful to Brian Wallis for his superb editing skills and to Katy Homans for devising the book's handsome design.

At the AFA, *William Sidney Mount* has benefitted from the talents of numerous staff members. Suzanne Ramljak, curator of exhibitions, oversaw the organization of the exhibition, and Michaelyn Mitchell, head of publications, managed the book's production. Karen Convertino, registrar, coordinated the handling and packing of the exhibition's travel; Jillian Slonim, director of communications, guided the promotion and publicity efforts for the project; and Katey Brown, head of education, developed the educational resources. I also want to recognize Thomas Padon, director of exhibitions, and his predecessor, Robert Workman, who worked on the project in its early stages. Thanks are also due Robin Kaye Goodman, exhibitions/publications assistant, and Sarah Zorochin, communications assistant.

We want to acknowledge the generosity of the lenders to the national tour, as well as the museums presenting the exhibition: the New-York Historical Society; the Frick Art Museum, Pittsburgh; and the Amon Carter Museum, Fort Worth.

Lastly, we wish to acknowledge the Henry Luce Foundation, Inc., for its generous grant toward the exhibition and catalogue, the National Endowment for the Arts, the Institute of Museum and Library Services, the New York State Council on the Arts, the Brown Foundation, Inc., and the National Patrons of the AFA.

Serena Rattazzi
Director
The American Federation of Arts

Acknowledgments

Recognition and appreciation are due the following people for their numerous contributions to *William Sidney Mount: Painter of American Life*. The staffs of the library of the New-York Historical Society and the Emma S. Clark Memorial Library provided invaluable assistance during my research. Frank, Bernard, and I extend our sincerest thanks to Laurette E. McCarthy for her expert research skills. Serena Rattazzi and the staff at the American Federation of Arts have been a pleasure to work with. Notable are the many contributions of Michaelyn Mitchell and Suzanne Ramljak, as well as Robin Kaye Goodman and Mary Grace Knorr. Former and present staff members and trustees of the Museums at Stony Brook have provided incredible support, in particular, Richard B. Russell, chairman of the board of trustees; Victoria Costigan, trustee; Judith O'Sullivan, former president; and co-workers Lauren Poulos, Susanne Lavarello, Judith Estes, Ron Kellen, and Ita Berkow. My friend and colleague William S. Ayres, director for collections and interpretation, merits particular recognition. Bill's enthusiasm for the Mount project and his input on my essay are deeply appreciated. I am indebted to my co-authors, Elizabeth Johns, Franklin Kelly, and Bernard Reilly. Their years of work and important contributions to the understanding of Mount's career are valued greatly.

Finally, I celebrate the vision of Ward and Dorothy Melville, whose dedication to the legacy of William Sidney Mount culminated in the outstanding holdings of Mount's works of art and papers in the collection of the Museums at Stony Brook.

Deborah J. Johnson
President and Chief Executive Officer
The Museums at Stony Brook

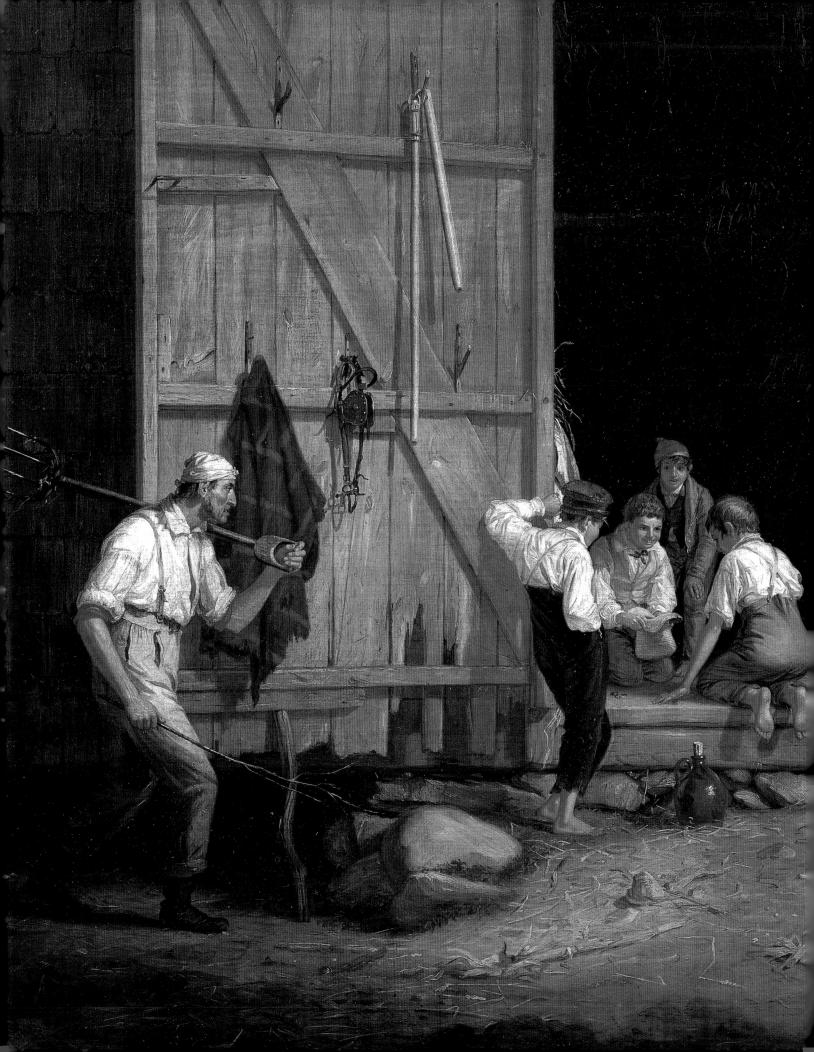

Elizabeth Johns # "Boys Will Be Boys"

Notes on William Sidney Mount's
Vision of Childhood

What do we make of William Sidney Mount in 1998, nearly a century and a half after his career? We live in a society different in so many ways from the one he knew that it is a challenge to enter his times imaginatively. Although recent scholarship and the escalating art market have assessed Mount as a major figure in our art history, the present exhibition is the first one in some time to focus on him exclusively.

Modern appreciation for Mount's work really began just fifty years ago, during the wave of nationalism associated with World War II. In 1944, amid a rising interest in American art, Bartlett Cowdrey and Herman Warner Williams, Jr., published *William Sidney Mount, 1807–1868* (New York: Metropolitan Museum of Art and Columbia University Press), a book that brought together for virtually the first time all known material by and about Mount. Then, as the field of American art history began to grow in the 1960s, monographic studies focused on the political and art historical contexts of Mount's early work. Stuart P. Feld looked specifically at Mount's *Cider Making*, 1841 (fig. 46), locating it within the periodical literature of its time ("In the Midst of 'High Vintage,'" *Metropolitan Museum of Art Bulletin*, April 1967), and Donald D. Keyes examined the print sources for Mount's early work in order to place him in a tradition of genre painters ("The Sources for William Sidney Mount's Earliest Genre Paintings," *Art Quarterly*, Autumn 1969). Scholars soon began to consider Mount and his work within the broader framework of what other American genre artists were doing during the nineteenth century. The invaluable studies here were Hermann Warner Williams's *Mirror to the American Past* (New York: New York Graphic Society, 1973) and Patricia Hills's *The Painters' America, Rural and Urban Life, 1810–1910* (New York: Praeger Publishers in association with the Whitney Museum of American Art, 1974). Both authors saw Mount's work as reflecting cultural realities. The first real monograph on Mount was Alfred Frankenstein's massive *William Sidney Mount* (New York: Harry N. Abrams, 1975), which is not analytical but instead transcribes selections from Mount's diaries, autobiographies, account books, and letters and provides reproductions of most of his works. More archival work followed from the Museums at Stony Brook, the repository of most of Mount's papers and artworks, with David Cassedy and Gail Shrott's *William Sidney Mount: Annotated Holdings of the Museums at Stony Brook* (Stony Brook, N.Y.: Museums at Stony Brook, 1983) and *William Sidney Mount: Works in the Collection of the Museums at Stony Brook* (Stony Brook, N.Y.: Museums at Stony Brook, 1983).

Among the most influential interpretive work on Mount is *Catching the Tune: Music and William Sidney Mount* (Stony Brook, N.Y.: Museums at Stony Brook, 1984), which includes substantive essays on the musical practices of the communities in which Mount lived and which broadens considerably our knowledge of Mount's friendships and social life. My own

book on American genre painting, published in 1991 (*American Genre Painting: The Politics of Everyday Life* (New Haven: Yale University Press), sought to dispel the "reflection" thesis (the idea that representations merely reflect, rather than produce, historical reality) and argued that Mount and other genre painters of the pre–Civil War period played to a New York patronage concerned with establishing their own social status and regional superiority. Within this cultural milieu, I maintained, Mount's major pictures served a critical role in negotiating the class differences between urban and rural Americans by providing clever visual translations of current vernacularisms.

These recent revisions in our understanding of Mount's work leave unanswered two closely related questions: What character of the era of the 1830s and '40s informed his art? And what was it in his pictures that made patrons and critics respond so enthusiastically to them? I propose to initiate an answer to these questions with a brief consideration of an apparently minor, but revealing, aspect of Mount's iconography: his depictions of childhood.

In the late 1820s, the period when Mount reached maturity, the nation was in the midst of dizzying social, economic, and political changes. New York City, where Mount had settled, was the center of a profound political shift from old-family leadership to the ambitious machinations of the nouveau riche. And this local transfer of power had broad national implications. After the election of Democrat Andrew Jackson to the presidency in 1828, the proliferation of political participation was accompanied by dazzling new opportunities for economic success. Rural citizens crowded into the city, exchanging the overfarmed and barren New England fields for the often illusory hopes of wealth in the city. Although the nation's symbolic language remained rural—the farmer or yeoman was held up as the ideal citizen, and journalists and orators cherished the moral health of agriculture—city life replaced the rhythms of planting and harvesting with unpredictable market cycles and dangerous speculation. Social strivers of middling origins schemed to be introduced into the circles of long-established families. But the vortex of economic ups and downs made the 1820s an uncertain time. Those who had only recently earned their status in the strategies and risks of importing, wholesaling, and real estate were constantly aware that in an instant they could lose everything.

Mount knew uncertainty well; he was born into it. In his autobiography, which he wrote in fragments throughout his life, Mount frequently returned to the hazards he endured—death, instability, and loneliness. Of the eight children his parents bore, three who came after Mount did not survive infancy; he was taken for dead himself at one point. When Mount was seven his father died, initiating a long series of relocations in which Mount lived temporarily with various grandparents, siblings, and other relatives. This shuttling between small town and big city ended abruptly at age seventeen when Mount was apprenticed to his brother Henry, a sign painter in New York City. There, the artist began a professional life that was also unpredictable: he progressed from sign painter to would-be history painter and finally to a painter of figure or genre scenes, but regularly he had to fall back on portraiture to make ends meet. He did not marry, whether from economic prudence or disinclination, and he was often ill; throughout his life he suffered from various medical disorders, preoccupied

himself and others with remedies, and took to his bed for periods of time. Mount does not seem to have been unhappy, but at the same time he seems never to have felt fully in control of his circumstances.

Sharing with his viewers the anxieties of the era, Mount obviously considered carefully the kinds of responses with which one could adjust to such uncertainties. One strategy was to adopt a kind of whistling-in-the-dark cheerfulness; another was to assert complete sophistication and attribute naivete to others, especially one's rural counterparts; yet another was to clear oneself of guilt for complicity in the machinations of the urban social and economic worlds by imputing such scheming behavior to country citizens. Perhaps the most widely popular solution, however, was for grown men to look for images of boyhood to provide insights into their own situations.

With an ambition driven by the difficulties and frustrations he had experienced, Mount turned in 1830 from sign-painting and fruitless history painting to genre scenes. He took his subjects from the major motifs of contemporary storytelling and jokes about rural folk from just beyond city boundaries (Long Islanders were a favorite target). Farmers and rural boys made up Mount's cast of characters; he showed them talking and scheming and dreaming. Unfailing cheer and innocence were the prevailing moods of his pictures. Patrons were drawn to Mount's paintings because his themes were at the heart of their interior dilemmas.

Fundamental to the meaning of these works was the representation of boyhood. On one level, Mount appealed to his viewers' nostalgia for the securities of their own childhood and youth. But more directly, he alluded to the current economic and social climate in which, as adults, they schemed and risked being caught. In *School Boys Quarreling*, 1830 (fig. 16), for instance, two boys, each about ten or eleven years old, have thrown down their books in a disagreement that is about to erupt in a fistfight. Mount depicts not only the immediate altercation but also the engagement of the boys nearby: one champions an antagonist, and three others, all younger, look on with fascination. Behind them, a woman looks out of the top half of a double door, attentive to what's happening and waiting for the right moment to intervene. In *The Truant Gamblers (Undutiful Boys)*, 1835 (fig. 28), subtitled "Boys hustling coppers on the barn floor," several eight- or nine-year-old boys hunker over their gambling just inside a barn, blissfully unaware of the approach of an old farmer. Stick in hand, he is ready to bring them up short. In *Farmers Nooning*, 1836 (fig. 30), a young boy tickles the ear of a sleeping African American farmhand, mischievously breaking the mood of pastoral slumber.

Of course, "putting on a good face" was part of making one's way, and Mount filled the faces of his boys with a cheerful obliviousness. But even in his adult figures there is a surprising air of unsquashed hopefulness. The grown man in *Long Island Farmer Husking Corn*, 1833–34 (fig. 22), for instance, looks to be the happiest person imaginable. The painter in *The Painter's Triumph (Artist Showing His Own Work)*, 1838 (fig. 41), who is perhaps Mount's presentation of himself, shows his picture to a visitor with a flourish of his palette and an unrestrained, youthful pride. This exuberance isn't restricted to younger men: *Rustic Dance After a Sleigh Ride*, 1830 (fig. 12), *Dancing on the Barn Floor*, 1831 (fig. 19), and *Dance of the Haymakers*, 1845 (fig. 51), are full of characters who, even in midlife, are caught up in the glee of

patterned yet exuberant movement. Mount was also a master at capturing an adolescentlike incompetence in adults: the countryman in *The Sportsman's Last Visit*, 1835 (fig. 25), registers confusion over his imminent rejection as a suitor with a touching social clumsiness; and the old fellow facing the viewer in *The "Herald" in the Country (Politics of 1852—or, Who let down the bars?* 1853 (fig. 71), is a study in puzzlement as he tries to absorb his younger companion's wisdom about current politics.

In many of these pictures in which he depicted ebullient farmers and farm boys, Mount employed popular puns that themselves sprang from a nervousness in the culture about the discrepancies between what is seen and what is hidden. Mount's first such picture was *Bargaining for a Horse (Farmers Bargaining)*, 1835 (fig. 27), in which two characters cheerfully—and completely calculatingly—negotiate over a horse.[1] The play in this image is around the word "horsetrading," a derogatory term that had been adopted by political opponents to describe the corrupt deal-making of Democrats. In *Farmers Nooning* Mount used the tam-o'shanter-capped young boy with his tickling straw to make visible the phrase "tickling the ear," which alluded to the (false) promises that abolitionists made to slaves about freedom. The next year, Mount capitalized on yet another popular phrase, this time "gone goose," which meant to lose all one's money in speculation. In his picture *Raffling for the Goose (The Raffle)*, 1837 (fig. 37), the men in the backroom are gambling, and the goose on the table is an explicit symbol that all of them are being fooled.

These paintings marked the high point of Mount's career for his New York viewers. The patrons who bought them were the "new men" who were, in a sense, most vulnerable to the dilemmas the pictures represent: getting bested in bargaining, being swayed by political rhetoric, and losing one's investment.[2] Like Luman Reed, the parvenu grocer and wholesaler who bought *Bargaining for a Horse* and *The Truant Gamblers*, these patrons saw themselves as the new kids on the block. Mischief sold well in a cultural climate that encouraged "go-ahead-ism" or ambition to win out over others. Such images offered patrons comic relief about their own naivete in social situations in which older citizens had long been comfortable. And they enabled viewers to admit, at least privately, that they could suffer economic disaster as well. The visual puns in these paintings heightened their appeal to newly rich patrons by allowing them to share the pleasure of feeling superior, or "in," because they "got" the joke. Viewers who laughed uproariously at Mount's puns were also pleased with their own cleverness, a trait that separated them from base entrepreneurs. In making up the pictures, Mount translated the stories, jokes, and slang of the 1830s into a visual imagery that caught the complexities of "arriving" in New York.

Critics did not quite know how to assess Mount. Many found his pictures clever, but some were puzzled about their relationship to art. George Pope Morris, for instance, wrote in 1835, "Mr. Mount has talents, if not of a higher order than the portrait painter, at least of a very different description."[3] Another critic, though amused by what he saw, urged Mount to work with "a subject of a higher grade in the social scale."[4] And even though he was very successful with patrons and critics during the 1830s, the cultural anxiety that Mount was tapping lasted only for a short period. Mount's fortunes began to turn in 1836, when Luman

Reed, one of his most devoted patrons, died. But that loss was only part of a larger political picture.

If the early years of the 1830s offered the uncertainty of new opportunities, the latter part of the decade signaled a different direction for politics and the economy. Political campaigning lost its ambivalence and became sheer manipulation of carefully chosen symbols, while the long depression after the Panic of 1837 chastened the spirits of financial speculators. Mount shifted his attention from the jubilance and anxiety of the arriviste (and his class) to the threats posed by popular politics. His *Catching Rabbits* or *Boys Trapping*, 1839 (fig. 43), seemingly an innocent evocation of boys having fun setting a trap, is actually a dig at grown boys (men) playing at politics, specifically the Whig practice of luring Democratic voters (the "people" rather than the "aristocrats") through deceptive rhetoric. In fact, the Whig campaigns of the late 1830s and early 1840s were marked by the use of political symbols that transparently cloaked the truth: in 1840, Whig presidential candidate William Henry Harrison used the log cabin motif endlessly to suggest that he was a common man born in humble circumstances who drank ordinary cider (in actuality, Harrison was well born and quite wealthy).

Mount's *Cider Making*, a direct response to the Harrison campaign, is an elaborate allegory in which every element in the picture is meant to unmask a specific political practice or campaign slogan. After seeing *Cider Making*, one critic complained that Mount's work had lost its sparkle and wit: "Mount, has for the last few years, been making large strides backwards, and is still on that march . . . the consequence is, that he is not to be compared in 1840 with himself in 1836."[5] Unfortunately, as print historian Bernard F. Reilly, Jr., demonstrates in his essay in this volume, Mount continued on this path in the 1850s, hoping for a large viewership for lithographs with banal themes, such as the musicality of the African American, which had already become clichés. No single painting is stronger evidence of this loss of inventive energy than Mount's *Coming to the Point*, 1854 (fig. 72), a tame reworking of his first big "hit," *Bargaining for a Horse* from 1835.

But patrons continued to clamor for Mount's evocations of boyhood—as if the subject of manhood was now marked as entirely disagreeable. For these customers Mount simply repeated his earlier ideas. As art historian Franklin Kelly points out in his essay "Mount's Patrons" (in this volume), in 1843 publisher Edward L. Carey commissioned Mount to paint a new version of *The Truant Gamblers (Undutiful Boys)* for reproduction in his "giftbook," *The Gift*, and Mount produced for him *Boys Hustling Coppers (The Disagreeable Surprise)*, 1843 (fig. 50). A few years later, a patron requested yet a third version, and Mount produced *Caught Napping*, 1848 (fig. 59), which shows the young boys in the field rather than in a barn. Mount also repeated himself in *The Dead Fall (The Trap Sprung)*, 1844 (fig. 45), a reworking of his *Catching Rabbits* of 1839.

Mount's evocation of the dreaminess and hopeful aspect of boyhood in 1845, long after the political and economic direction of the society had seemed so unfortunately set, is the hallmark of the most enduringly popular picture of Mount's career: *Eel Spearing at Setauket (Recollections of Early Days—"Fishing Along Shore")* (fig. 55). This picture was commissioned

by attorney George Washington Strong to capture his own cherished days of childhood on Long Island (a circumstance that he and Mount shared, though more than a generation apart). Deeply satisfied with the comfort and peace radiating from the scene, Strong went on to commission his own version of Mount's now twice-repeated theme of miscreant boys. At least one critic saw the resulting work, *Caught Napping*, as pure wish-fulfillment: "We, who are pent up within the city walls, look with feelings of regret somewhat akin to envy at the delicious indolence of the boys *Caught Napping* who bask under the shady trees and are troubled by no care or anxiety."[6]

As we look at Mount's pictures today, they can provide a lesson about strategies for getting through hard times. Although the images seem unremittingly cheerful, with themes and details that, of course, may be enjoyed for themselves, this top layer can be pulled away. Underneath are all the corrosive tensions that inspired these images of young boys and grown-up boys who calculate, smile, and hope.

Notes

1. I discuss this and the following pictures in detail in *American Genre Painting: The Politics of Everyday Life* (New Haven and London: Yale University Press, 1991), pp. 24–59.

2. Here I depart from Franklin Kelly in that I distinguish between new and old money. The only old-money (and thus truly "aristocratic") patron that Mount had was Henry Brevoort, Jr., who was engaged at the time in the precise activity—speculation—that Mount critiqued in the picture that Brevoort bought, *Raffling for the Goose* (fig. 37).

3. "No 55—The Studious Boy," *New-York Mirror,* May 30, 1835, p. 397.

4. "The Fine Arts," *New-York Mirror,* June 13, 1835, p. 395.

5. "W. S. Mount, N. A.," undated clipping, Setauket Scrapbook, p. 13.

6. "The Fine Arts," *The Literary World* 3, no. 69 (May 27, 1848): 328.

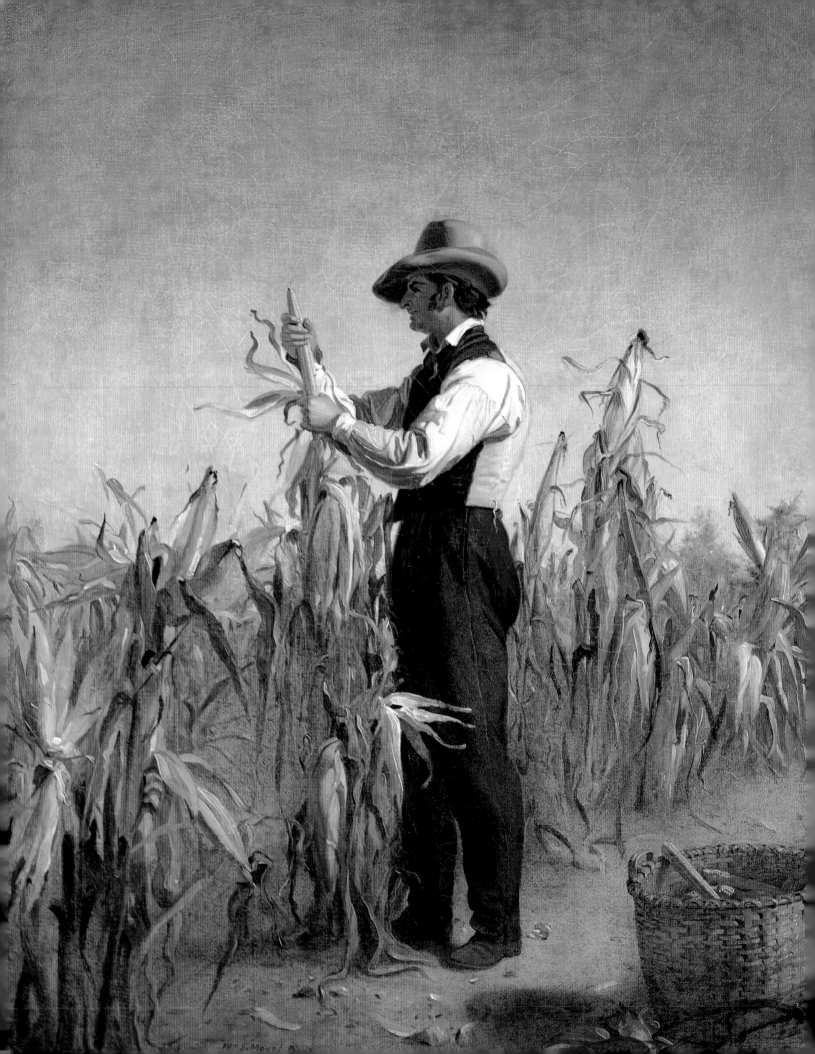

Deborah J. Johnson

William Sidney Mount

Painter of American Life

William Sidney Mount was born November 26, 1807, in the village of Setauket, New York, on the north shore of eastern Long Island, an area where his ancestors had been prominent for five generations.[1] Jonas Hawkins (1752–1817), Mount's maternal grandfather, had been a major in the Continental Army and worked in nearby Stony Brook as a farmer, storekeeper, and tavern owner; from 1807 to 1816, he served as the presidentially appointed postmaster for the area. His daughter, Julia Ann Hawkins (1782–1841), married Thomas Shepard Mount (1778–1814), whose family was among the founders of Middletown, New Jersey.[2] Like Jonas Hawkins, Julia and Thomas Mount operated a farm, as well as a store and tavern bordering the village green in Setauket. They were Presbyterians, who worshiped at a church led by veterans of the Revolutionary War and considered to be more "American" than the Anglicized church of the local Episcopalians.[3]

Death hovered over the Mount family and continued to haunt the artist throughout his life. Three of Mount's younger siblings died in infancy, and he was himself given up for dead shortly after birth. Of the five children who did survive, William was the youngest boy; his older brothers were Henry Smith Mount (1802–1841), Shepard Alonzo Mount (1804–1868), and Robert Nelson Mount (1806–1883). His only sister, Ruth Hawkins Mount (1808–1888), was younger than him.[4] William was cared for by his grandparents for substantial periods of time, and he attended school at the residence of his grandfather in Stony Brook. On October 21, 1814, William's world was shattered when his father died.

When his grieving mother moved to Stony Brook to live with her parents, eight-year-old William was sent to stay with his uncle and aunt, Micah and Letty Hawkins, in New York City.[5] In 1815, William rejoined the family to be "a farmer boy" on his grandfather's farm, but Jonas Hawkins died the following year.[6] While William stayed in Stony Brook, his brothers Shepard and Robert were sent to apprentice in the coach-making firm of James Brewster in New Haven, and Henry, the eldest, established a sign and ornamental painting business in New York City.[7] William later moved to New York to work as an apprentice in Henry's shop.[8]

In New York, William was also reunited with his uncle, Micah Hawkins (1771–1825), who operated a tavern and grocery store on Catherine Slip but was best known as a leading amateur musician. In fact, Hawkins has been described by music historian Vera Brodsky Lawrence as "probably the most versatile and original figure to inhabit the early nineteenth-century music scene in New York."[9] Hawkins was a composer, playwright, mimic, and poet, in addition to playing the piano, flute, and violin. His works mixed storytelling and popular music to address national themes and political issues, to articulate the country's increasing social stratification, and to characterize the stock of American characters or "types" then gaining favor in theater and popular culture. These themes and techniques were later central to Mount's own genre paintings, and the artist himself became an adept musician and composer.

Meanwhile, Mount's older brother Henry served as an influential link to the growing

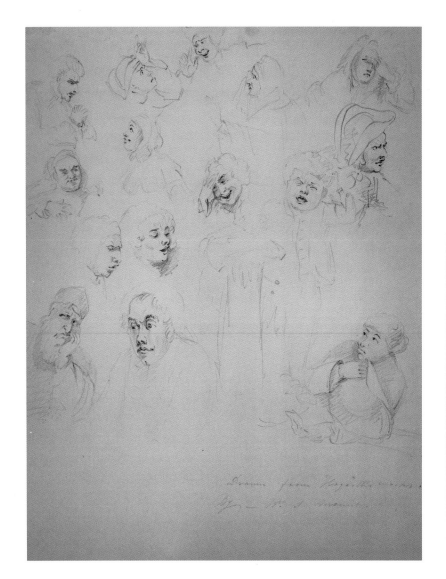

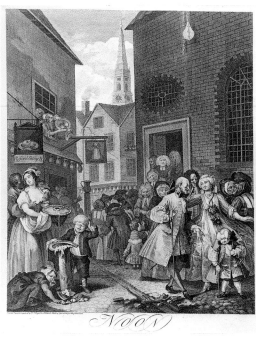

Figure 1
"Drawn from Hogarth's works,"
ca. 1826

Figure 2
William Hogarth (1697–1764)
Noon
Plate 2 from the series
The Four Times of Day, 1738
Engraving
Plate 19 ⅜ x 16 inches
Image 17¾ x 15 inches
Yale Center for British Art; Paul
Mellon Collection

world of art in metropolitan New York. While serving his apprenticeship with Henry's sign and ornamental painting business, William honed his artistic skills by practicing "drawing with lead pencil, and sometimes with white chalk on a blackboard."[10] With Henry's encouragement, William visited the American Academy of Fine Arts exhibition in City Hall Park in 1825, an event that had a profound impact on him.[11] There, in addition to portraits by American artists, he saw for the first time substantial numbers of paintings by seventeenth- and eighteenth-century European artists, many of which depicted subjects from biblical history.[12]

Prominently featured in the 1825 Academy exhibition were two large canvases depicting scenes from Shakespeare's *Hamlet* and *King Lear* by the American expatriate artist Benjamin West, who was then revered in the young republic. Having left his native country to practice history painting in England, West had risen to the highest status an artist could then attain, the presidency of the Royal Academy of Art in London, a post he held from 1792 until his death in 1820. West was a proponent of the "Grand Manner," a tradition that advocated the study and replication of themes and prototypes found in the art of classical antiquity, the Renaissance, and the Baroque. In the United States, the Grand Manner style was spread mostly by West's

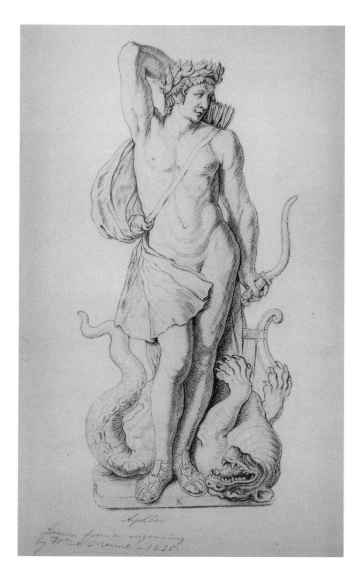

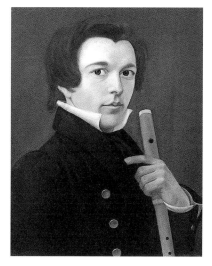

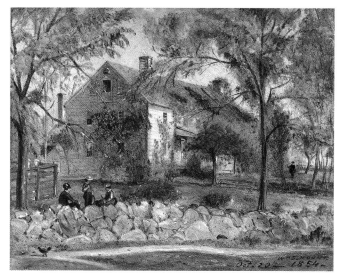

students, who included John Vanderlyn, Washington Allston, Samuel F.B. Morse, and John Trumbull.[13]

After the experience of the Academy exhibition, William Sidney Mount focused his attention on becoming a history painter after the manner of Benjamin West. But unlike most professional artists of the period he did not train as an apprentice to a successful painter. Rather, he sought to educate himself while still working for his older brother. In 1826 Henry Mount entered into partnership with another sign painter, William Inslee, who had artistic aspirations and who owned a large set of engravings by the British artist William Hogarth.[14] Young Mount avidly set about copying the Hogarth prints, and one of his earliest sketches is a composite of expressive head and figure studies inscribed, "Drawn from Hogarth's works," ca. 1826 (fig. 1). These details are clearly recognizable as taken from various engravings in Hogarth's series *The Rake's Progress* (1735) and *The Four Times of Day* (1738), which included *Noon* (fig. 2) and *Industry and Idleness* (1747). Among the individual engravings that Mount reproduced excerpts from are *A Chorus of Singers* (1732), *The Laughing Audience* (1733), *Paul Before Felix* (1752), and *The Cockpit* (1759).[15]

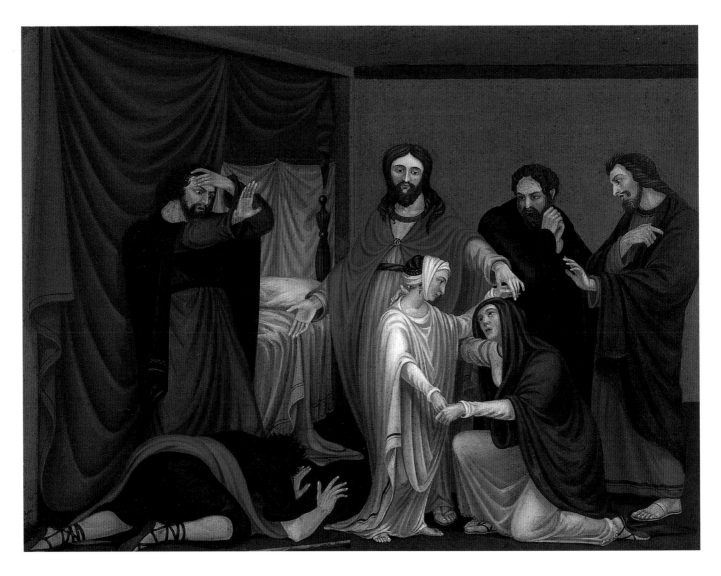

Figure 6
Christ Raising the Daughter of Jairus, 1828

When another family friend, architect Martin E. Thompson, saw William's drawings, he recommended that he enroll as a student at the newly formed National Academy of Design, of which Thompson was a founding member.[16] Academy students were encouraged to study European works of art and engravings, as well as casts of classical statuary, which were deemed important for proper instruction. Sketches by William dated 1826 include anatomical studies drawn from casts, as well as an Apollo inscribed, "Drawn from an engraving" (fig. 3). Mount was enamored with the Grand Manner and eagerly consumed volumes of ancient history. He later recalled this period saying, "I thought of the Galleries of pictures in Europe. My mind was brimful of the grand style, & I was desirous to become an historical painter."[17]

For his early history paintings Mount often selected scenes from classical texts that represented death, resurrection, or near-death experiences. When he composed designs "in umber and white" from Shakespeare's *Hamlet*, for example, he chose to depict the moment when Hamlet first encounters the ghost of his father.[18] From *Pericles*, he illustrated the near-death of the hero's daughter. And his first major oil painting, *Christ Raising the Daughter of Jairus*, 1828 (fig. 6), depicts the moment described in the New Testament Book of Mark when Christ commands the young girl to arise from the dead and walk. In Mount's version, the

daughter is still bound in her winding sheet but she stands firmly in the center of the picture reassuring her astonished mother.

Despite the stiffness of the figures and the crudely flattened space in Mount's *Christ Raising the Daughter of Jairus*, the work ably replicates the principles of the Grand Manner. Indeed, the friezelike composition, the expressive poses of the figures (representing the child's parents, as well as the disciples Peter, James, and John), and the finely painted details are all elements found in Benjamin's West's paintings of classical and biblical subjects. In addition, the elegant, figure-eight-shaped line that passes through the arms of Christ and those of the child and her mother is typical of West's compositional technique. In this, his first major work, Mount demonstrated his sophistication by not just copying West's effect but utilizing the line to emphasize the dramatic focal point of the story and to signify the miracle of resurrection.[19]

Figure 7
Study for **Christ Raising the Daughter of Jairus**, 1828

Mount's *Christ Raising the Daughter of Jairus* created a sensation when it was first shown at the National Academy of Design exhibition that opened on May 6, 1828.[20] No contemporary reviews have been located, but in an extraordinary letter to the artist, his brother Henry recounted how he had defended the work before the academy's council:

> *The Council doubted the originality of your Picture, because in their opinion, it was impossible that one of your age, and chance of improvement, and Education and whatnot, should do any thing half as well. . . . It creates great sensations in the Academy. . . . I tell you that Mr. [Samuel F. B.] Morse says if "your Picture is an Original design, he has not seen its equal amongst any of the modern Masters." In fact Bill you have astonished the whole Academy and you are in a fair way to stand, or set, or hang in the highest grade, of the Arts in the Academy.*[21]

As this letter shows, the issue of originality was important to the masters of the young American art, despite their emphasis on copying from antique models. In the case of Mount's *Christ Raising the Daughter of Jairus*, there are strong similarities between its individual figures and those found in engravings after paintings by West.[22] While this may suggest that Mount copied some of West's designs, no painting or print has been identified that could have provided the complex overall composition for the picture. Nor does any other American work of the period prepare one for the boldness, energy, and spatial sophistication of Mount's original study for the painting (fig. 7). So far as we know, the conception was entirely Mount's own.

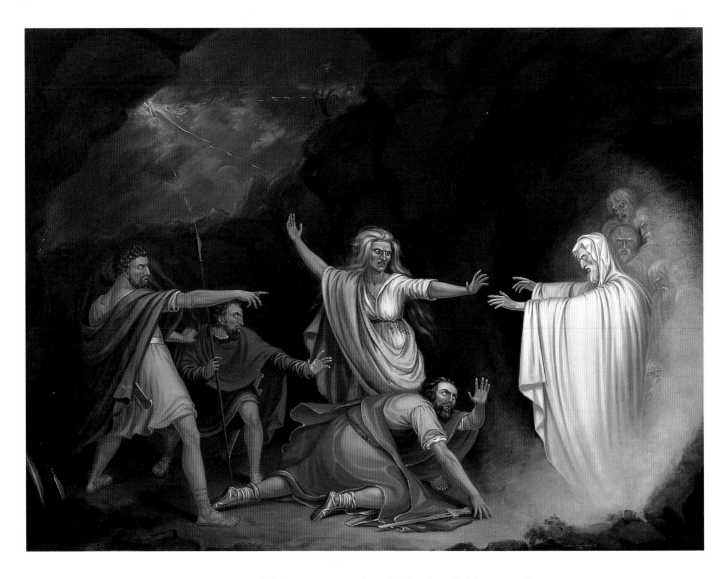

Figure 8
Saul and the Witch of Endor, 1828

West did, however, provide a clearly identifiable source for Mount's next major picture, *Saul and the Witch of Endor*, 1828 (fig. 8), which also addresses the passage between life and death.[23] West's famous version of the same scene, painted in 1777, had been engraved three different times by the mid-1820s, and Mount was undoubtedly quite familiar with one of the prints (fig. 9).[24] From West, Mount appropriated the gestural poses of the figures and the plumes of otherworldly mist surrounding Saul. But while West chose the ghost of Saul as his pictorial focus, Mount placed the wide-eyed witch, the medium between the living and the dead, in the center of his composition. Still, in homage to West, Mount copied the witch's pose from that of Daniel in West's *Daniel Interpreting to Belshazzar the Writing on the Wall* (1775), which had also been engraved several times (fig. 10).

As if to emphasize the theme of death and resurrection that he was exploring in his historical paintings, Mount exhibited three paintings on this subject at the National Academy of Design in 1829.[25] In addition to *Saul and the Witch of Endor*, Mount showed *Crazy Kate*, 1829 (present location unknown), and *Celadon and Amelia*, 1829 (fig. 11), which were based on moments in eighteenth-century British literature. A poem by William Cowper about a serving maid mourning the death of her lover was the basis for Mount's *Crazy Kate*.[26] And

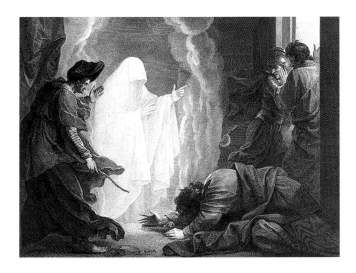

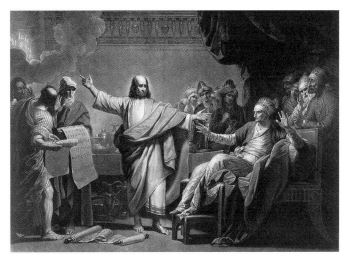

Figure 9
William Sharp (1749–1824)
The Witch of Endor, 1788
After Benjamin West (1738–1820)
Saul and the Witch of Endor, 1777
Engraving
19¼ x 24½ inches
Yale Center for British Art; Paul
Mellon Collection (B1977.14.14498)

Figure 10
Valentine Green (1739–1813)
**Daniel Interpreting to Belshazzar
the Writing on the Wall**, 1777
After Benjamin West (1738–1820)
**Daniel Interpreting to Belshazzar
the Writing on the Wall**, 1775
Mezzotint
6⅞ x 8¹³⁄₁₆ inches
The British Museum (1839-4-13-51)

Figure 11
Celadon and Amelia, 1829
Oil on canvas
24¾ x 20½ inches
The Museums at Stony Brook;
Bequest of Ward Melville (77.22.539)

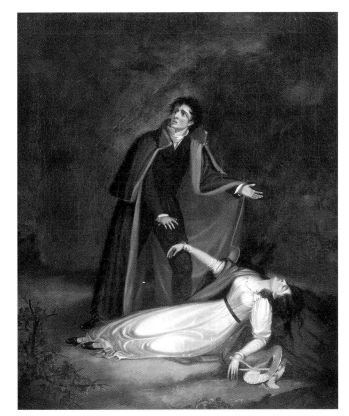

Mount's *Celadon and Amelia* was taken from a passage in James Thomson's *The Seasons* describing the demise of a young woman struck dead by lightning.[27] All three works were listed for sale in the exhibition catalogue, but none sold. In desperate need of funds, Mount abandoned history painting, first for portraiture, then for genre painting.[28]

Mount was encouraged to pursue genre painting by the enthusiastic reception his initial efforts received at the National Academy in New York. His first major triumph of genre painting was the multifigural *Rustic Dance After a Sleigh Ride*, 1830 (fig. 12), which was shown at the 1830 National Academy exhibition along with his *Girl with a Pitcher*, 1829 (fig. 13).[29] There has been considerable speculation regarding the sources for the *Rustic Dance,*

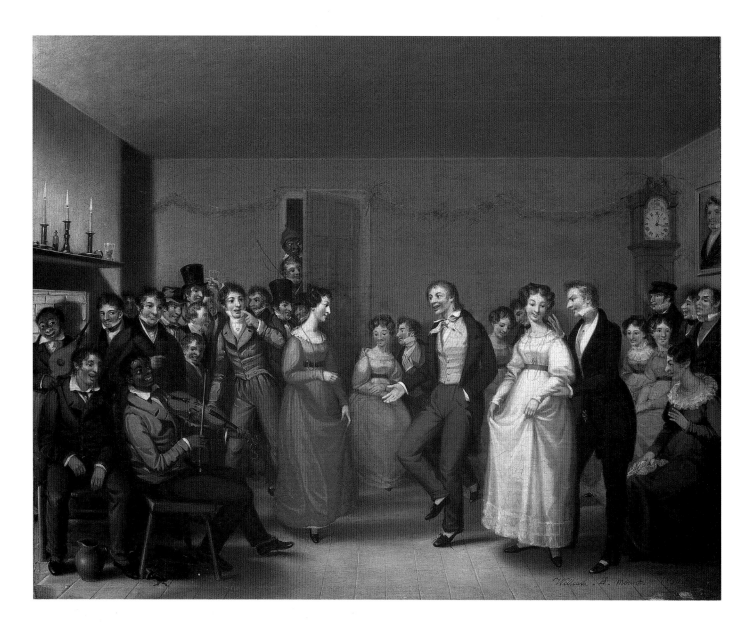

Figure 12
Rustic Dance After a Sleigh Ride,
1830

including the suggestion that Mount may have copied it from John Lewis Krimmel's *Country Frolic and Dance* of 1819 or a watercolor version of the same scene dated 1820.[30] But the clearest basis for the format of *Rustic Dance* is an early drawing by Mount of a child reciting on a stool (fig. 14).[31] Unlike the drawing, however, Mount's emphasis in *Rustic Dance* is quite different. Despite the crowded scene, the viewer's attention is skillfully directed toward the performance of the dance itself, and, in particular, toward the relationships between the principal figures. Quite unlike his earlier works, which were centered on death, this early genre painting is about love and its narrative is told through the symbol of the heart. One heart is seen affixed to the cravat of the man in an olive-green suit (standing behind the fiddler) and another suspended from the neck of the woman in the white gown. The man in the olive-green suit looks with bewilderment at the woman who is about to dance with a rival beau.

When *Rustic Dance* was exhibited at the National Academy, a critic stated that Mount's picture depicted "the dance taken from the popular story of the 'Sleigh Ride.'"[32] Although the source to which this critic alludes is unknown, it seems likely that Mount was illustrat-

Figure 13
Girl with a Pitcher, 1829

Figure 14
**Family Group with Child Reciting
on a Stool**, ca. 1826–27

Figure 15
Artist unknown
Dancing Party
From Gilles Jcobsz Quintijn,
**De Hollandsche Liis Met de
Brabandsche-Bely**,
The Hague, 1629
Engraving
The National Gallery of Art

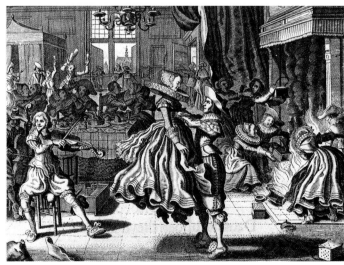

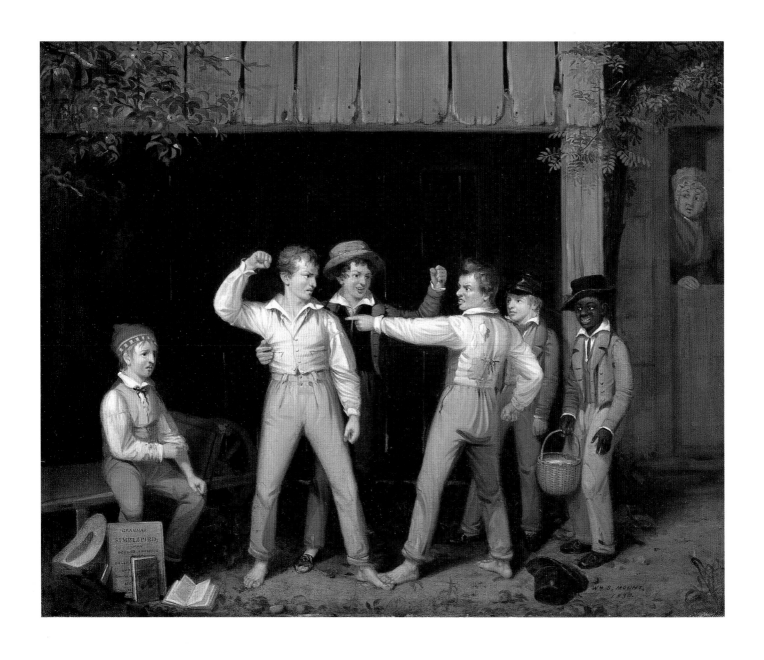

Figure 16
School Boys Quarreling, 1830

ing a familiar scene from contemporary popular literature. He certainly included in the painting many of the stock rural characters from early nineteenth-century American theater and fiction, including an African American musician, the awkward countryfolk, the upwardly mobile Yankee, and prankish boy onlookers. Some of the staging may have been inspired by seventeenth- and eighteenth-century Dutch genre scenes of dancing and merrymaking, such as the Dutch engraving *Dancing Party* of 1629 (fig. 15), but Mount's singular achievement was to make these models distinctly American.[33]

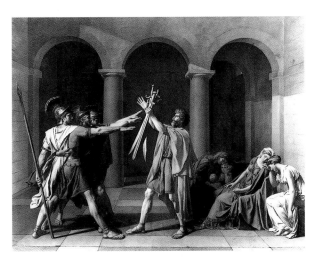

Figure 17
Jacques-Louis David (1748–1825)
Oath of the Horatii, 1784
Oil on canvas
10 feet 10 inches x 14 feet
The Louvre, Paris

Mount continued his bold assimilation of American genre types into European classical models in his *School Boys Quarreling*, 1830 (fig. 16). Although the subject of this work is an apparently trivial squabble between two young students, the prototype for the work is no less heroic than Jacques-Louis David's *Oath of the Horatii*, 1784 (fig. 17).[34] David's painting, which depicts a nationalistic call to arms and the pledge of allegiance by three sons to their father Horace, was widely celebrated in Paris as "the most beautiful picture of the century."[35] By using David's famous painting as a source for a work about everyday life, Mount interjected a twist into the vaunted traditionalism of the Grand Manner and, in particular, its practice of quoting motifs from revered works of art.

But *School Boys Quarreling* is also a sly commentary on the warring camps of the American art establishment of the 1830s, with the young combatants representing the conservative American Academy of Fine Arts, led by John Trumbull, and the upstart National Academy of Design, presided over by Samuel F.B. Morse. As a clue to his underlying subject, Mount placed a grammar book in the lower left corner inscribed with the words "Ocular Analysis." This phrase invites the viewer to analyze the painting for visual clues to its meaning. But it also suggests that the use of visual perception in the creation of art was the critical point of debate between the battling academics.

In fact, a large part of the dispute centered on the older American Academy's contemptuous treatment of aspiring artists, particularly those desiring to study from their collection of casts, engravings, and books. After being barred from the collections, various students and their supporters banded together to form an alternate academy, which became the National Academy of Design. In short order, the rivalry between the two academies became so great that words such as "snake," "daggers," and "poison" were bandied about in the press. One artist issued a challenge for satisfaction "either public or private," and members of the National Academy were "sneered at as 'beardless boys.'"[36]

In Mount's painting, there is no clear indication which adversary represents which academy, though it seems probable that the figure on the left represents the upstart National Academy of Design. He boldly raises a clenched fist and stands protectively before a seated youngster with the bloodied nose and books at his feet, who may represent the offended students. His opponent, who is modeled after the figure in David's *Horatii*, has been in a scrape already and is probably the cause of the bloody nose. Here, the bully steps on the other boy's bare foot in a gesture of challenge and guards two other boys (one white, one black), while an

Figure 18
Joseph Alexander Adams
(1803–1880)
Boy on a Fence, 1834
After William Sidney Mount
Country Lad on a Fence, 1831

Figure 19
Dancing on the Barn Floor, 1831

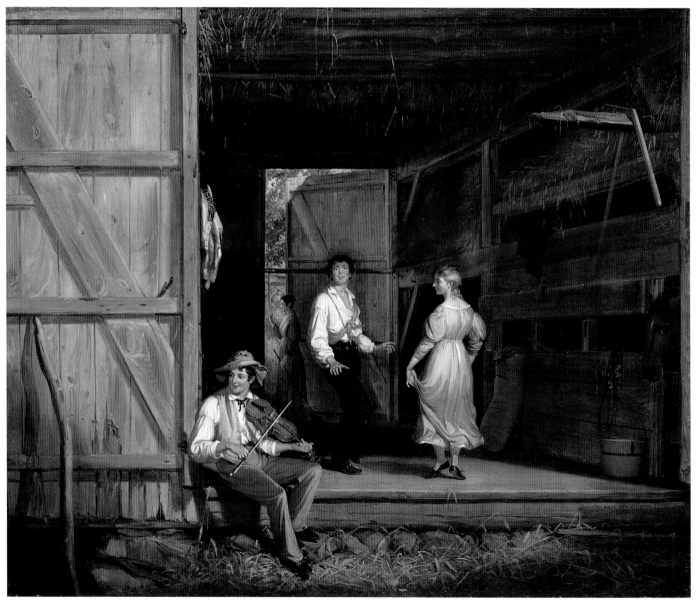

old lady peers out of a window. As Mount presents his allegory, the bloody-nosed youngster may have made the initial attack against the bully (students against the American Academy), but now a protective agent has come to his defense (the National Academy of Design).

In this contextually sophisticated vehicle, multiple issues are raised about the state of the arts in America. Mount's clear reference to David's *Horatii*, for example, is an observation about the dependency of American artists upon the models of Europe. By using the classic pose from the *Horatii* in a comic scene drawn from "common" life, he tinkers with the established traditions of the Grand Manner. And in contrast to David's pictorial symbol of camaraderie and unification, Mount uses the European model to depict the conflict and division between New York's art academies. Finally, if there were any lingering doubt about the artist's own allegiance in the quarrel of the academies, on May 4, 1831, as *School Boys Quarreling* was on exhibition, Mount was elected an associate of the National Academy of Design.

A reviewer for the *New-York Mirror* missed the point of *School Boys Quarreling* when it was exhibited at the National Academy in 1831, and said merely that the picture was "a humorous delineation, and eminently successful."[37] But even if critics did not always catch on, Mount's picture makes clear that from the start he thought of his genre paintings in starkly symbolic terms, frequently in relation to topical political issues. In all his works, Mount provided rebuslike visual clues, allowing the viewer to "read" the painting and to formulate his or her own interpretation. As another contemporary writer perceptively noted, "The more carefully one has cultivated the spirit of observation, the more delight and admiration will he receive from Mr. Mount's pictures."[38]

The themes of music and dance, which first appeared in *Rustic Dance After a Sleigh Ride*, were reinterpreted by Mount a year later in *Dancing on the Barn Floor*, 1831 (fig. 19). The picture shows a young country couple in a barn, dancing to a fiddler's melody. Mount continued to tap the appeal of his earlier "rustic" dance, but he moved the setting out of the parlor and into a barn, the most potent symbol of the nation's agrarian-based economy. Hay is baled neatly in the loft, while, on the right, a horse pokes its head through an open stall to watch the festivities. The fiddler sits casually in the sunshine illuminating the barn doorway, wearing a straw hat, while, at the rear door, a woman beckons to someone outside to join the fun.

An undated pencil sketch by Mount (fig. 20) records the fact that he derived the basic compositional format for *Dancing on the Barn Floor* from a performance of the stage play *The Heart of Midlothian*, which was adapted from the novel by Sir Walter Scott and presented on the New York stage from 1826 to 1831.[39] From the theatrical setting, Mount borrowed the

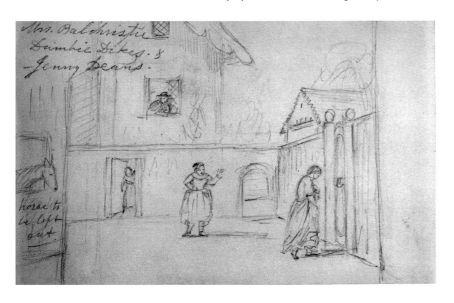

Figure 20
Scene from "**The Heart of Midlothian**," ca. 1830

boxlike space that frames the action, the elevated stage to set the actors apart from the audience, and the set design that supports the story's content. Similarities between the sketch and *Dancing on the Barn Floor* are found in the horse's head protruding from an opening in a stall, the principal characters occupying center stage, and the figure at the rear in an open doorway. On the left side of the sketch, the young artist wrote, "horse to be left out," suggesting that the drawing may have been intended as the basis for another version of the painting. In the theater, the actor's dialogue and movements (and, if provided, the musical accompaniment) are the primary mechanisms by which the plot unfolds. Mount's challenge was to tell a story effectively through a static and purely visual medium. In the final painting, the tight, geometric framing and the elevated floor of the barn provide a realistic environment for the artist to present the simple entertainments of country life.

It is clear from reviews of *Dancing on the Barn Floor* how original Mount's subjects were in American art and how great was their appeal. There was immediate praise for "these essays of the rising genius of our country."[40] Mount was proclaimed "the future Wilkie of America," referring to Sir David Wilkie, the Scottish genre artist, whose work was then highly regarded in the United States.[41] And, at a time when originality was valued, the critic for the *New-York*

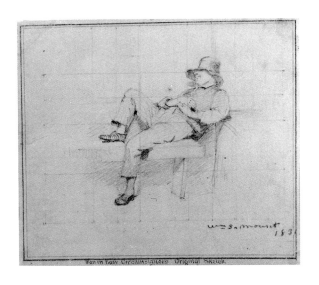

Mirror remarked favorably on "the peculiar style of the artist."[42] In 1832, the year *Dancing on the Barn Floor* appeared at the National Academy, Mount was elected a full-fledged academician. Yet, despite the support of his peers and all the published enthusiasms for his work, Mount's painting failed to attract a buyer.

In 1832 Mount accepted an order from "the temperance society" to paint a small picture called *A Man in Easy Circumstances* (present location unknown). A preliminary sketch for the painting shows a man comfortably positioned on a bench looking slightly inebriated (fig. 21). However, upon seeing the finished work, the gentleman who commissioned it stated, "Mount, that will never do—you have represented the drunkard so happy, that it will not answer for the cause."[43] The work was then sold to the collector Lewis P. Clover for thirty dollars, and later resold to publisher Edward L. Carey for a hundred dollars. When it was exhibited at the National Academy in 1832 it received a mixed response from one critic: "The revolting character of the subject almost neutralizes our pleasure in admiring the skill of the artist in representing an incident of familiar life. . . . As a work of art, it is masterly for its truth."[44]

After a summer of studying the statuary casts at the American Academy, Mount returned, in the fall of 1833, to Stony Brook, where he reestablished his ties with nature.[45] "When I occasionally refer back to the progress I made from 1827 to 1838 as one of the first . . . to paint directly from nature," Mount later wrote, "it stimulates me to stick to nature as a short road to perfection."[46] The work he painted that fall, *Long Island Farmer Husking Corn*, 1833–34 (fig. 22), was, he said, "painted in the open air—the canopy of heaven for my paint room."[47] The monumental farmer is silhouetted in profile against the sky on the outer edge of a field dense with stalks laden with ears of corn. His basket is nearly full with the shucked golden harvest,

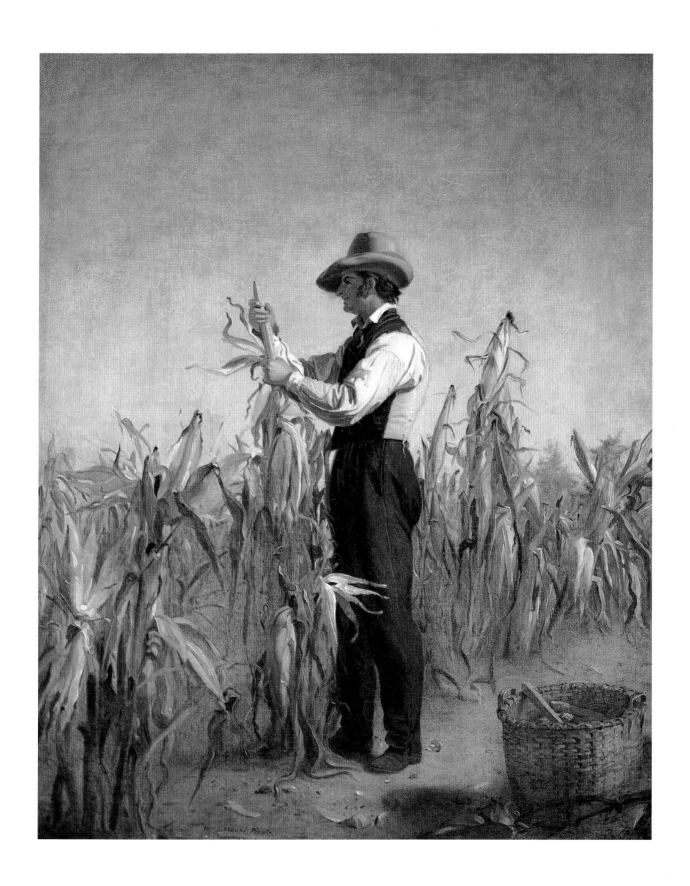

Figure 22
Long Island Farmer Husking Corn,
1833–34

and he seems pleased with the fruits of his labor. But the subject is striking mainly for its bold evocation of the everyday world of rural labor.

Mount's inclination toward such common subjects perplexed certain segments of his audience.[48] Critic Alden J. Spooner, writing in the *Long Island Star*, expressed hope that Mount would paint subjects of "a higher order, . . . something magnificent, historical, dramatic, or mythological."[49] But other critics compared Mount's accomplished technique and realism in this picture to the work of the esteemed seventeenth-century Dutch genre painter David Teniers the Younger.[50] And those with influence championed Mount's subjects and understood perfectly their direct relationship to emergent forms of national expression in the arts: "Mr. Mount is the only artist that we know of who has taken the rustic habits of this country as subjects for the *easel*; the general familiarity with the original is of no objection to him."[51]

Mount's interest in the nation's "rustic habits" paralleled nationalist trends in American literature and theater. Native themes, infused with descriptions of national characters, were manifest in the popular writings of Seba Smith, Washington Irving, and James Kirke Paulding. On the American stage of the 1830s and 1840s, regional themes and character types had gained tremendous momentum, in part through the influence of Mount's uncle, Micah Hawkins. A favorite character type was the New England Yankee, who, though sometimes lampooned as a bumbler, was generally championed for his shrewdness and independence. Humorist Seba Smith's immensely popular letters and stories viewed the nation through the eyes of a typical Yankee farmer, Major Jack Downing of Downingville, Maine.[52] Actor James Henry Hackett achieved renown and acclaim for his farmer roles Uncle Ben and Jonathan Plowboy.[53] Even the Frenchman Michael Chevalier agreed that the Yankee farmer best embodied the concept of American liberty; he wrote, "The preeminence of the Yankee . . . has made him the arbiter of manners and customs. . . . [He] is the laborious ant. . . . He is individualism incarnate."[54] Mount's Long Island farmer is another exemplar of this Yankee type, which became an extremely potent national image, symbolizing an American society unified in its commitment to individual liberty.[55] In this guise it was widely reproduced on engraved currency.[56] The noble yeoman heralded the arrival of a golden age in which prosperity would be harvested from the native soil.

For American viewer's of genre paintings in the 1830s there was a direct association between the authenticity of the rural subject matter and realism as a style. In a story written to accompany an engraving of Mount's *Long Island Farmer*, Seba Smith has Major Downing say, "There aint no more nateral picters in the world, than them that's drawn from nater."[57] This view, widely accepted by critics of Mount's day, seems to have bolstered the popularity of his rural themes and his general practice of painting from nature. When Mount's small painting *The Studious Boy*, 1834 (present location unknown), which was painted outdoors, was purchased by George Pope Morris of the *New-York Mirror*, the newspaper noted that "[studying] Jan Steen's master, Nature, is doing as much for the Long Island boy, as Jan Steen could do for him."[58]

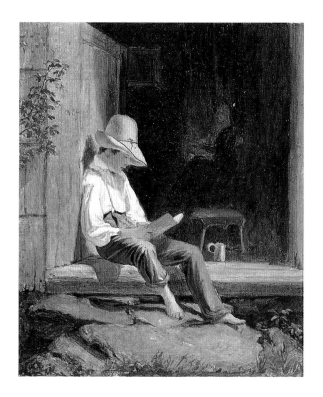

Figure 24
John Frederick Kensett (1816–1872)
The Cottage Door, ca. 1840
After William Sidney Mount
The Studious Boy, 1834

Two of Mount's submissions to the National Academy exhibition of 1835—*The Sportsman's Last Visit* (fig. 25) and *The Breakdown (Bar-room Scene)* (fig. 26)—seemed to exploit the public's enthusiasm for works that struck a contrast between the polish of genteel society and the rusticity of country folk.[59] Critics heartily endorsed these pictures of American life; the *Evening Star* proudly declared: "At Mount's age, Wilkie had not a third of his genius."[60] As with his popular *Rustic Dance After a Sleigh Ride* of 1830, Mount's painting *The Sportsman's Last Visit* centers on a lover's triangle. A young woman attired in a white gown is seated with the utmost propriety beside a formally dressed young swain who is courting her. Meanwhile, a rustic hunter, who also has designs on the woman, has entered the humble home. In the moment portrayed by Mount, it has dawned on the sportsman that in his pursuit of (or "hunt" for) the young lady he has been eclipsed by another, and that the lady has been complicit. (Suspended from her neck is an inverted cross, perhaps suggesting that this vision of innocence is in fact the devil in disguise.) The sportsman's predicament is summed up by a pair of scissors lying on the rug next to a basket of ribbon: this simple vignette alludes to the then-popular expression "to cut out," meaning "to supersede one in the affections of another."[61]

But the cause célèbre at the Academy exhibition was *The Breakdown (Bar-room Scene)*, sometimes called by Mount "Walking the Crack," a work that struck tender nerves of social division and reform in America. As Mount's audience would have recognized, the central figure is engaged in a fashion of dance known as "doing one's steps," which polite society then considered vulgar.[62] One writer said, "They [the dancers] may be very skillful and possibly (to some) funny; but they are also rude and coarse."[63] In addition, Mount's dancer is clearly a hard-cider drunk, a fact indicated by the earthenware jug on the floor and the ax (a reference to the cutting of wood on public lands as a legal punishment for drunkenness).[64] Curiously, the onlookers who form a circle around the dancer do not hold mugs or other containers that would be evidence of drinking. In the rhetoric of the time, true, virtuous citizens were abstinent; the abuser constituted the irresponsible and unproductive, often

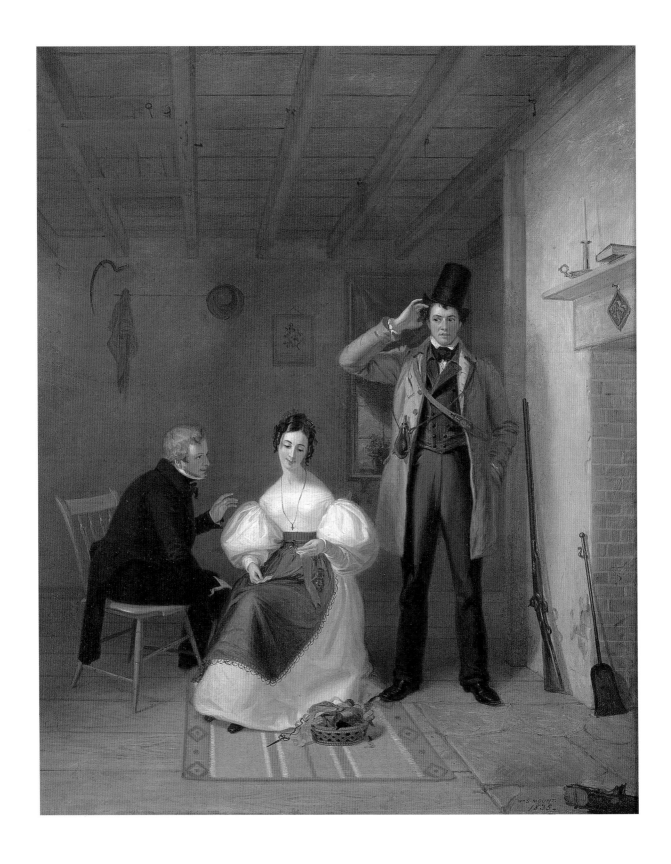

Figure 25

The Sportsman's Last Visit, 1835

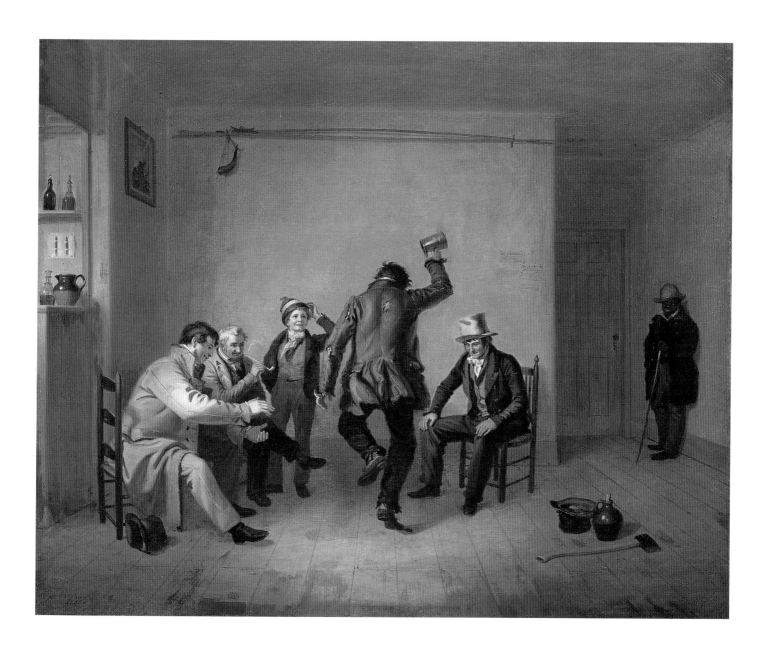

Figure 26
The Breakdown (Bar-room Scene), 1835

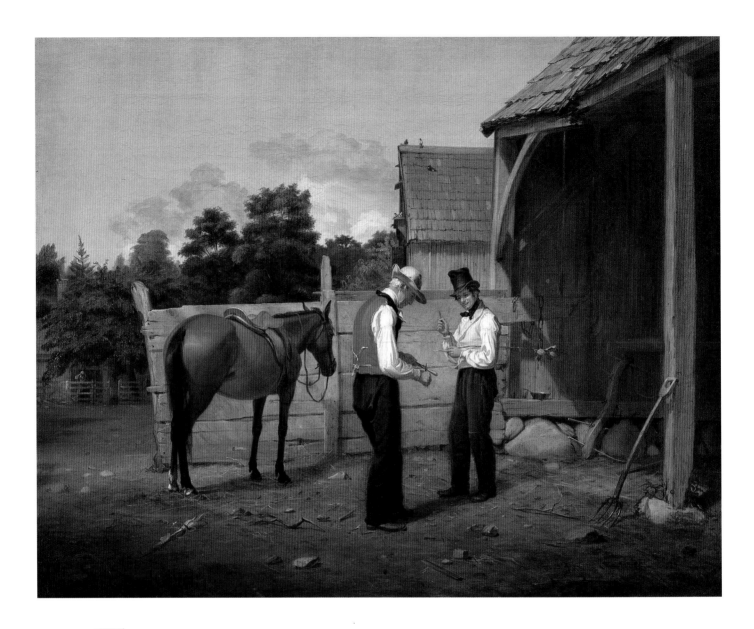

Figure 27
Bargaining for a Horse (Farmers Bargaining), 1835

defined as the immigrant or lower classes of society.[65] The consumption of alcohol per person had reached its highest levels nationally in the 1830s, and the tavern or barroom was the symbol of iniquity for the temperance societies, of which New York State had many. In *The Breakdown*, Mount calls attention to the local activities of the nationwide movement to prohibit drinking through a "Temperance Meeting" announcement posted on the wall. He may have intended a moralistic message in his pairing of the shabbily dressed tipsy dancer and the temperance notice, but more likely this was intended to be an ironic pun.

The following year, Mount was represented at the National Academy of Design exhibition by two pictures, *Farmers Bargaining*, now called *Bargaining for a Horse*, 1835 (fig. 27), and *Undutiful Boys*, now called *The Truant Gamblers*, 1835 (fig. 28). Both paintings were owned by Luman Reed, who was then one of the city's wealthiest residents but who had come from a modest, rural background.[66] It was especially appropriate that the businessman Reed owned *Bargaining for a Horse* since it is a symbol of how Americans transacted exchanges. Two well-dressed farmers, one grey-haired, the other younger and wearing a top hat, stand before a

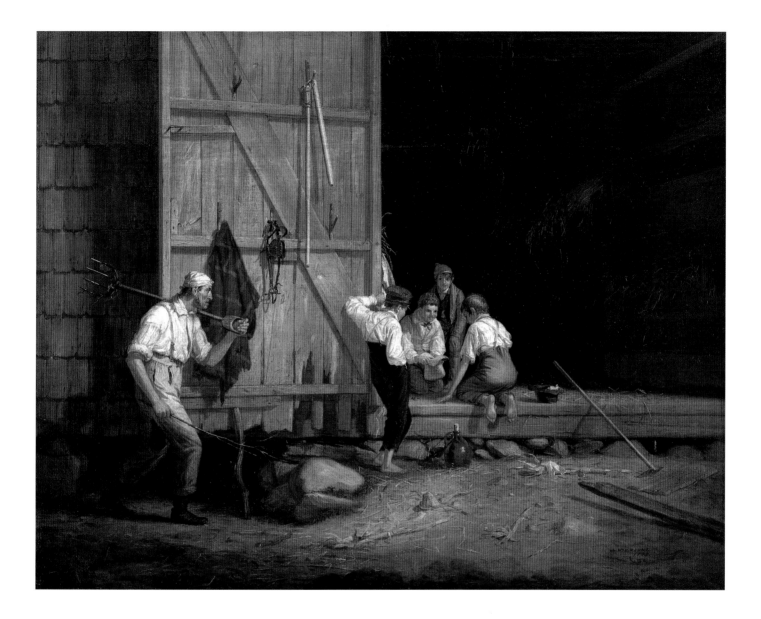

Figure 28
The Truant Gamblers (Undutiful Boys), 1835

somewhat dilapidated barn, striking a deal.[67] The object of both farmers' interest is a young, fine-boned horse in top condition, the type of animal bred for riding not field work. The well-trained animal stands unhitched with the reins circling its neck; the English saddle on its back suggests that it was just ridden by the prospective purchaser. Bargaining for this worthy horse would constitute a substantial transaction for both parties involved and a true test of Yankee business acumen.

By 1835 American cities and urban markets were growing, yet the nation was still predominantly agricultural in its enterprise. The traditional rural economy continued to be based on bartering, person-to-person transactions that entailed swapping labor or goods, with only a limited exchange of coin or paper currency. Such negotiations served an economic necessity, as well as being a form of social intercourse. In his observations of American life, written in 1835, the French tourist Michael Chevalier noted, "The American is always bargaining; he always has one bargain afoot, another just finished, and several more in mediation."[68]

Here, Mount pairs one Yankee against another; it is a contest of equals. The progress of their bargaining is signaled by their whittling. Thin, curly slivers of cut wood found on the ground between the two men show that the dealing is well along. The younger farmer has made an offer signified by his raised knife. It is not accepted. The older farmer continues his cut away from his body; a deal struck would be marked by a cut of the wood in the opposite direction.[69] In a humorous detail, Mount has painted the horse's ears erect and turned back as if it were listening in on the negotiations. *Bargaining for a Horse* reduces to very simple terms the freedoms and power associated with ownership through the depiction of a level of commerce understood and trusted by most Americans.

Mount had completed *Bargaining for a Horse* in September 1835 and had it delivered to Reed.[70] Immediately after receiving the painting, Reed wrote to Mount, describing how he had "called on [Asher B.] Durand + a few other friends . . . and we all pronounced it the best thing we had seen from your pencil."[71] Among those friends viewing the work was Seba Smith, who wrote a short story about it, which was published in the *New-York Gazette and General Advertiser* shortly thereafter.[72] Smith's fictional interpretation centered on his well-known Yankee characters—the relatives of Major Jack Downing and the residents of Down-ingville, Maine. Smith called the two negotiating farmers "Uncle Joshua" and "Seth Sprague," and identified "Aunt Nabby" standing behind the split-rail fence in the background. After reading Smith's story, Mount wrote to Reed, "I think the author studied the picture closely . . . tell him I was perfectly delighted with his conception."[73]

Mount's second picture for Luman Reed was *The Truant Gamblers (Undutiful Boys)*, which the artist subtitled "Boys hustling coppers on the barn floor." It was painted in Stony Brook from August to November 1835 and delivered to Reed in early December.[74] Like *Bargaining for a Horse*, *The Truant Gamblers* is about swapping or exchange, but of a less legitimate type. The four undutiful boys have abandoned their chores to hustle pennies, or "coppers," on the barn floor. The boys are engrossed in a game of chance or speculation with the wager in the form of "hard money" displayed at the center of the group on the barn floor. From the left, a farmer approaches with a pitchfork over his shoulder and a switch in one hand. One boy has caught a glimpse of the approaching farmer. It is a suspenseful instant, with the viewer fully aware of how the scene will play out.

Mount's showing at the 1836 National Academy exhibition was a triumph. The critic for the *Evening Post* exulted, "The sight of these alone is worth the price of a season ticket."[75] And, as word of these paintings spread, the public flocked to see the works and collectors begged the artist to produce more.[76] In May, Reed wrote to Mount wanting more paintings.[77] But, before Mount could reply, Reed died unexpectedly at the age of forty-nine.[78] New patrons surged to fill the void. Reed's business partner, Jonathan Sturges, had also requested paint-ings, as did Baltimore collector Robert Gilmor, Jr.[79] And, that summer, John Trumbull intro-duced Mount to Henry Brevoort, Jr., among the wealthiest men in New York City, who soon after ordered a picture.

For Jonathan Sturges, Mount painted *Farmers Nooning*, 1836 (fig. 30), which was immedi-ately acclaimed as a masterpiece when it was exhibited at the National Academy in 1837.[80] Mount may have gleaned the subject matter for this picture from engravings after paintings

Figure 29
Courtship or **Winding Up**, 1836

of haymakers at work or at rest by British artists George Stubbs and Francis Wheatley. But Mount's version is strikingly American. It is a late summer day, the scent of fresh-cut hay is thick in the air, and the field hands are relaxing after their noon meal. While one worker carefully sharpens the blade of his scythe, another stretches out on the grass with his head nestled in his arms, and a third man in a red vest sits with his back to the viewer. These three figures are all in shade. In sharp contrast is the scene in the sun-drenched middle ground, a conception that differs radically from Mount's original study for the picture (fig. 31). There, a mischievous child reaches out with a spear of grass to tickle the ear of an African American laborer sleeping on a haystack.

As a pictorial invention, this figure of the reclining black man is an extraordinary achievement in the tradition of the Grand Manner. Reclining figures were rare in American

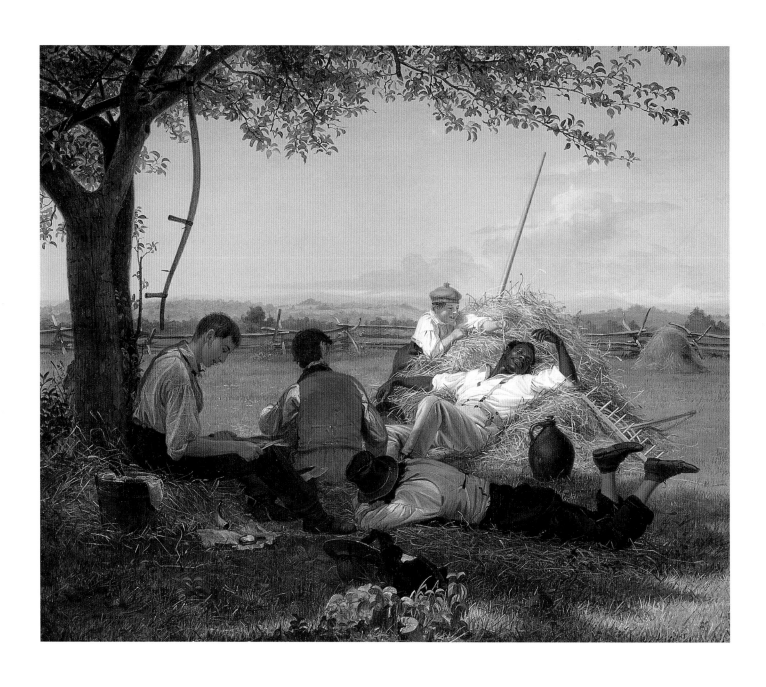

Figure 30
Farmers Nooning, 1836

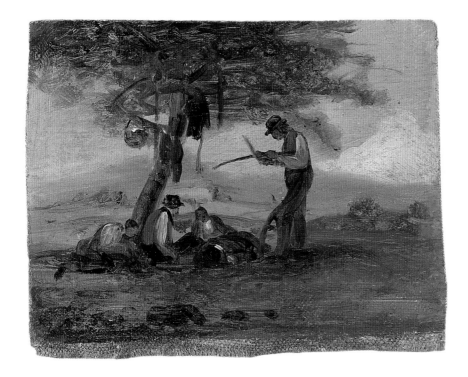

Figure 31
Study for **Farmers Nooning**, ca. 1836

Figure 32
John Vanderlyn (1775–1852)
Antiope, 1808–1809
After Correggio (1489–1534)
Jupiter and Antiope, 1524–25
Oil on canvas
70¼ x 51 inches
The Century Association, New York

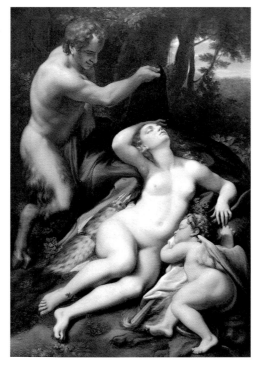

art up to that point, and those were generally the dead or dying in the heroic battle scenes of artists such as John Trumbull. Occasionally images of gods and goddesses from classical mythology were painted in reclining poses by Benjamin West, John Vanderlyn, and other followers of European high styles. In fact, the major precedent for Mount's sleeping hayman was Vanderlyn's *Antiope*, 1808–1809 (fig. 32), a copy after Correggio's *Jupiter and Antiope* in the Louvre, which was displayed for years in the Rotunda in New York's City Hall Park.[81] Vanderlyn's version depicts the nude Antiope sleeping in the woods, a cupid resting alongside her. One arm is raised above her head in the gesture indicating that the figure is asleep, not dead. Some viewers complained, however, that the figure of the nude goddess did not conform to the "habits" of America or to "the taste of . . . [its] countrymen."[82] But, for the most part, Vanderlyn's *Antiope* demonstrated that as an established motif in Italian Renaissance and Neoclassical art the reclining figure was a viable subject for American practitioners of the Grand Manner.

Mount may also have derived the motif of someone playfully tickling a sleeping figure from European traditions. This image appeared frequently in seventeenth-century Dutch genre painting. One example is Jacob Duck's *Soldiers Arming Themselves*, mid-1630s (fig. 33), in which a soldier tickles the nose of his sleeping comrade.[83] Another example is Jan Steen's *The Dissolute Household*, ca. 1668 (fig. 34), which shows a boy using a piece of straw to tickle the nose of an old woman who has fallen asleep at the table.[84] A third example is by French Rococo artist François Boucher, who revived the motif a century later in *The Interrupted Sleep*, 1750 (fig. 35). There, within an idealized pastoral landscape, a peasant lad extends a piece of straw to tickle the cheek of a sleeping shepherdess. By referencing such classical motifs in the rustic idiom of *Farmers Nooning*, Mount demonstrated his sophisticated knowledge of the European masters. More than any other American artist up to

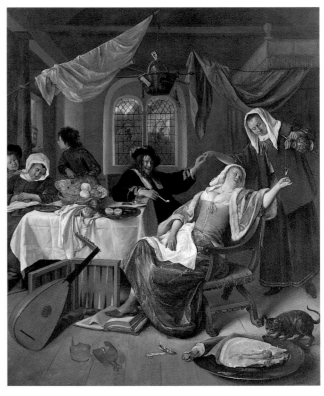

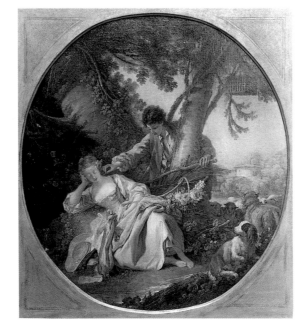

Figure 33
Jacob Duck (ca. 1600–1667)
Soldiers Arming Themselves,
mid-1630s
Oil on panel
16⅞ x 22⅜ inches
The Minneapolis Institute of Arts;
The Ude Memorial Fund and Gift of
Bruce B. Dayton (88.2)

Figure 34
Jan Steen (1625/26–1679)
The Dissolute Household, ca. 1668
Oil on canvas
47½ x 35½ inches
The Metropolitan Museum of Art;
The Jack and Belle Linsky Collection
(1982.60.31)

Figure 35
François Boucher (1703–1770)
The Interrupted Sleep, 1750
Oil on canvas
31 x 27¾ inches
The Metropolitan Museum of Art;
The Jules Bache Collection, 1949
(49.7.46)

this time, Mount successfully wed the artistic traditions of Europe with a vivid vocabulary specific to contemporary society in the New World.

Mount's surprising choice of a black man as the focus of *Farmers Nooning* had obvious significance in the context of contemporary political debates over slavery. Many scholars have addressed the issue of Mount's representation of African Americans, either as indications of the artist's own political views on race or as part of a larger iconography of blacks in the antebellum United States.[85] Unfortunately, however, Mount's own views on race are simply enigmatic. Although many of his genre paintings depict African Americans, few of his writings make reference to them. And the majority of those remarks (some quite derogatory) date from after the Civil War, when Mount felt that blacks were being manipulated by Radical Republicans. Yet, during this same period, Mount sadly noted in his journal the death of a local resident, Jules (Killis) Howard, whom he described as "colored industrious & full of humor."[86] Other evidence, though scant, suggests that Mount had a high regard for individual African Americans whom he knew. Census

records, family estate inventories, and other primary materials show that African Americans—enslaved, indentured, and free—were always part of the community of Mount's youth.[87] What is more difficult to determine are his views on the broader issue of "race" and the politics of equality.

Mount's depictions of African Americans in his genre paintings were drawn largely from the visual vocabulary of his contemporary social environment. In that context, the African American, or "Negro," like the New England Yankee, was considered, in very simplistic terms, a "comic" character. However, while the Yankee was accorded some positive attributes, such as patience and intellectual shrewdness, the Negro was typically assigned a childlike naiveté and talents limited to music and dance. Mount, and those who saw his paintings, were surely cognizant that these interpretations of African Americans were oversimplified and demeaning, but, in general, they were accepted without question. This propensity for racial stereotyping is evident in published remarks about Mount's pictures. For instance, in a review of *The Breakdown*, an African American in the background is offhandedly referred to as "Young Cuffee . . . who has a smile of more mind than belongs to his race."[88]

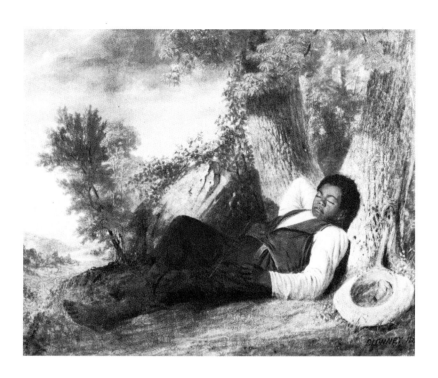

Figure 36
James G. Clonney (1812–1867)
A Negro Boy Asleep, 1835
Oil on canvas
13¾ x 17 inches
Courtesy of J. N. Bartfield Galleries

Several scholars have suggested that Mount decided to paint a black man in a reclining position to support the then-current stereotype of blacks as indolent and lazy.[89] Yet, Mount's African American is shown within the larger framework of a day's work in the fields sharing the noon respite with his white co-workers, and he is not the only reclining figure. A more ambitious interpretation has been proposed by art historian Elizabeth Johns, who sees the painting as a political allegory about the dangers of abolitionism aimed at "strongly antiabolitionist New Yorkers."[90] She argues that the tam-o'shanter worn by the young tickler was a common abolitionist symbol that had appeared in American graphic art by 1834. Moreover, she continues, "*Ear tickling*, the activity of the young boy in Mount's picture, meant filling a naive listener's mind with promises."[91] While such a specific reading—particularly regarding the mix of politics and wordplay—might seem consistent with Mount's earlier work, here it seems that he does not advocate any particular position. Rather, he depicts the black man in a liminal state, suspended between the slumber of slavery and the awakening of emancipation. Indeed, by refusing to specify the ideal course of action, Mount challenges his viewers to imagine the future and confront their own political convictions.

Joining *Farmers Nooning* at the 1837 National Academy exhibition was *The Raffle*, now known as *Raffling for the Goose* (fig. 37), which was painted in late 1836 and early 1837, toward the climax of speculation fever. The picture depicts a humble interior in which six men are

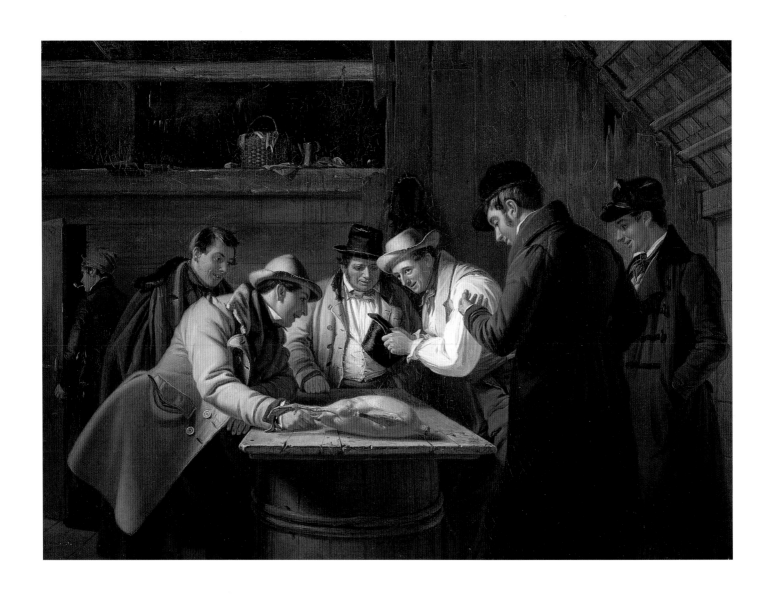

Figure 37
Raffling for the Goose (The Raffle),
1837
Oil on panel
17 x 23⅛ inches
The Metropolitan Museum of Art;
Gift of John D. Crimmins, 1897
(97.36)

grouped around a makeshift table engaged in illicit gambling, a raffle for a goose. One figure is seen leaving the room before the outcome of the wager is known. As indicated by his workingman's cap and his tattered coat, he is a man of humbler means than the gamblers, and was evidently not involved in the raffle. To him, the goose would constitute food on the table, whereas for the others it represents only a fleeting amusement.

As early as 1833, Seba Smith had cautioned his countrymen about the rash of speculative ventures brought on by the tremendous expansion of the nation and its economy.[92] And by 1835, the Frenchman Michael Chevalier, was reporting, "Every body is speculating, and every thing has become an object of speculation. The most daring enterprises find encouragement; all projects find subscribers."[93] Speculative ventures could be instigated by anyone who had a "goose," but only men with assets could play the game. But "gone goose," the theme Mount plays on in his picture, was, as John Russell Bartlett explained in his 1849 *Dictionary of Americanisms*, a Northern expression for someone who was "past recovery," in other words, a lost man, a victim of speculation.[94] This image was timely. On May 11, just three weeks after Mount's painting *Raffling for the Goose* was exhibited at the National Academy, former New York mayor Philip Hone made the following ominous notation in his diary: "A dead calm has succeeded the stormy weather of Wall Street and the other places of active business. All is still as death. No business is transacted, no bargains made, no negotiations entered into."[95] The economy had crashed. Sadly, for many Americans devastated by the ensuing Panic of 1837, "gone goose" became an all too familiar description.

Like *Raffling for the Goose*, Mount's *The Long Story (The Tough Story)*, 1837 (fig. 38), painted the same year for Robert Gilmor, Jr., explores speculation and national expansion.[96] In a nondescript room, three men huddle by a small wood stove, conversing. There are three "types": the lame old man, the youthful speculator who smokes a pipe, and a cloaked traveler whose eyes are covered by his cap. Mount has skillfully juxtaposed the old man with a bandage wrapped around one knee and a crutch propped against his leg with a notice for the Long Island Rail Road affixed to the wall. If the old man's lameness represents limited mobility, the railroad notice is a potent symbol for expansive movement, a driving force behind the free enterprise of the time. Railroads, in particular, constituted an easy and efficient mode of access to land, goods, and natural resources, and, therefore, represented a potential means for profit. Other visual clues support the picture's underlying themes of national expansion and economic speculation. Playing cards, symbolizing speculation, spill from the invalid's top hat. The man in the cloak is, by Mount's own explanation, a traveler, who is "waiting for the arrival of the Stage." Although such horse-drawn vehicles as the stagecoach were the traditional modes of transport in rural America of the 1830s, railroads constituted a new and as yet undeveloped challenge. The Long Island Rail Road alluded to in Mount's picture is a case in point. Although construction on this rail link between Long Island's agricultural and fishing industries and Eastern coastal seaports was begun with great fanfare in the mid-1830s, the financial panic of 1837 abruptly halted its progress. Plagued by financial problems, the Long Island Rail Road remained uncompleted until 1844.[97]

When Gilmor received the painting in December 1837, he wrote to the artist offering an interpretation of the subject matter. In response, the artist gave his version of the events por-

trayed, and, given the rarity of Mount's own explanations of his themes, it is worth quoting this text at length:

> The man puffing out his smoke is a regular built Long Island tavern and store keeper, who amongst us is often a Gen. or Judge, or Post Master, or what you please as regards standing in society, and as you say has quite the air of a Citizen. The man standing wrapted in his cloak is a traveler as you suppose, and is in no way connected with the rest only waiting for the arrival of the Stage, he appears to be listening to what the old man is saying. I designed the picture a conversation piece. The principle interest to be centered in the old invalid who certainly talks with much zeal. I have placed him in a particular chair which he is always supposed to claim by right of possession, being seldom out of it from the rising to the going down of the sun. A kind of Barroom oracle, Chief Umpire during all seasons of warm debate whither religious, moral, or political, and first taster of every new barrel of cider rolled in the cellar, a glass of which he now holds in his hand while he is entertaining his young landlord with the longest story he is ever supposed to tell, having fairly tired out every other frequenter of the establishment.[98]

Although in his commentary Mount seems to have adopted the pseudo-naive tone of the fictional Yankee, what is particularly significant is his designation of the painting as a "conversation piece." This particular genre, popular in eighteenth-century England, was based on the idea of family portraiture but was expanded to imply any figural grouping of individuals engaged in intimate conversation. The further implication that this conversation might engage the viewer as well suggests Mount's interest in the form and reveals that he specifically intended his paintings to be a stimulus to debate. Clearly, in his genre paintings, Mount meant to motivate discussion about political and social themes central to American life.

Audiences identified with Mount's subjects as contemporary images, but there was also a reminder of the not-so-distant past fused with the present. Mount thought in terms of recognizable symbols, and it is evident that his viewers were meant to recognize these situations and characters.[99] And with the exhibition of *The Long Story* in 1838, the critics seemed to have reached a determination of what Mount's pictures actually were: they were defined as "history paintings" or "historical" subjects, with the implication that Mount's paintings were of the highest order in the hierarchy of subjects in fine art.[100] This acceptance of Mount's scenes from everyday life as "history paintings" opened the floodgates for his contemporaries to follow suit, and many of them painted in direct imitation of Mount.

At the same 1838 National Academy exhibition Mount also showed another conversation piece, a large work titled *Dregs in the Cup* or *Fortune Telling*, 1838 (fig. 39).[101] It was not well received, perhaps because it differed markedly from Mount's previous work. It is the first major genre picture by Mount to feature only women, and it is also unusual because the scene is not specific to country life. In fact, the stylishly dressed females listening to the fortune-teller read their tea leaves appear fashionably urbane, especially compared to Mount's usual rustic types. A preliminary sketch for the painting (fig. 40) shows a lit candle on a small table between an aged fortune-teller and two young women. The room is expansive with impressive cascading draperies on the left and a monumental fireplace mantel on the right. The setting resembles the interior of an upper-class urban home, not that of a rural

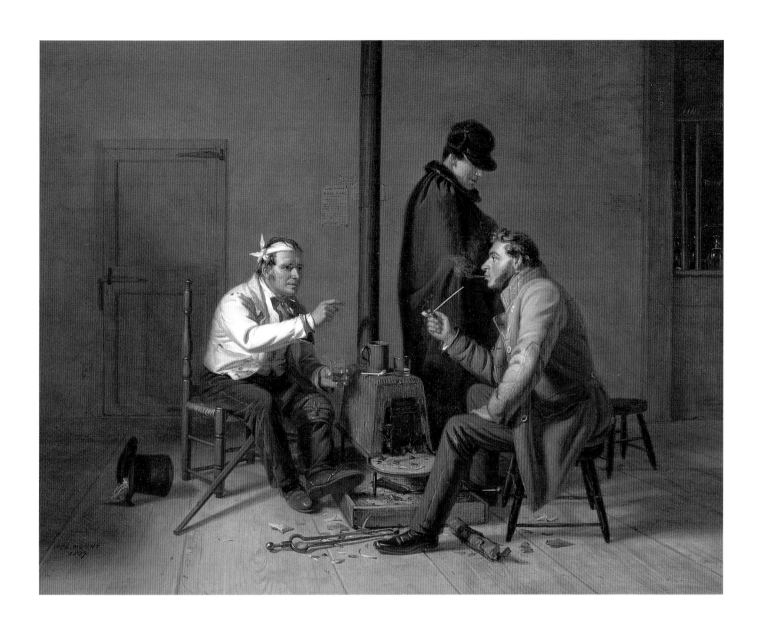

Figure 38
The Long Story (The Tough Story), 1837

Figure 39
Dregs in the Cup or **Fortune Telling**,
1838

farmhouse. It appears that Mount originally intended to portray a vignette of bourgeois entertainment.

In the finished painting, Mount tightened the scene so that the large figures fill the composition; the background is murky and obscure. Raking light and a pronounced contrast between light and dark heighten the mysterious nature of the subject. One critic found *Dregs in the Cup* "a little too serious"; another complained that the canvas was "too large for a comic subject."[102] Overall, the reviews were peppered with remarks about the work's failings:

Figure 40
Study for **Dregs in the Cup**
Pencil on paper
4¼ x 5¼ inches
Sketchbook, 1831–39
The Museums at Stony Brook;
Bequest of Ward Melville
(77.22.674)

the figures were "crude and sharp," the coloring was "false," and the effect was "chalky."[103] Although offered for sale, the picture failed to attract a buyer. From this experience Mount learned a powerful lesson. The critics expected from him pictures of a certain size and subject matter—images of rustic life and perceptions of "national character." For a number of reasons, *Dregs in the Cup* simply did not fit the mold.

The critical failure of *Dregs in the Cup* may have prompted Mount to paint *Artist Showing His Own Work*, now known as *The Painter's Triumph*, 1838 (fig. 41). The work might more appropriately be called "The Painter's Revenge," since this painting is a pointed yet humorous response to the critics about the role of the artist as the bearer of enlightenment.[104] In Mount's work, the young artist (modeled after Mount himself) triumphantly displays his latest work to a fascinated visitor. The large painting on its easel faces away from the viewer, its subject known only to the artist and his guest. But its considerable proportions suggest that it is a major work (perhaps even *Dregs in the Cup*). The other canvases in the room are turned to the wall. The only work of art visible in the studio is a sketch of Apollo, the personification of light and truth, and the symbol of noble artistic purpose.

At the center of the composition, the painter's outstretched arm points to the work on the easel in a dramatic gesture recalling Zeus hurling his thunderbolt or Mount's own earlier image of the witch conjuring Saul from the dead. The artist clutches a palette and brushes in his upraised hand, and his hair is in wild disarray. An intense circle of light hits the artist's forehead, signifying his superior intellectual and creative powers. The visitor, a rustic everyman holding a working-class whip, leans forward, hands on knees, to study the canvas, appreciating the passage indicated by the artist. But the head of Apollo in the nearby sketch turns away from the canvas on the easel. This contrast between classical taste and the art of the people is a pointed reference to the critical debates of the time. Enamored with European traditions, critics of Mount's work often alluded to the Old Masters or Dutch genre painters as instructional models for the artist. Mount's aggressive response to the critics, in the form of an *en guard* fencing pose, clearly favors the opinion of the people.[105] The implicit message of *The Painter's Triumph* is that art is for the common man, not the critics or wealthy patrons. As Mount later wrote, "Never paint for the few but for the many."[106]

During the winter of 1838–39, Mount worked on *Catching Rabbits* or *Boys Trapping* (fig. 43).[107] In early March of 1839, Jonathan Sturges wrote to the artist, "hoping to see something

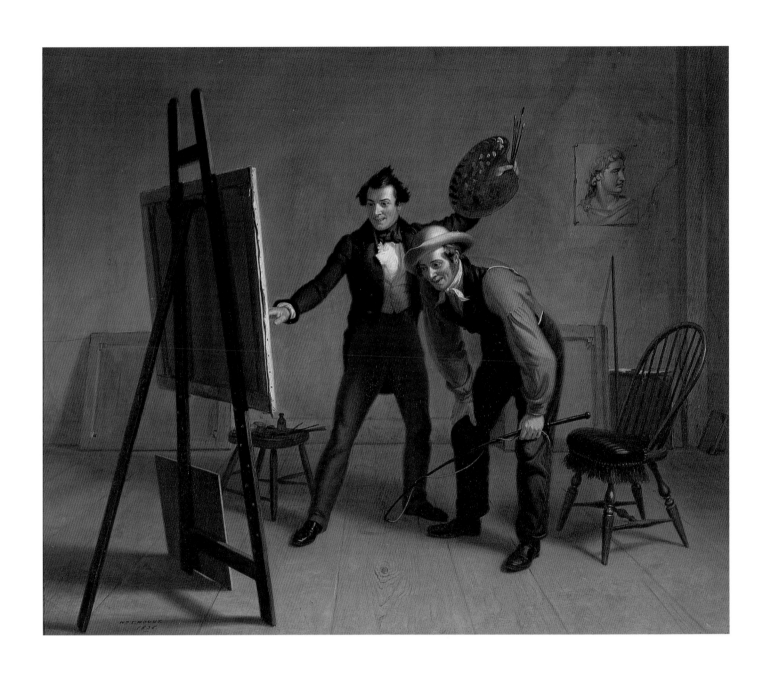

Figure 41
The Painter's Triumph (Artist Showing His Own Work), 1838
Oil on panel
19½ x 23½ inches
Museum of American Art of the
Pennsylvania Academy of the Fine Arts,
Philadelphia; Bequest of Henry C. Carey

of you in the Spring—we must stir them up."[108] And when *Catching Rabbits* was exhibited at the National Academy exhibition, which opened on April 24, it certainly caused a stir. Critical opinions of the picture ranged wildly, from describing it as "the best of his works" to dismissing it as a picture that "will not enhance Mount's reputation."[109]

Catching Rabbits was the first snow scene painted by the artist. Two boys have entered the woods on a crisp winter day to check their rabbit trap. One holds high a plump victim, the other readies the trap for another catch. Elizabeth Johns has interpreted *Catching Rabbits* as a timely observation on the national political scene.[110] For her, the rabbit is the key to Mount's underlying meaning. Popular literature of Mount's day had, through some ambitious wordplay, "transformed *rabbit* to *hare*, *hare* to *hair*, and *hair* to *wig*."[111] The rabbit catchers, then, are Whig politicos trapping votes for their cause. The wily boys in the picture are proud of the respectable trophy they have caught and are prepared to snare more. In the presidential campaign of 1836, the Whigs had emerged as a viable opposition to the powerful Democrats. Although the Democratic candidate, Martin Van Buren of New York, won that year, by the next election, in 1840, the Whigs were a formidable political force. Mount's patron for this work was Charles Augustus Davis, an outspoken Whig.

Figure 42
Study for **The Painter's Triumph (Artist Showing His Own Work)**, ca. 1838
Pencil on paper
4¼ x 5¼ inches
Sketchbook, 1831–39
The Museums at Stony Brook;
Bequest of Ward Melville
(77.22.674)

Although his involvement with politics fluctuated throughout his life, in 1839 Mount was a Democrat. In January 1839, during the period he was working on *Catching Rabbits*, he attended a social event at New York's Tammany Hall, where he also boarded.[112] Mount supported Van Buren, a dominant force within the Tammany organization, for a second term as president in 1840.[113] Nationally, however, there was widespread disillusionment for the Van Buren administration's failure to curb the sinking economy. In addition, the unity of the Democratic party had been weakened by division.[114] *Catching Rabbits* can be seen as Mount's warning to the public not to be baited and trapped by the Whigs in the upcoming election. In particular, this message was aimed at those Democrats tempted to run like rabbits and desert their party.

The National Academy exhibition was a very public arena in which to present such a politically symbolic work as *Catching Rabbits*. And, to some extent, Mount's admonition was heeded: to represent their campaign, the Democrats merged the concept of the trap with the potent Whig emblem of the log cabin. This graphic imagery, accompanied by rhetoric cautioning Democrats against being lured and captured by the Whigs, is prevalent in election broadsides from 1840 (fig. 44).[115] Although an effective piece of political symbolism, the log-cabin trap and the prospect of being a "dead rabbit" failed to persuade voters; the Democrats were defeated by William Henry Harrison.

On the eve of the 1840 campaign, publisher Edward L. Carey had tried unsuccessfully to secure the reproduction rights to what he called "Snaring Rabbits" for publication in *The Gift*.[116] Carey was persistent, however, and by 1843 he declared that if he could not have the 1839 picture, he would be satisfied with a similar work.[117] Mount complied, and during the

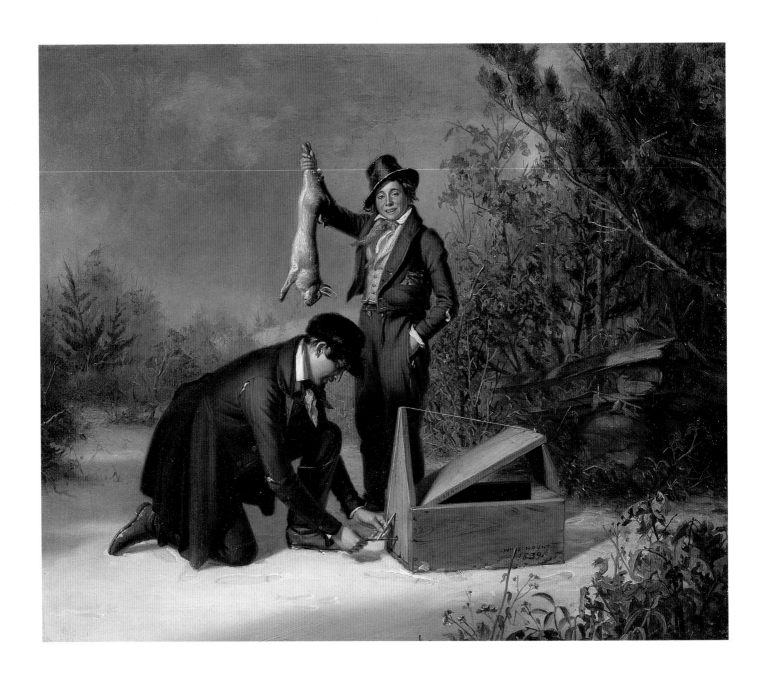

Figure 43
Catching Rabbits or **Boys Trapping**,
1839

1844 presidential campaign, in which the incumbent Whigs were opposed by the Democrats, he painted *The Trap Sprung*, now called *The Dead Fall*, 1844 (fig. 45). One of the youths in *The Dead Fall* holds in his hand a dead rabbit, evidence of a prior successful capture, which may symbolize the rewards of the 1840 campaign. The boys approach their trap, excited with the prospect of another victory. In the 1844 election James Polk recaptured the White House for the Democrats, but it is not known which candidate Mount supported. Yet his continuing interest in the Democrat/Whig contest is demonstrated in a journal entry in December 1844; among the subjects he considered painting was "A Whig after the Election."[118]

If *Catching Rabbits* was Mount's rallying cry to the Democratic party, *Cider Making*, 1841 (fig. 46), was, like its patron, Charles Augustus Davis, all Whig. The "Log Cabin and Hard Cider" campaign staged by the Whigs in the presidential election of 1840 is considered a watershed in American political history for its blatant use of fabrication and propaganda. The public was saturated with imagery and slogans (such as "Tippe-canoe and Tyler, Too!") promoting the election of William Henry Harrison and his running mate, John Tyler.[119] Foremost among the images deployed by the Whigs were the log cabin, falsely claimed as Harrison's humble birthplace, and the barrel of hard cider, the favored drink of the intemperate electorate if not the candidate himself. Mount punctuates *Cider Making* with five casks, fully conscious that the cider barrel was a symbol inseparable from the Whig party. To nail his point, the barrel in the foreground is prominently dated "1840." Harrison soundly defeated Democrat Martin Van Buren in the November 1840 election. Less than a month later, Mount was at work on *Cider Making*, and he had evidently written to his brother Robert with a description of it.[120]

Mount's theme was so topical that *Cider Making* was announced in the media while still on his easel.[121] In addition, a short story, developed from the picture, appeared in the *New York American*, the leading Whig newspaper.[122] The story identifies all the rustic folk in the picture by appropriately quaint names and their character roles within the scene. As

Figure 46
Cider Making, 1841

Figure 47
Ringing the Pig (Scene in a Long Island Farm-Yard), 1842

Elizabeth Johns has convincingly demonstrated, each character in Mount's picture represents an actual member of the Whig party leadership.[123] Certain words and passages throughout the story, emphasized by italics and quotation marks, underscore every subtle reference. The story is essentially a guide for appreciating Mount's mastery of presenting sociopolitical issues under the guise of genre.

The fact that Mount, ostensibly a Democrat, was able to produce such an elaborate political allegory for a Whig victory suggests that when it came to commissions the artist did not take sides. In fact, in the lower right corner of *Cider Making*, Mount included what is apparently a derogatory reference to his own party: a pair of sleeping but well-fed hogs may symbolize the greed of certain Democrats who dozed while the Whigs stole the election. In 1842, Mount made a similar jab at the Democrats with his riotous hogpen originally titled *Scene in a Long Island Farm-Yard*, now called *Ringing the Pig*, 1842 (fig. 47). Another foray into the arena of political commentary, *Ringing the Pig* was, in the context of the recent run

Figure 48
"Trying to back out"
Study for **Ringing the Pig (Scene in a Long-Island Farm-Yard)**, ca. 1842

of Democrat election defeats, a clear rebuke to Mount's own party, represented here as the hog.[124] In the picture, a farmer straddles a well-fed pig for the purpose of fitting a ring into its snout, to prevent it from rooting up shrubs. The hog has dug its hooves in and is straining against the rope tethered to a sturdy post. As the hog squeals, a boy in a red cap covers his ears. An older lad at the rear of the pen raises a sturdy corn stalk to keep the other pigs at bay, and one surly beast glares up at him from the corner of its eye.

In addition to its specific allusions to the Democratic Party, *Ringing the Pig* was also meant as a commentary of the political spoils system. As evidenced on the hindquarters of the hog in the foreground, the party's "true spots" were readily apparent. It had been widely reported that self-serving speculators, aided by key political appointments, had contributed significantly to the national economic devastation and its lingering effects. Such appointments were rich rewards not infrequently abused. The most notorious example was the Tammany-connected Samuel Swartwout, a Jackson-Van Buren appointee to the post of collector of the Port of New York, who "borrowed" well over a million dollars and absconded to Europe.[125] In *Ringing the Pig*, Mount called on the honest and hardworking citizens of America to set aside political affiliations, recognize these hogs for what they were, and rein them in.

As for the critics, the picture again redeemed the artist: "There is no mistake about it, Mount *is* one of the most gifted artists that ever lived . . . he *has* not, and never had a superior, in this or any other country."[126] Although Mount had regained his ability to hit the mark with the critics, his production of major genre paintings had dwindled. A malaise had settled over the artist. In January 1841, his brother Henry died suddenly at the age of thirty-nine, an event that sent Mount into depression.[127] Then, Mount's mother was taken ill, and in November she died. During this period of mourning, Mount painted what may be his least typical work, an image that can be considered a reflection of his grief. The shore scene, *Crane Neck Across the Marsh*, 1841 (fig. 49), completed in August, is remarkable for its combination of broad horizontal bands of color, limited palette, diffused light, and loose technique.[128] Only the tiny figures on the beach, the incidental sailboats on the water, and the faint indications of birds in the sky suggest the way the breathtaking scale of nature overwhelms all living things.

For almost a year Mount did not paint.[129] His lack of productivity was evident at the National Academy exhibition of 1843, where he was represented by only one picture—*The Painter's Triumph* from 1838. As if compelled to escape the memories of his Long Island home, Mount traveled for the greater part of 1843 and 1844. In July 1843, he visited Hartford and Norwich, Connecticut; then he revisited New York City before traveling on to Albany. After a brief return to Stony Brook, he soon left again for the city. But once there he felt "a desire to study landscape," so on September 2 he journeyed up the Hudson to Catskill, where he stayed for a month and visited frequently with that village's most famous resident, painter Thomas Cole.[130] "I spent several evenings with Mr. Cole at his house," Mount wrote. "We talked of painting and music, and I found him (like the scenery that surrounded him)

Figure 49
Crane Neck Across the Marsh, 1841

Figure 50
Boys Hustling Coppers (The Disagreeable Surprise), 1843
Oil on panel
8 x 10 inches
Private collection

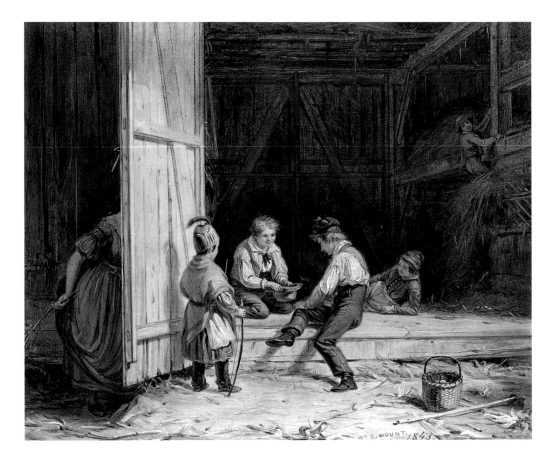

truly interesting. . . . We sketched and painted together in the open air, and rambled about the mountains after the picturesque. Mr. Cole made me a present of a small landscape."[131]

Rejuvenated by his mountain retreat, Mount returned to New York City, where he resided from late October 1843 through mid-June 1844. The only documented pictures from this period are three portraits and *The Dead Fall*. But even this tentative renewal of painting assured Mount's appearance at the National Academy's 1844 exhibition. He submitted three portraits and one genre painting—*Boys Hustling Coppers (The Disagreeable Surprise)*, 1843 (fig. 50). Since publisher Edward L. Carey had been unsuccessful in securing the reproduction rights to Mount's *Truant Gamblers* from 1835, he had commissioned the artist to paint another version, to be engraved for *The Gift*. The result, *Boys Hustling Coppers*, is a small work, only eight by ten inches, which, as Carey observed, is painted in a freer style than was customary for the artist.[132] A boy kneels on the barn floor extending his hat in an invitation for another to participate in a game of chance. Boys on either side watch this engagement; another climbs from the hay loft to get a closer look. Behind the barn door a woman spies on the proceedings, a switch held ready at her side.

Why did Mount accommodate Carey while other patrons waited, sometimes for years? Simply put, Carey gave the artist's images circulation and longevity. With the exception of limited public viewing periods at the annual exhibitions of the National Academy and a handful of other urban art organizations, Mount's paintings disappeared into private homes or galleries. The owner's permission was required to place a picture on public exhibition or have it reproduced, while the artist generally had no say and received no compensation.

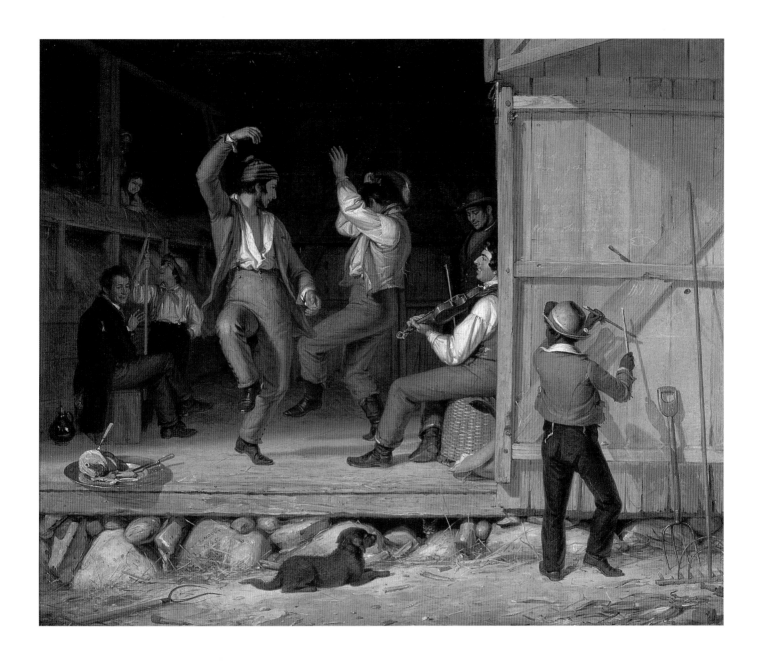

Figure 51
Dance of the Haymakers, 1845

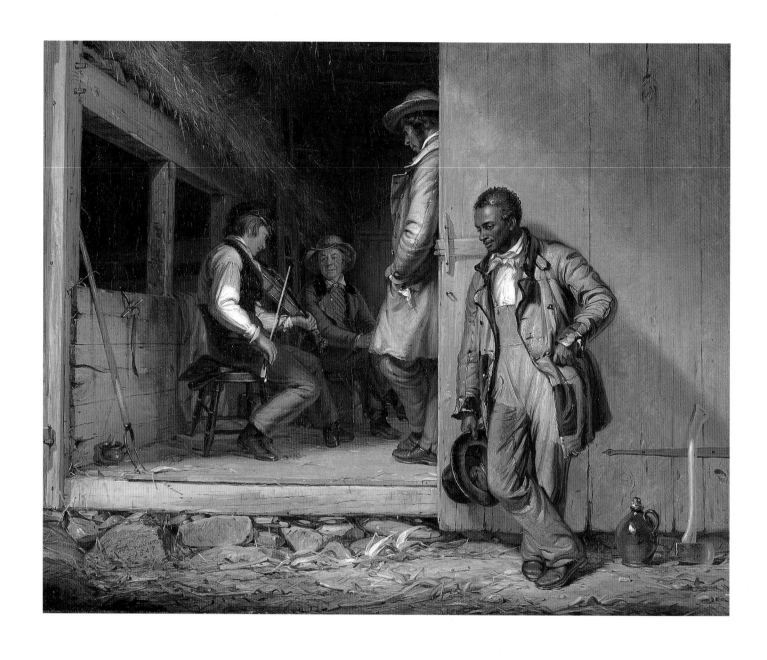

Figure 52
**The Power of Music
(The Force of Music)**, 1847

Carey was a valuable friend to Mount in that he assured engraved reproductions of relatively good quality for *The Gift*, an annual gift book. Widely distributed in the United States, these gift books had also entered the European market where they were apparently "well received."[133] Until 1848, when Goupil, Vibert & Co. issued the first of many lithographs after Mount's paintings, *The Gift* engravings were the main vehicles by which Americans and Europeans were likely to become acquainted with Mount's work. And Mount recognized Carey's unique ability to disseminate his images to the public.

Figure 53
Studies for **Dance of the Haymakers** and **The Power of Music (The Force of Music)**, ca. 1845

After four years of mourning and travel, Mount returned to the type of subject that had initially won him notice. In 1845 he painted *Dance of the Haymakers* (fig. 51), which recalls his early *Dancing on the Barn Floor* of 1831, as well as other works of his that treated the themes of music and dance—*Rustic Dance After a Sleigh Ride* (1830), *After Dinner* (1834), and *The Breakdown* (1835). Music and dance had remained active forces in the artist's life, and Mount frequently attended concerts and dances as well as playing the violin himself. Yet, for ten years these themes were absent from his genre paintings.

Mount's *Dance of the Haymakers* is a joyous celebration of country life and community. Two dancers celebrating the completion of the harvest have partaken of a smoked ham and cider and are now inside the barn performing a free-form style of dance, perhaps a jig. A fiddler plays eagerly. One dancer, in the midst of his "fancy steps," glances over his shoulder to assess the performance of the other. It is a competition of skill and stamina. The others in attendance take pleasure in comparing and judging the abilities of the dancers. To underscore the notion of a contest of endurance, underneath the barn a dog and a cat stare each other down, waiting for the first move that will end this challenge. Meanwhile, just outside the barn a young black boy uses a pair of rough drumsticks to beat time to the fiddler's lively tune on the barn door.

One of the nineteenth century's great patrons, New Yorker Charles Mortimer Leupp, commissioned *Dance of the Haymakers*. The following year he ordered a variation on this theme, *The Force of Music*, now called *The Power of Music*, 1847 (fig. 52), for his mother-in-law, Mrs. Gideon Lee.[134] Mount clearly conceived of *Dance of the Haymakers* and *The Power of Music* at the same time, as evidenced by a preliminary double sketch (fig. 53). The lower drawing depicts the general format and content for *Dance of the Haymakers*, while the upper sketch outlines the schema for *The Power of Music*. In the latter sketch, a figure pauses outside what appears to be a home, with a door and a multipane window, not a barn. Inside, a fiddler plays for a man, woman, and child.

Mount began *The Power of Music* in November 1846; he painted the barn outdoors and the figures in his studio.[135] In the final picture, a young fiddler, seated on a wooden stool inside the barn plays the violin while two men, one elderly, the other middle-aged, concentrate on the music. Outside, and concealed from those inside by the barn door, is an older

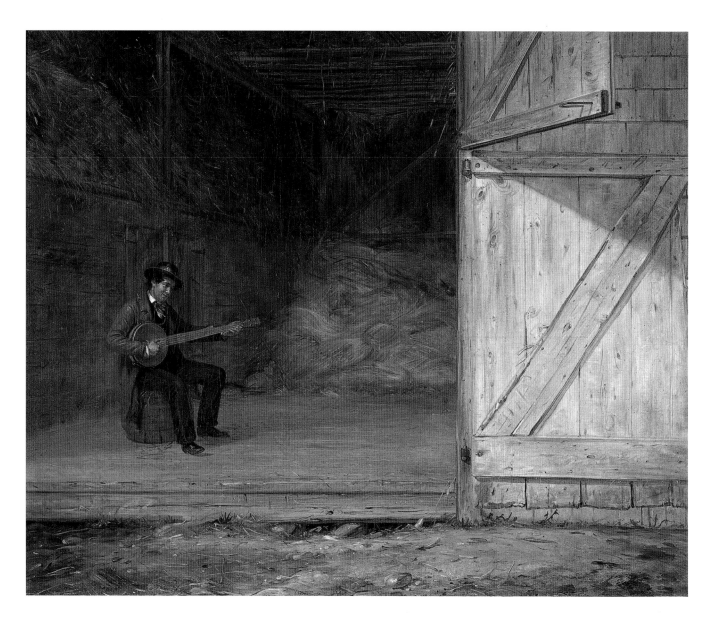

Figure 54
The Banjo Player in the Barn,
ca. 1855

black man who has laid aside his ax and jug. He leans forward, straining to catch every note. No lively hornpipe is being played, but a slow, sweet ballad. Mount accentuates two figures in *The Power of Music*—the young fiddler and the African American listener framed by raking light and silhouetted against the barn door. The pictorial and psychological connections between the two are compelling, prompting the viewer to question their relationship and wonder if the black man is perhaps the teacher of the young musician demonstrating his skills. The scene calls to mind Mount's own admiration for Anthony Hannibal Clapp, a local African American master of the violin, at whose knee Mount sat as a youngster. In a broad context, as the painting's title clearly indicates, Mount is suggesting that music is a common denominator, a universal language. According to one observer, the painting did "not need the name in the catalogue, 'The Force of Music,' to be understood by anyone."[136]

Another major painting to emerge from this period was *Recollections of Early Days—"Fishing Along Shore,"* now called *Eel Spearing at Setauket*, 1845 (fig. 55).[137] The painting was commissioned by George Washington Strong, an attorney in New York City, to recall his

Figure 55
**Eel Spearing at Setauket
(Recollections of Early Days—
"Fishing Along Shore")**, 1845

Figure 56
St. George's Manor at Setauket
"A sketch of the residence of the
Hon. Selah B. Strong. L.I., 1845"
Oil on panel
6½ x 10 inches
Private collection

Figure 57
Study for **Eel Spearing at Setauket
(Recollections of Early Days—
"Fishing Along Shore")**, ca. 1845

Figure 58
Study for **Eel Spearing at Setauket
(Recollections of Early Days—
"Fishing Along Shore")**, ca. 1845

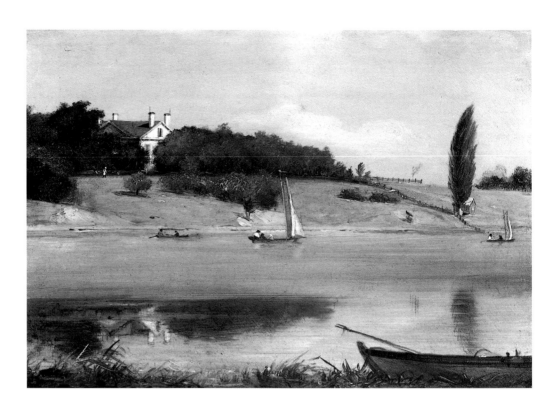

childhood, which, like Mount's own, was spent in Setauket. The boy in the boat represents Strong as a youth (his nephew, Thomas, modeled for the picture), and the magisterial African American woman who is spearing fish from the bow is Rachel Holland Hart, who worked for Strong's father, Judge Selah B. Strong.[138] The white house with two chimneys on the horizon is St. George's Manor, the family home on Strong's Neck, an extensive property that had been in that family for generations.

Mount worked hard and long on this picture, as is evident by the number of associated oil, ink, and pencil sketches. The largest of these, *St. George's Manor at Setauket*, 1845 (fig. 56), depicts the manor house more completely. The two men in a skiff would find their counterpart in the middle ground of *Eel Spearing at Setauket*, and the boat beached on the shore in the lower right corner is quite similar to the one in the finished work. Another oil study concentrates on the figures and the boat (fig. 57). Mount placed the woman in the very center of the composition, her eel spear held at a dramatic diagonal, poised for a capture. Additional studies (fig. 58) explore further the positioning of the woman in the boat, with Mount moving from a frontal view to one in almost total profile, as well as experimenting with the diagonal line of the eel spear.

Like many of Mount's paintings, *Eel Spearing at Setauket* has a highly structured composition, achieved by placing the pyramidal forms of the figures close to the picture plane. Within a triangle created by the horizontal line of the boat and the diagonals of the paddle and the eel spear, the figures are portrayed in shallow relief as if in a processional on a classical frieze. Depth is defined by planes of receding space, marked by reflections in the water, the small craft in the middle ground, the strip of land dotted with buildings, and, finally, the sky. The boat, its contents, and the figures are rendered with a crisp line that contrasts with the more painterly technique applied to the water and landscape. The faces of the boy and woman are models of concentration. The figures seem not to breathe, frozen in suspense. Even the dog is alert to the moment, his ears pricked, waiting for the plunge of the spear.

Given the waterways around Stony Brook and Setauket, spearing for fish was a common activity. Mount had his own recollections of early days spent fishing, memories he later recorded in response to an inquiry from Charles Lanman about local flat-fish (flounder). Mount remembered receiving his first lesson in fish spearing from an "old Negro by the name of Hector." The water was calm and clear as a mirror, conditions necessary to see the fish in the sand. Young Mount was seated in the stern with a paddle, learning "to creep." Hector, in the bow, gave instructions to his young companion while studying the sand, watching for the "eyes, how they shine like diamonds." When a large flounder was spotted, Hector moved swiftly. He hoisted the prize from the water, and the way he shouted, Mount recalled, "was a caution to all wind instruments."[139]

The following year Mount undertook another commission to represent "recollections of Mr. Strong's early days." In *Caught Napping*, 1848 (fig. 59), an older gentlemen, believed to be Strong's father, Judge Selah, approaches from the left to discover three boys, Strong's nephews, napping beneath a copse of trees.[140] Like the mischievous lads in *The Truant Gamblers* and *Boys Hustling Coppers*, these boys have abandoned their chores. Here, they sleep, play cards, and daydream. But despite the familiarity of the theme, Mount was unin-

Figure 59
Caught Napping, 1848

Figure 60
Loss and Gain, 1848

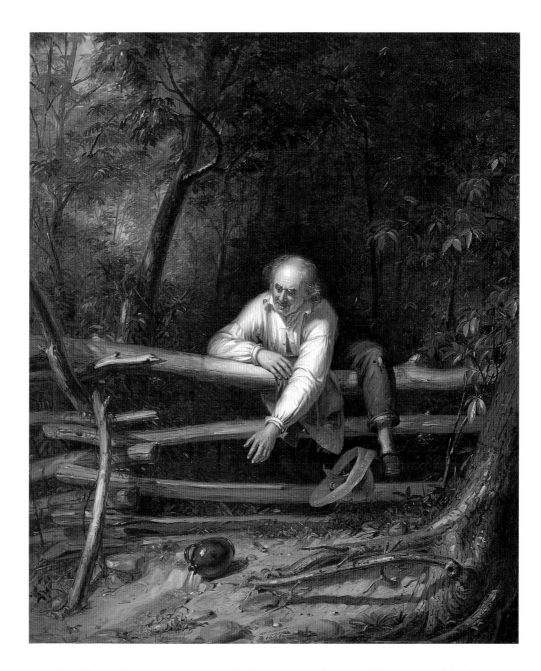

spired and he took a long time to finish the painting. Frustrated, he wrote to his sister-in-law, "I shall be glad when I am done with it, I am tired of such orders."[141]

In 1849 Mount recorded in his journal a possible subject for a picture: "Reading about the gold diggings."[142] After gold was discovered at Sutter's Mill in California in 1848, Easterners eagerly followed the news of the latest strikes and planned their own schemes for getting to the gold fields. Mount himself noted the effect in rural Long Island: "For about two months past there has been great excitement about the *Gold Places's* in *Northern California*. Thousands are rushing there to have a hand in sifting & picking—I hope it may turn out a blessing to the country—than a curse."[143] Among the newspapers fanning the flames of gold fever was the *New-York Daily Tribune*, whose copublisher, Thomas McElrath, commissioned Mount's *California News*, 1850 (fig. 62).[144]

The setting for this painting is a rural post office, much like the one Mount's grand-

Figure 61
Farmer Whetting His Scythe, 1848

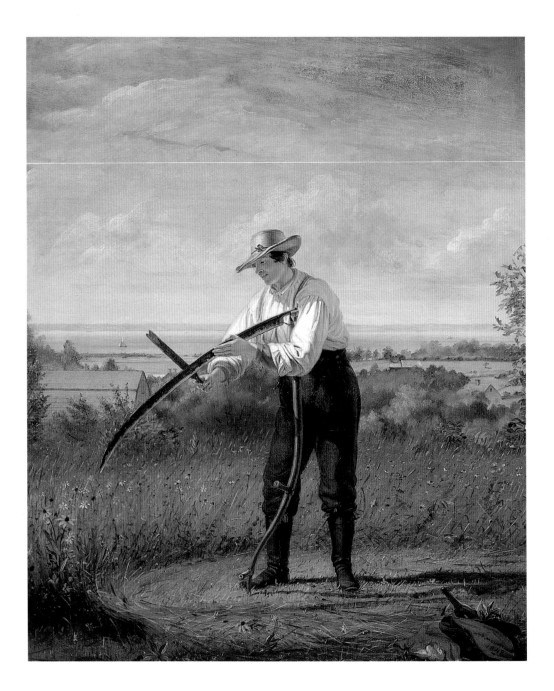

father, Jonas Hawkins, once operated out of the Hawkins-Mount home. The latest issue of the *Tribune* has just arrived in the mail and a crowd has gathered to hear the news about the "forty-niners." A distinguished-looking gentleman seated at the table reads the paper aloud to a heterogenous audience of listeners—young and old, male and female, black and white, workers and gentry. Just outside the door at the rear, a young man beckons to others to hurry lest they miss the latest California news. Mount, ever attentive to the ephemera of specula-tion and promotion, has distributed throughout the painting evidence of California's allure. Clearly featured on the table in the foreground is a folded broadside that reads "California Emigrants, Look Here!!!" Posted on the wall are a notice for the sale of a 350-acre farm, an advertisement for "gold digger outfits," and posters for ships departing for California from New York City and Sag Harbor. Above the door is a small painting of two hogs feeding, an

Figure 62
California News, 1850

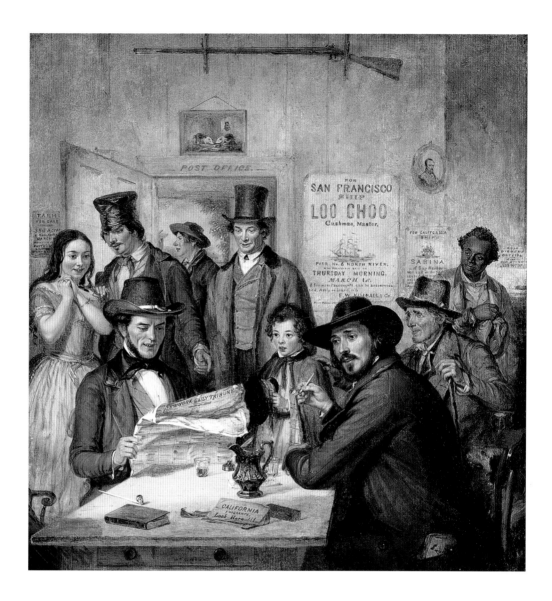

overt allusion to the greed involved in the gold rush but also a sly reference to the country's doctrine of expansionism, the insatiable appetite for the extension of the United States to the Pacific Ocean.[145]

To expand the territory of the United States to the Pacific Ocean, President James K. Polk had instigated military aggression against Mexico in 1846. At stake were the disputed territories of Texas and other lands in the Southwest. The Mexican War, as this conflict was called, was vehemently denounced by McElrath's *New-York Daily Tribune*, a Whig newspaper. His copublisher and editor, the formidable Horace Greeley, predicted that the Mexican War would be America's Waterloo.[146] Politically, however, the Whigs were concerned that if the war were won by the United States, the glory would go to Polk and the Democrats. Given this background and the prominently positioned rifle above the door, one might argue that a key subtext of this painting is the Mexican War. And, indeed, just as Mount was finishing the painting, Wilhelm Schaus, an American agent for the Paris publishing house of Goupil, Vibert & Co., wrote to him to ask, "Is the picture of 'Mexican News' ready?"[147]

Throughout his career Mount continued to paint portraits, and the subject received con-

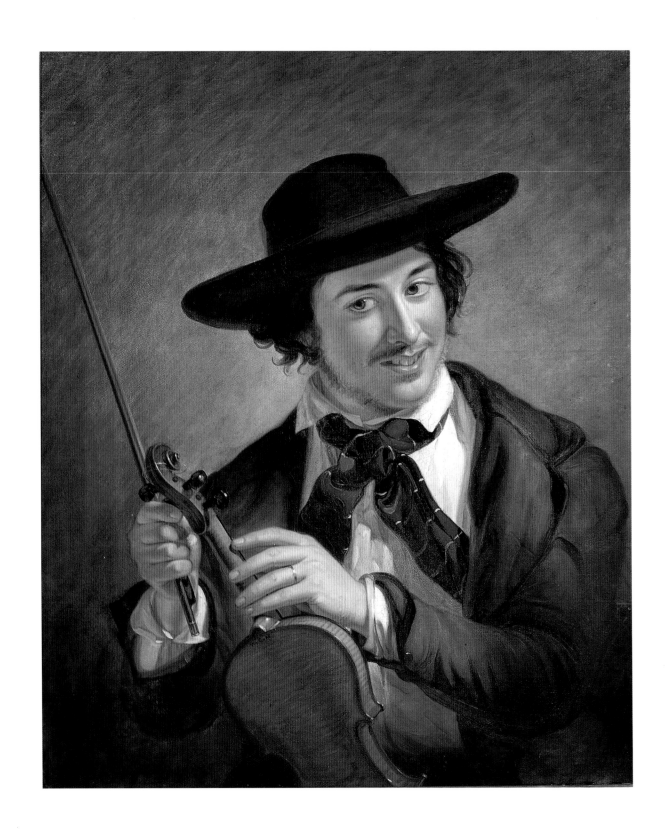

Figure 63
Just in Tune, 1849

siderable attention in his journals. As the years progressed, however, the critics began to take Mount to task for "wasting" his time painting portraits instead of genre pictures.[148] In a journal entry to himself in November 1848, Mount prepared his defense: "Portrait painting is a noble art—I should like to paint a dozen or twenty heads to show some of my friends that I can paint a portrait—and I must not allow myself to be driven from portraits into the picture line."[149] Out of this need to prove he could paint a powerful portrait Mount conceived the painting *Just in Tune*, 1849 (fig. 63), which one critic called an "experiment of combining portrait and comic design."[150] The work is essentially a portrait, showing a stylish violinist listening attentively as he tunes his instrument, but it carries the implication of narrative and maintains Mount's engagement with the themes of music and dance. Edward Buffet, Mount's early biographer, claimed that the model for *Just in Tune* was Mount's brother, Robert N. Mount, a dancing instructor and violinist.[151]

Even before the painting was exhibited to the public, Wilhelm Schaus had made an arrangement with Mount to reproduce the image as a lithograph.[152] In 1848 Goupil had published a print after Mount's *The Power of Music*; the following year they had issued a lithograph after Mount's *Dance of the Haymakers* under the title *Music is Contagious*, and in 1850, they had released a reproduction of Mount's *Boys Trapping* with the title changed to *Catching Rabbits*. According to Schaus, these prints constituted "the first recognition of American art by Europe."[153] So significant was this development for American art that the newspapers announced the departure of Mount's painting *Just in Tune* for Paris in late 1850.

Figure 64
Advertisement for Mr. Woodbury's Musical Works
Published in **The Musical Review and Choral Advocate**, January 1853
The Museums at Stony Brook

Simultaneous with the appearance of the lithograph of *Just in Tune*, Mount exhibited the original picture at the National Academy in the spring of 1851. The critics seemed approving of the fact that the painting was a departure from Mount's previous works. But the lithograph was regarded as a momentous event. One writer asserted that Goupil, Vibert & Co. deserved "great credit for bringing before the European public the masterpieces of the finest genius in comic painting this country has produced."[154] The print was so popular in the United States that it seems to have inspired at least one other, probably unauthorized, version (fig. 64).

In early 1850, Goupil commissioned a companion piece to *Just in Tune*, with the negotiations handled by Schaus in Goupil's New York office.[155] Mount requested clarification on the commission, asking Schaus, "Do you wish a negro man, or a white man as a companion to the picture 'Just in Tune'?" Schaus replied, "I think a Negro would be a good companion."[156] By the end of December 1850 Mount completed *Right and Left* (fig. 65), as well as the next commission from Goupil, *The Lucky Throw*, 1850 (present location unknown).

The subject of *Right and Left*, as Schaus suggested, is an African American violinist, though Mount has made the man rather more elegant than his patron might have expected.

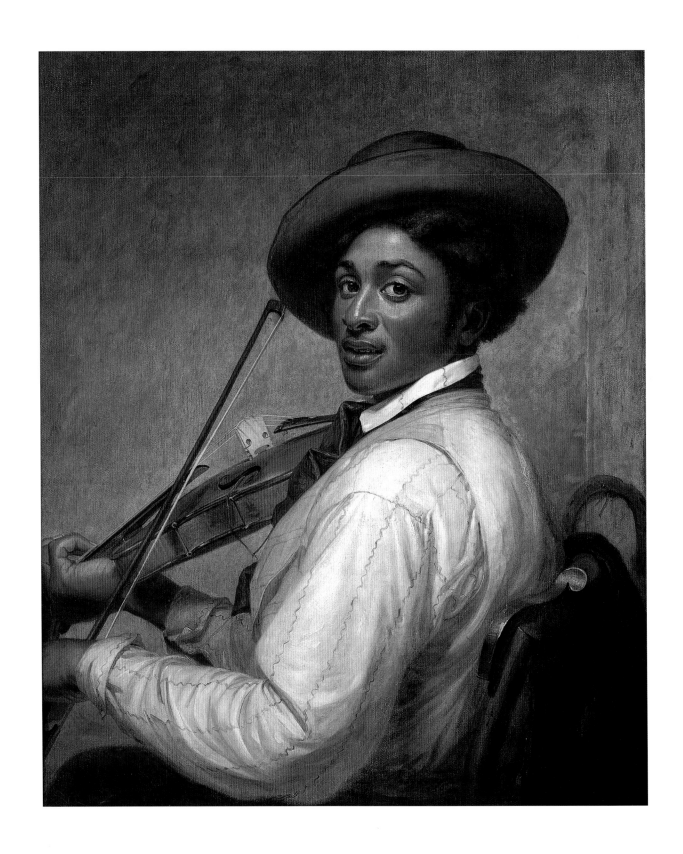

Figure 65
Right and Left, 1850

One critic, on viewing the painting at Goupil's New York gallery, proclaimed that it was "indeed a *chef d'oeuvre* of Ethiopian portraiture."[157] Pictorially, Mount's depiction is the antithesis of the caricatures of African Americans prevalent in graphic and fine art of the nineteenth century or the cartoons of whites in "blackface" makeup associated with minstrel shows. From the visual evidence in the picture, it appears that Mount's subject was a free man of color from the North and, given his natty clothes, a person of some means. He wears a dark-green felt hat tilted rakishly on his head. His white shirt has French cuffs and is patterned with gray undulating lines, and his bright yellow vest accentuates his flowing red-and-green silk necktie. The musician is left-handed, which explains, in part, the painting's title. Mount was irked when the lithograph after the painting reversed the image and made the violist seem to be right-handed (fig. 66).[158]

Figure 66
Jean-Baptiste Adolphe Lafosse
(1810–1879)
Right and Left, 1852
After William Sidney Mount
Right and Left, 1850

But the title is also a key to interpreting the genre elements in the picture, since "right and left" is a common figure in American square dancing. Calling the figures during a square dance was a great innovation of nineteenth-century American dance; the caller's change of a figure kept the dance fresh and exciting.[159] Calling required an acute sense of timing, awareness of each figure's applicability to certain music, articulate speech, and an attentiveness to the dancers' abilities and mood. A skilled musician with a broad repertoire was essential to a successful dance. With the popularity of "calling the figures," expert callers were also in great demand. An individual who was an accomplished fiddler *and* caller completely controlled the dance. As companion pieces, *Just in Tune* and *Right and Left* convey a sequence in time—one musician tuning up prior to a performance, the other poised to initiate the festivities.

Aside from stipulating that *Right and Left* depict a black musician, Schaus seems to have given Mount full artistic license in developing the image. With *The Lucky Throw*, however, Schaus exerted a somewhat heavier hand. In fact, his specifications to the artist were quite explicit; he ordered, "One picture negro african—near life size—laughing—showing his white teeth + holding something funny in his hands."[160] Interestingly, what Mount produced was a subtle variation on his own earlier themes of bargaining, raffling, and speculation. Although the original is now lost, the Goupil lithograph, published as *Raffling for a Goose*, 1851 (fig. 67), gives a clear sense of Mount's design for the painting. This bust-length portrait shows an African American boy in a light blue coat wearing a cap banded in red-and-white plaid. His face is punctuated with a wide smile that adheres to Schaus's request to show "white teeth." The "something funny in his hands" is a plucked, plump goose. On the table is the hat from which the chances were drawn and, beside it, the wager, four copper coins.

Mount completed *The Lucky Throw* in December 1850, a year marked by intense political debate over the extension of slavery. In July, at the very height of the political conflict,

Figure 67
Jean-Baptiste Adolphe Lafosse
(1810–1879)
Raffling for a Goose, 1851
After William Sidney Mount
The Lucky Throw, 1850

President Zachary Taylor, "Old Rough and Ready," the hero of the Mexican War and a Virginia-born slaveholder, died suddenly. It was his vice president and successor, Millard Fillmore, who signed the Compromise of 1850 in September. The Compromise ratified the much-debated Fugitive Slave Act, a bill that enabled slave owners to extradite blacks who had escaped to free states, as a concession to the Southern congressmen in exchange for allowing California to enter the Union as a free state. In this heated atmosphere, any image of an African American would clearly have had political connotations. But, as if to enhance the patriotic effect, Mount dressed his African American in red, white, and blue and added a Scottish cap that would have easily been recognized as an abolitionist symbol. Also, the buttons on the boy's coat are decorated with horses, a reference to mobility, expansion, and the flight of fugitive slaves. And the goose he carries is a symbol of the African American himself, the focus of a high-stakes wager between proslavery and abolitionist forces. By implication, the Compromise has made the African American a "gone goose," or lost man, his freedom past recovery.[161] The picture poses two questions: Who will win the lucky throw? And, as suggested by the coins on the table, at what cost?[162]

Almost six years later, in April 1856, Mount painted two additional genre portraits for Schaus and his printmaking enterprise, works that can justifiably be seen as companion

pieces to *Just in Tune* and *Right and Left*.[163] Like their predecessors, both *The Bone Player*, 1856 (fig. 68) and *The Banjo Player*, 1856 (fig. 69) depict African American musicians engaged in performances of music. The well-dressed bone player, who sports a goatee and amber earrings, skillfully grasps the two pairs of ivory "bones" between the fingers of each hand. In the other picture, a younger, though no less stylish banjo player strums his instrument and glances to his left. The warmth of the depiction is enhanced by Mount's composition in that the circle of the banjo drum is echoed in the player's head, his circular shirt cuffs, the line of his gold-trimmed vest lapels, and his shining gold watch chain.

Mount's genre portraits—*Just in Tune* (1849), *Right and Left* (1850), *The Lucky Throw* (1850), *The Bone Player* (1856), and *The Banjo Player* (1856)—were patterned after a noted seventeenth-century Dutch tradition. The motif of the half-length portrait of a musician was a virtual staple in the repertoire of such artists as Hendrick ter Brugghen, Judith Leyster, Gerrit van Honthorst, and Frans Hals.[164] A typical example is Dirck van Baburen's *Flute Player*, painted in ca. 1623 but more widely available in an engraving by Cornelis Bloemaert issued in 1625 (fig. 70). The *Flute Player* shares key features with Mount's *Right and Left*: the placement of the figure close to the picture plane, the positioning of the body to the left, the careful detailing of the clothing, the three-quarter view of the head looking across the shoulder toward the viewer, the hat set at an angle, the prominent placement of the instrument, and the nondescript background that accentuates the figure. As might be expected, Mount developed this tradition by giving it an American reference and a political specificity.

Both the banjo and the bones were simple instruments.[165] But in the United States in the mid-nineteenth century, the principal association with these instruments was the minstrel show, in which white performers donned blackface to parody "Negroes," or black musicians and dancers performed in a style that was deemed stereotypical by white audiences.[166] Group minstrel theater had its debut in New York City in February 1843, when the four-member Virginia Minstrels took the stage of the Bowery Amphitheatre. Their blackface performance consisted of songs, instrumental music (banjo, fiddle, bones, and tambourine), dancing, and jokes. This "Ethiopian band" paved the way for a host of minstrel troops impersonating the tattered plantation "darky" or the free Northern "dandy." Composer Stephen Collins Foster contributed to minstrel entertainment, becoming the leading writer of "Ethiopian" melodies. The majority of the minstrel performers were Northerners playing to Northern and Midwestern audiences. As the national debate over slavery increased in fervor, so did the public's attraction to these "negro extravaganzas" and their songs, much of which grossly caricatured blacks.

Schaus's orders for a "Negro" musician in *Right and Left*, a "Negro playing the Banjo and singing," and a "Negro playing with Bones" certainly played on the immense popularity of the minstrel theater and the images it spawned.[167] As businessmen, Schaus and Goupil grounded their selection and commission of subjects from Mount in the potential marketability of the images. In America and Europe, works like *Right and Left*, *The Bone Player*, and *The Banjo Player* were a means by which to capitalize on the profitability of minstrel theater. For European audiences, such pictures served as "comic" exemplars of the American people and the exotic aspects of its society. American audiences also viewed these pictures as

Figure 68
The Bone Player, 1856
Oil on canvas
36⅛ x 29⅛ inches
Museum of Fine Arts, Boston; Bequest of Martha
C. Karolik for the M. and M. Karolik Collection of
American Paintings, 1815–1865 (48.451)

Figure 69
The Banjo Player, 1856

Figure 70
Cornelis Bloemaert (1603–1684)
The Man with the Flute, 1625
After Dirck van Baburen
(ca. 1595–1624)
Flute Player, ca. 1623
Engraving
The Metropolitan Museum of Art;
Harris Brisbane Dick Fund, 1917
(17.3.1402)

comical, and apparently had no difficulty accepting their denigrating stereotypes. After viewing Mount's *Banjo Player* and *Bone Player*, a critic for the *New York Herald* wrote, "In both pictures the artist has chosen the negro in his happiest moments—when, under the influence of musical inspiration, he gives way to all the joyousness and *abandon* of his sensual nature."[168]

Mount was well acquainted with such derogatory characterizations of blacks by whites. Several musical compositions by his uncle Micah Hawkins were written and performed in pseudo-Negro dialect and are among the earliest examples of blackface entertainment.[169] In Mount's own collection of transcribed music are several tunes of the type frequently performed in minstrels, works such as "Martin's Juba," "De Darkies Home," and "Plantation Song."[170] While supportive of minstrelsy, Mount also clearly appreciated the capabilities of African American musicians. His portraits of the bone player and the banjo player are not stereotypes but depictions of actual performers from the local sphere of popular entertainment. One such performer who Mount may have seen was the noted dancer William Henry ("Juba") Lane, a freeman from Rhode Island, who honed his skills among the freed slaves and poor Irish in the notorious Five Points District of Manhattan.[171] His style of hybrid dancing—a combination of African dance and Irish jigs with a mix of his own improvisation—earned Lane top billing in the Ethiopian Minstrels as "Master Juba, the Greatest Dancer in the World."

In addition to these genre portraits, Mount had also produced other, more conventional genre pictures on commission from Goupil. In early 1853 Mount had painted *Politics of 1852 —or, Who let down the bars?* now called *The "Herald" in the Country* (fig. 71), another of his forays into current political events (although, when the lithograph was issued in 1854 as *The "Herald" in the Country*, the specific reference to the 1852 presidential election was removed). In the painting, two men stand on opposite sides of a split-rail fence. The left ends of the top two rails, or bars, have been removed, and they lean at angles on either side of the fence, signaling the poacher's illegal entrance. The gentleman in the foreground is the poacher; he has been hunting and has propped his rifle against a post near a dead quail. Apparently, the sound of his shots has brought the farmer, armed with a pitchfork, into the woods. To defuse the situation, the hunter tries to act casual by leaning against the fence and commencing to read aloud from the *New York Herald*.

The picture and its original title are a humorous reference to the candidates of 1852 and their party platforms. Democrat Franklin Pierce was a Northerner with Southern sympathies, a "doughface" in the political vernacular of the time. Winfield Scott, the Whig nominee, was a Virginian, ambivalent on the Compromise of 1850 and actively supported by William H. Seward, an abolitionist senator from New York. Oddly, the platforms of both parties were in agreement on the major issues: both supported the Compromise of 1850 (including the Fugitive Slave Act), upheld states rights, and mandated limits on the powers of the federal government.[172] Mount's subtitle *Who let down the bars?* refers to the blurring of the traditional distinctions between Democrat and Whig in the 1852 election. This attitude was also

Figure 71
**The "Herald" in the Country (Politics of
1852—or, Who let down the bars?)**, 1853

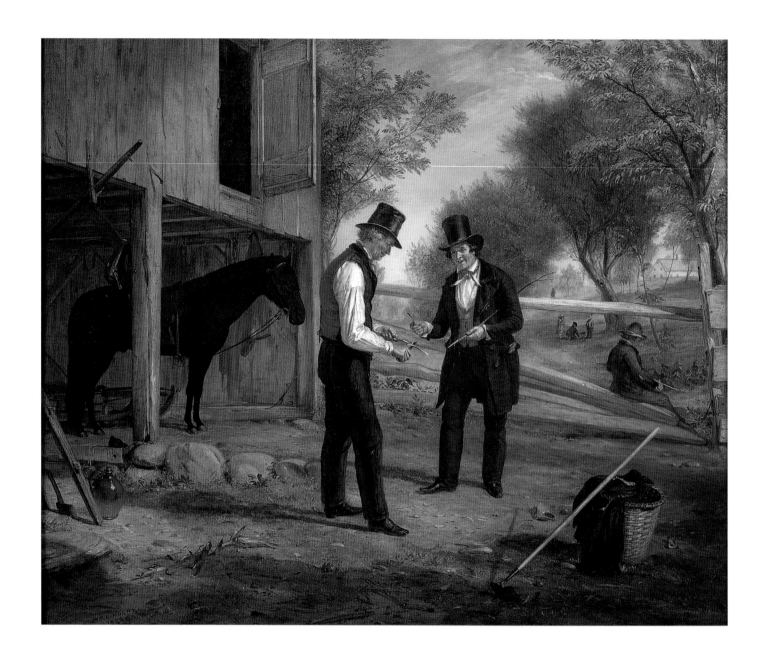

Figure 72
Coming to the Point, 1854

exemplified by the *New York Herald*, one of the most widely circulated newspapers of its time. Its publisher, James Gordon Bennett, often underscored the nonpartisan nature of his paper, saying that its content was reflective of "good, sound, practical common sense."[173] In other words, in adopting a nonaffiliated position, the *New York Herald* tended to stand on both sides of the political fence.

In addition to commissions from Schaus, Mount had several longstanding orders for paintings from private individuals, only a couple of which were ever filled. In 1854, Mount painted *Coming to the Point* (fig. 72), a variation, by request of the patron Adam R. Smith of Troy, New York, on his earlier painting *Bargaining for a Horse* (1835).[174] The new version was barely finished before Schaus began negotiating for the rights to produce a lithograph from it, to which Smith assented.[175] But, other than *Coming to the Point*, Mount produced few new genre paintings during the 1850s.

As his journals and correspondence attest, Mount was a man of varied interests. Music, in particular, was a major preoccupation. He had designed and patented a uniquely formed violin, which he called the "Cradle of Harmony," and which he exhibited at the Crystal Palace in New York in 1853.[176] He also had an avid interest in phrenology, a popular pseudoscience that attempted to interpret character based on the conformity of one's skull.[177] And as early as 1853, Mount had attended a private spiritualist "circle" in New York City and had participated in seances and table knockings. One session had established contact with the spirit of his uncle Micah Hawkins, who answered Mount's questions about his deceased mother, brother Henry, and other relatives.[178] The spiritualist conferences that Mount attended in the city featured the clairvoyant and spirit communicator Andrew Jackson Davis, whose teachings about the graduated phases of spiritual life and about love and compassion were later reflected in Mount's own writings on spiritualism. For Mount, as for many other Americans in the nineteenth century, a central struggle in his spiritual life was to balance the organized religion of Christianity with the miraculous possibilities of the occult.

Figure 73
"Spirit Drawing" of Rembrandt, 1855
Ink on paper
Image 3¾ x 2¼ inches
The Museums at Stony Brook

Spiritualism does not seem to have directly affected Mount's work, but in 1855 it did yield an automatic spirit drawing and two spirit letters from an apparition that identified itself as "Rembrandt" (fig. 73).[179] The letters are, in part, complimentary, with Rembrandt describing Mount as "the best *National* painter of your country." There is also a considerable discussion about Mount's use of color and a critique of some of his shortcomings as an artist, including "sameness of design" and a repetition of "the same subject in a different point of view." These were issues that critics had already addressed with regard to Mount's work, but it is likely that these views were more palatable coming from the immaterial Rembrandt. In general, spiritualism seems to have filled an intellectual and emotional void in Mount's life. It was a medium through which, as an artist, he sought to restore his flagging confidence, to reaffirm his natural abilities, and to confront his inevitable faults.[180]

On the eve of the Civil War, Mount was preoccupied with the presidential campaign of 1860. The election prompted journal entries, as well as correspondence with Suffolk County Democratic leaders. As in previous campaigns, the explosive issue was slavery. The Democratic Party platform of 1860 sought, in particular, to make clear the party's stance on the Supreme Court's Dred Scott decision of 1857, which held that African Americans, whether

free or slave, were not citizens of the United States, and that Congress had no power to prohibit slavery in federal territory. The Democrat's plank ended with the phrase, "The Democratic party will abide by the decision of the Supreme Court of the United States upon these questions of Constitutional law."[181] While the Democrats, under Stephen Douglas, shifted the slavery debate from moral issues to concerns over the maintenance of the Union, the Republicans, led by Abraham Lincoln, argued that new territories should be free and that each state should have the right "to order and control its own domestic institutions according to its own judgment exclusively." As a Democrat, Mount's primary concern was the preservation of the United States.[182]

The Civil War seems to have inspired a number of Mount paintings, including *The Confederate in Tow* (1861), *Peace and War* (1861/62), *Northern Sentiment* (1865), and *Peace* or *Muzzle Down* (1865), none of which, unfortunately, have been located.[183] Among the war-related themes that Mount considered but apparently never painted was an idea for a picture of a "Union picket whistling *Yankee Doodle*—& at a distance a confederate *picket whistling Dixie*."[184] To benefit the United States Sanitary Commission, part of the Northern war effort, Mount painted *Child's First Ramble* (1864), which was exhibited and sold at the Brooklyn and Long Island Fair; he also donated a small still life, *Apples on Tin Cups* (1864), to the Metropolitan Fair.[185] In addition, a now-lost work titled *Before the War* was exhibited and listed as for sale at the National Academy in 1865.

Curiously, the project that most dominated Mount's time during the Civil War had no direct relation to the conflict, though it did have symbolic and historical import. In early 1863, on the recommendation of his friend Martin E. Thompson, Mount was approved by the Commissioner of Public Buildings in Washington to paint a twenty-by-thirty-foot mural for the eastern staircase of the Senate Chamber.[186] Other murals in the Capitol had been assigned to Emanuel Leutze and William Henry Powell. The historical subject for Mount's mural had already been determined by the commissioner: George Washington's youthful descent of the Allegheny River. Mount, tired of painting to order, tried to convince the officials to consider a broader range of iconography.[187] But Congressman John M. Gardner, who was in charge of the commission, was adamant: "We want to see the Allegheny River full of ice pouring down those stairs and bearing the raft, with young Washington and Mr. Gist. . . . You will incur risk in the 'choice of subject' as you call it." Gardner closed by informing Mount that Congress had appropriated $25,000 for the commission.[188] Suddenly, Mount agreed that the subject was excellent: "Washington's desperate struggle in crossing the Allegheny river—is the grand turning point in his history. Life or death."[189]

Mount began to prepare for the monumental assignment by reading and copying excerpts from John Marshall's *Life of Washington* (1804).[190] In July 1863 he made a small copy of Daniel Huntington's image of Washington and Gist on the raft, which had been engraved for *The Gift* of 1845, and in May 1864 he copied William T. Ranney's painting of the same subject.[191] Mount completed at least one version of his design, in the form of a small oil sketch (fig. 74). But then, in late 1863, due to the war, the commission was suspended for more than a year. In March 1865, Gardner again wrote Mount, saying that of the four staircase murals, two remained. Gardner still supported Mount for the subject of Washington

Figure 74
Study for **Washington and Gist Crossing the Allegheny River**,
Design for Staircase Mural,
United States Capitol, 1863
Oil on panel
7½ x 11¾ inches
Private collection

and Gist.[192] Ultimately, however, the opportunity was lost. In May 1865, Gardner explained, "Mr. Middleton thinks you require political influence to succeed in obtaining the order from Congress. . . . I don't approve of your log-rolling. I don't believe you have any experience in that business, nor desire to have."[193]

In the election of 1864, Mount supported the Democratic candidate General George B. McClellan.[194] The party's national platform called for a negotiated peace to end the war.[195] Mount echoed this position in his journal: "For my part, I wish to see peace & harmony throughout the Country and if each State had minded its own business, the present state of affairs would not have happened."[196] But Lincoln was reelected, and, according to Mount, "The democrats seem well pleased with the result. They desire the republicans to finish the negro agitation & the war."[197] Shortly after the Confederate surrender in April 1865, Mount noted, "The War Cloud is passing away. . . . We have bright skys; notwithstanding the assassination of President Lincoln."[198]

Lincoln's successor, Andrew Johnson, had been in office for less than six months when Mount began to paint *Fair Exchange, No Robbery*, 1865 (fig. 75).[199] The painting addresses the new president's shifting political positions. In a clearing near a cornfield a well-dressed man approaches a ragged scarecrow. The scarecrow is propped up in a wooden barrel and is costumed in tattered castoff clothing, except for a stylish hat in surprisingly good condition. The man passing by is shown exchanging his own battered hat for that worn by the scarecrow, an act that might well be regarded as a "fair exchange." The title of the painting is taken from a passage in Lord Byron's poem "The Deformed Transformed" (1821–22), which presents the drama of a self-hating hunchback who makes a pact with the devil.[200] The devil, in the form of a "Stranger," gives the hunchback the opportunity to shed his deformity and "To wear the form of heros." But, the Stranger tells him, "if I give you another form, it must/Be by fair exchange, not robbery."

Figure 75
Fair Exchange, No Robbery, 1865

Mount's use of Byron's poem as an allegory of the predicament of President Andrew Johnson is apt.[201] Prior to the Civil War, Johnson was a Democratic senator from Tennessee whose sensational speeches in the Senate made clear his conviction that secession was a declaration of war on the Constitution and the Union. The Southern Democratic leadership found him too sympathetic to the North and the abolitionists and branded him a traitor. However, by bringing the Unionist Democrat onto his Republican ticket in 1864, President Lincoln was able to win reelection against stiff opposition. Following Lincoln's assassination, Johnson's early demands for retribution against the South for "treason" implied that he would carry forth Lincoln's mandate. This satisfied the Radical Republicans. But instead, Johnson allowed the Southern states to return to the Union unpunished (virtually denying that they had ever seceded), provided amnesty and pardon for Southern leaders and military, and refused to act on black suffrage, declaring the issue under the jurisdiction of the individual states and not within the responsibilities of the federal government.

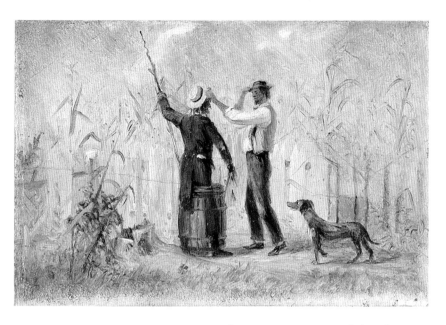

Figure 76
Study for **Fair Exchange, No Robbery**, ca. 1865

Johnson's actions appealed to the instincts of conservative Democrats like Mount; to them he was indeed "the deformed transformed." In *Fair Exchange, No Robbery*, the scarecrow represents the Radical Republicans. That party's Whig origins are indicated by the wooden barrel (once the symbol for William Henry Harrison), now rotting and full of holes. The scarecrow himself is nothing more than a pretense, a straw man. His only redeeming asset is his hat, here symbolizing President Johnson. The man passing by with his dog represents "the people," and, by extension, the Democratic party. The hat is about to be transferred onto the head of the man, thereby adorning another form. Under the conditions set forth by Byron's Stranger, this transformation is by "fair exchange, not robbery."

Johnson notwithstanding, the Radical Republicans emerged as a powerful political force during Reconstruction. But Democrats like Mount were convinced that the Radicals' campaign for black suffrage was grounded in a thinly veiled desire to exploit the political power of black votes. "Those who voted the Republican Ticket," Mount noted in his journal after an election in 1867, "voted to kill white men and enslave themselves in order to give freedom to the Negro."[202] After the vote, in which Democrats defeated Republicans in many state and local elections, Mount celebrated. With several other men, he designed and painted a large allegorical banner that was displayed in a store. As illustrated in a study (fig. 77), the banner, which Mount titled *Politically Dead*, depicted "A Rooster standing upon a *dead* Negro."[203] The image prompted the editor of the *Long Island Star*, a Republican paper, to interpret the "old Cock" as the Democratic party and the Negro as the Republican party.[204] Mount responded with a clarification: the rooster symbolized the Radical Republicans "trying to make more

Figure 77
Study for **Politically Dead** banner,
November 6, 1867
Pencil on paper
3¹⁄₁₆ x 4 inches
The Museums at Stony Brook;
Museum Purchase

Figure 78
The Dawn of Day (Politically Dead),
1867–1868
Oil on panel
7¾ x 12 inches
The Museums at Stony Brook;
Gift of Mr. and Mrs. Ward Melville
(x58.9.4)

capital out of the Negro who is about used up for their purposes, which is glorious news for the Country. The African needs rest."[205]

Mount had not included African Americans in his paintings since *The Bone Player* and *The Banjo Player* of 1856. But with the end of the Civil War and the process of Reconstruction underway, Mount apparently felt compelled, once again, to allegorize national events. Enamored with his clever image for the banner, Mount began a small painting of it, which is now called *The Dawn of Day*, 1867–68 (fig. 78), but which the artist titled variously "Politically dead," "Radical crowing will not awake him," and "The break of day."[206] In his journal, Mount insisted, "The slavery controversy has been settled. The 'peculiar institution' is dead and buried and only lunatics could desire to exhume its putrescent remains."[207]

The Dawn of Day is unusual among Mount's paintings in that it began as explicit political propaganda. Previous pictures with social or political themes were more subtle in their purpose and message. First and foremost, they were genre paintings, rustic and realistic representations of everyday life that could also be appreciated as idealized works. The pretext

for *The Dawn of Day* is more blatantly political; its subtext of genre is surprisingly unsophisticated. In fact, the image is more like a political cartoon than a genre painting. Its value, therefore, is principally as an expression of Mount's political sentiments. And those views made the picture controversial. Democratic party leader August Belmont considered purchasing the painting when it was completed, but then declined, saying he had no room in his gallery for the work. [208] Mount intended to display the picture in the spring of 1868 at the National Academy, but "'On sober second thought.' I have concluded not to exhibit the picture at present."[209]

Toward the end of his life Mount painted two works that include genre elements but which are predominantly landscapes, *Long Island Farmhouses*, begun 1862 (fig. 79) and *Catching Crabs*, 1865 (fig. 80). Mount was primarily a painter of people, but in *Long Island Farmhouses* the human form is reduced to nearly inconsequential detail. The large, barren tree silhouetted against a dramatic early winter sky is the most significant presence in the picture. Its massive trunk and extenuating branches encompass almost two-thirds of the canvas. The light is an ocher glow, which subtly transforms the colors of the grass and buildings. In his journal Mount recorded the moment he began the painting: "Nov. 26th 1862. It is my birthday. . . . I commenced to paint to day (after a careful drawing) a view from my studio window of the residences of John Davis & R. N. Mount as a background to figures."[210] The studio he mentions was a portable studio on wheels, designed by the artist himself, constructed in Port Jefferson, and brought to Setauket just four days before.[211] Robert Nelson Mount's saltbox house is featured in the left background, and, in the right distance, between the branches of the tree, is St. George's Manor, which also appears in *Eel Spearing at Setauket*.

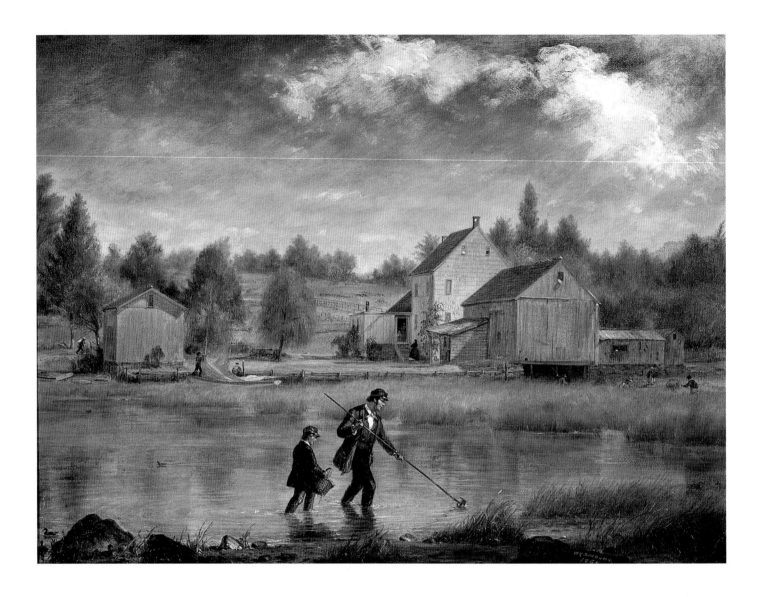

Figure 80
Catching Crabs, 1865

Wading along the shore in ankle-deep water in the foreground of *Catching Crabs* are a boy holding a basket and a man spearing a crab. The middle distance of the picture is water and grass; ducks punctuate this expanse and demarcate its spatial recession. The background depicts a hive of activity: a man with a bundle on his back is trudging up the dirt road, two figures in a skiff hoist a sail, a pair in the doorway converse with a woman at the base of the stairs, and a team of workers cut and stack salt hay. Typically, it was Mount's practice to place the action in the foreground of a picture, but in *Long Island Farmhouses* and *Catching Crabs*, he removed his simple human narratives to the nooks and crannies of the pictures' backgrounds.

In May 1866 Mount transcribed into his journal the following review: "National Academy of Design—Interior of a Kitchen (Eastman Johnson). . . . This picture is simply treated and tells its own story. In this line of painting Mr. Johnson has no equal in this country."[212] The notation must have provided a sad realization for Mount that a new generation of genre painters had eclipsed him. Although he was represented at every annual National Academy exhibition up to his death, portraits, not genre pictures, now comprised the bulk of his

Figure 81
Catching the Tune, 1866–67

offerings. Mount also recorded the comment of a local minister who said that when he saw the artist's recent painting *Going Trapping*, 1862 (present location unknown) "it took him back to the time when I had painted such compositions . . . that the work had *immagination & brains* in it."[213]

These signs all suggested that Mount's once prodigious powers were failing and that his current subjects were out of favor. Collector Samuel P. Avery implored Mount, "[T]urn your genius toward the production of those works which like your farmer productions will always live where American art is known."[214] But Mount's body was failing as well. Never in sound health, around 1865 Mount began suffering pain in his eyes, and his vision began to deteriorate.[215] Among his last genre paintings is *Catching the Tune*, 1866–67 (fig. 81). The subject is a variation on the power of music: a central group of three men is making music, while a young woman and a girl look on. The violinist has just stopped playing on the instrument that is clearly Mount's own "Cradle of Harmony" and he listens intently as a young man whistles a tune. Unfortunately, Mount's weak eyes, combined with the use of his nephew John as the model for all figures, result in a certain sameness among the faces and a stiff lack of interaction among the figures. For the first time, Mount seems to have painted not from direct observation but from memory.

On a trip to New York City to tend to the affairs of his recently deceased brother Shepard, Mount again became ill. Following his abrupt return to Setauket, William Sidney Mount died on November 18, 1868.[216] An anonymous critic best summarized Mount's significance for his generation when he wrote, "A keen and studious observer of American manners and peculiarities, [Mount] renders them with a truth and care, full at once of general character and minute detail. Long after the traits of character which belong to the present time shall have been swallowed up in the waves of succeeding years, will his pictures delight the observant mind."[217]

Notes

Numerous secondary sources were crucial to my research on Mount, including David Cassedy and Gail Shrott, *William Sidney Mount: Works in the Collection of The Museums at Stony Brook* (Stony Brook, N.Y.: Museums at Stony Brook, 1983); David Cassedy and Gail Shrott, *William Sidney Mount: Annotated Bibliography and Listings of Archival Holdings of The Museums at Stony Brook* (Stony Brook, N.Y.: Museums at Stony Brook, 1983); and Janice Gray Armstrong, ed., *Catching the Tune: Music and William Sidney Mount* (Stony Brook, N.Y.: Museums at Stony Brook, 1984). Also important are the earliest studies on Mount: Edward P. Buffett, "William Sidney Mount: A Biography," a series of fifty-six articles with an appendix, published in the *Port Jefferson Times*, December 1, 1923, through June 12, 1924; and [Mary] Bartlett Cowdrey and Hermann Warner Williams, Jr., *William Sidney Mount, 1807–1868: An American Painter* (New York: Columbia University Press, 1944). Elizabeth Johns's *American Genre Painting: The Politics of Everyday Life* (New Haven and London: Yale University Press, 1991) has been particularly valuable.

A seminal source for Mount studies is Alfred Frankenstein's *William Sidney Mount* (New York: Harry N. Abrams, 1975), comprised of transcriptions of Mount's correspondence and journal entries. Unfortunately, there are errors in Frankenstein's transcriptions, and his compilation of documents represents only a portion of the extant material associated with the artist. For this study I have returned to the primary source materials (correspondence, journals, notes, etc.). To distinguish one source from another in the notes, particularly in references to Mount's multivolume journal and his series of autobiographical sketches, I have supplied MSB accession numbers in brackets. In the interests of historical accuracy, quotes from primary sources are printed as written (the abbreviation "[sic]" is not used).

The following abbreviations are used to denote the major repositories of manuscript materials and objects relative to William S. Mount: MSB: Collection of The Museums at Stony Brook, Stony Brook, N.Y.; and NYHS: Collection of The New-York Historical Society, New York, N.Y. The "Setauket Scrapbook" is a collection of newspaper clippings and other papers kept by Mount and members of his family that were bound in the twentieth century. Few of the newspaper clippings are dated or identified with the publication of origin. The Setauket Scrapbook is in the collection of the Museums at Stony Brook, a gift of the Emma S. Clark Memorial Library, Setauket, N.Y.

1. Mount's great-great-great-grandfather, Zachariah Hawkins (baptized 1639–1699), came from near Newtown (now Cambridge), Massachusetts, to settle in Setalcotts, a tract of land purchased in 1655 from Native Americans and governed by the Connecticut Colony, of which eastern Long Island was then part. From Zachariah, Eleazer Hawkins (1688–1772) inherited property in Stony Brook, a few miles west of Setauket. His son Eleazer II (1716–1791) lived at what is now the Hawkins-Mount Homestead in Stony Brook. The Hawkins family genealogy and history have been reconstructed from records of the Setauket Presbyterian Church, Setauket, N.Y.; Frederick Kinsman Smith, *The Family of Richard Smith* (Smithtown, N.Y.: Smithtown Historical Society, 1967), pp. 104–5; Charles Werner, *Genealogies of Long Island Families* (New York: n. p., 1919), pp. 85–97; Benjamin Franklin Thompson, *The History of Long Island from Its Discovery and Settlement to the Present Time*, vol. 2 (New York: Gould, Banks, 1843), pp. 408–9, 434; Ralph Clymer Hawkins, *A Hawkins Genealogy, 1635–1939* (Baltimore: Gateway Press, 1987); Hawkins Association, *Newsletter*, various; and Hawkins-Mount family archival collections, MSB.

2. John W. Barber and Henry Howe, *Historical Collections of the State of New Jersey* (New York: S. Tuttle, 1847), pp. 353–56.

3. Howard Klein, *Three Village Guidebook* (Setauket, N.Y.: Three Village Historical Society, 1986), pp. 29–32.

4. Ruth Hawkins Mount (later Mrs. Charles Saltonstall Seabury) was a skilled amateur painter. William Sidney Mount later recalled that he had his first impressionable encounter with art at age twelve, when he observed his sister being taught "to execute figures in colored silks, & water colors combined" (Mount, "Autobiography [0.11.3548]," p. 1, MSB). Mount went on to say, "My Sister . . . , although the youngest, displayed the first taste in painting, when at the early age of eleven she took lessons of Mrs. Spinola. Then you could have seen me looking over my sister's shoulder, with my straw hat in hand to see how she put on the colours. A picture was then and always has been to me an object of great attraction. I had no idea at that time of ever becoming a painter, but, my mind from my earliest recollection was always awakened to the sublime and

beautiful in art & nature" (Mount, "Autobiography [0.11.3549]," p. 5, MSB). Two of Ruth Mount's works survive: a watercolor on paper titled *L'Orage* (The Storm), ca. 1820–26, after the painting by Sir David Wilkie, as engraved by François Janet; and an undated embroidery of a female figure in classical attire holding a bird in her hand (both, Museums at Stony Brook).

5. Mount, "Autobiography [0.11.3549]," pp. 1–2, MSB.

6. Ibid. The inventory of Jonas Hawkins's estate lists the contents of the household in which William lived. In addition to farming equipment, furniture, and foodstuffs, the inventory lists "6 pictures" and two lots of books. Jonas Hawkins Estate Inventory, May 15, 1817, Suffolk County Records, Surrogate's Office, Riverhead, N.Y., microfiche 1338.

7. William remained in Stony Brook "to cut off wood, attend our stock altho small, and go to school" (William S. Mount to Robert N. Mount, January 9, 1822, MSB). Concerned about his younger brother's situation, Robert wrote to their mother on July 4, 1824: "I understand that Brother William has not yet gone to a trade. It is my wish that he should go in some flourishing Town or City, where he may have a chance of learning his Truck well, besides getting considerable of other information" (Robert N. Mount to Julia Ann Hawkins Mount, July 4, 1824; Robert N. Mount, "Commonplace Book," MSB).

8. William worked at Henry Mount's shop at 104 Cherry Street. See Mount, "Autobiography [0.11.3549]," pp. 2–3, MSB; and Mount, "Catalogue of Pictures and Portraits by William Sidney Mount [77.22.678]," p. 4, MSB. The "Catalogue," begun July 29, 1839, is the artist's own record of paintings and autobiographical material from 1825 through 1866.

9. Vera Brodsky Lawrence, "Micah Hawkins, The Piped Piper of Catherine Slip," *New-York Historical Society Quarterly* 62, no. 2 (April 1978): 138, 143. For an excellent analysis of the early nineteenth-century New York cultural milieu in which Hawkins participated as a musician, see also Peter G. Buckley, "'The Place to Make an Artist Work': Micah Hawkins and William Sidney Mount in New York City," in Janice Gray Armstrong, ed., *Catching the Tune: Music and William Sidney Mount* (Stony Brook, N.Y.: Museums at Stony Brook, 1984), pp. 22–39.

10. Mount, "Autobiography [0.11.3548]," p. 1, MSB; see also Mount, "Catalogue [77.22.678]," p. 4, MSB.

11. The American Academy of Fine Arts exhibition was, according to Mount, "the first collection I ever had the pleasure of seeing" (Mount, "Autobiography [0.11.3549]," p. 3, MSB). He later noted that "the sight of so many pictures in rich frames, the figures the size of life looking upon me from all parts of the room—created a strange bewilderment of feeling such as I have never since known—I was alone, none to disturb the revery of delight with which I gazed upon them—my mind was awakened to a new life and big resolves for the future were then made" (Mount, "Autobiography [0.11.3549]," pp. 2–3, MSB).

12. For the exact works shown, see [Mary] Bartlett Cowdrey, *Exhibition Record, 1816–1852: American Academy of Fine Arts and American Art-Union* (New York: New-York Historical Society, 1953).

13. On Benjamin West and his followers, see Dorinda Evans, *Benjamin West and His American Students* (Washington, D.C.: Smithsonian Institution Press, 1980); and Wayne Craven, "The Grand Manner in Early Nineteenth-Century American Painting: Borrowing from Antiquity, the Renaissance, and the Baroque," *American Art Journal* 11, no. 2 (April 1979): 5–43.

14. According to William Sidney Mount, the partners Mount and Inslee were engaged in "a great variety of ornamental work such as—Hat signs, banners, transparencies and engine backs, requiring a vast deal of artistical skill" (Mount, "Autobiography [0.11.3549]," pp. 3–4, MSB). William Inslee is listed in the New York City directories as a sign painter from 1819 through 1835; he and Henry Smith Mount were partners from 1826 through 1830. Inslee exhibited paintings at the National Academy of Design from 1827 to 1830.

15. Mount recalled, "When I commenced art in 1825 I . . . made a few copies from engravings" (Mount, "Catalogue [77.22.678]," p. 40, MSB). All of the cited engravings by Hogarth are reproduced in Joseph Burke and Colin Caldwell, *Hogarth: The Complete Engravings* (New York: Harry N. Abrams, 1968).

16. Mount, "Autobiography [0.11.3549]," p. 4, MSB. For further information on Martin E. Thompson, see [Mary] Bartlett Cowdrey, ed., *National Academy of Design Exhibition Record, 1826–1860* (New York: New-York Historical Society, 1943), vol. 1, p. x.

17. Mount, "Autobiography [0.11.3547]," p. 29a, MSB.

18. Mount, "Catalogue [77.22.678]," p. 4, MSB. Mount's early works after scenes from Shakespeare are also recorded in Mount, "Autobiography [0.11.3547]," p. 1, MSB; and Mount, "Autobiography [0.11.3548]," p. 2, MSB.

19. In Christian iconography, the figure eight is the numeric symbol for resurrection. See Gertrude Grace Sill, *Symbols in Christian Art* (New York: MacMillan, 1975), pp. 137–38.

20. Information on Mount's exhibition record at the National Academy of Design is contained in Cowdrey, *National Academy of Design Exhibition Record*, vol. 2, pp. 41–45; and Maria Naylor, ed., *The National Academy of Design Exhibition Record, 1861–1900* (New York: Kennedy Galleries, 1973), vol. 2, pp. 665–66.

21. Henry S. Mount to William S. Mount, April 19, 1828, MSB.

22. There are similarities between figures in Mount's *Christ Raising the Daughter of Jairus* and certain models in Benjamin West's *Paetus and Arria* (1770), *Paetus and Arria* (1766), *The Plague Stayed by the Repentance of David* (1798), and *Chryseis Returned to Her Father* (1771/1777). For reproductions of the works by West, see Helmut von Erffa and Allen Staley, *The Paintings of Benjamin West* (New Haven: Yale University Press, 1986).

23. Mount records that this work, painted in the attic of Henry Mount's home at 154 Nassau Street, was inspired by the First Book of Samuel in the Old Testament. See Mount, "Autobiography [0.11.3549]," p. 7, MSB; and Mount, "Autobiography [0.11.3547]," p. 1, MSB.

24. Von Erffa and Staley, *Paintings of Benjamin West*, pp. 311–12.

25. At the same time, Mount also experimented with romantic versions of classical subjects. His large canvas *The Death of Hector*, painted in 1828 (present location unknown), was inspired by Homer's *Iliad*, as translated by the eighteenth-century British poet Alexander Pope. Mount described the work as "a scene from the Iliad of Homer on canvas, 3 by 4 feet.—Andromache, Hecuba, & Helen, mourning over the dead body of Hector—'First to the corse the weeping consort flew—around his neck, her milk white arms she threw.'" See Mount, "Autobiography [0.11.3548]," p. 2, MSB; this work is also recorded in Mount, "Autobiography [0.11.3547]," p. 1, MSB.

26. See Mount, "Catalogue [77.22.678]," p. 4, MSB; also recorded in Mount, "Autobiography [0.11.3547]," p. 1, MSB. For the source, see William Cowper (1731–1800), "Crazy Kate," from *A Landscape Described, Rural Sounds* (Columbia Granger's World of Poetry, CD-ROM, 1995).

27. For the source of Mount's *Celadon and Amelia*, see James Thomson (1700–1748), "Summer," *The Seasons* (1730; repr., London: C. Whittingham, 1802), p. 102.

28. During the spring of 1829, Mount and his brother Shepard established a portrait painting studio at 15 Cherry Street. In his autobiography Mount recalled, "We sat from day to day in idleness discoursing on the various styles of art, and wondering why so many should pass by without someone drop[p]ing in to encourage native talent." Lacking patronage the Mount brothers' portrait business in New York was short-lived. William returned to Stony Brook to paint "the mugs of Long Island Yeomanry" charging ten or fifteen dollars each. See Mount, "Autobiography [0.11.3549]," p. 7, MSB; and Mount, "Autobiography [0.11.3547]," p. 1, MSB.

29. Mount's first genre painting was *Girl with a Pitcher* (fig. 13), a work that has precedents in the eighteenth-century English "cottage pictures," by artists such as Francis Wheatley, George Morland, and Sir Joshua Reynolds, which depict rural middle-class life. Mount took as his sources for this work the everyday surroundings of his own home, the Hawkins-Mount House; his sister, Ruth Mount, was the model. (Ruth Mount's likeness is known through a portrait by William S. Mount, dated 1831, now at the Museums at Stony Brook.)

30. On Krimmel's painting as a source, see Donald D. Keyes, "The Sources for William Sidney Mount's Earliest Genre Paintings," *Art Quarterly* 32, no. 13 (1969): 259, 261; Catherine Hoover [Voorsanger], "The Influence of David Wilkie's Prints on the Genre Paintings of William Sidney Mount," *American Art Journal* 13, no. 3 (Summer 1981): 7, 17; Cassedy and Shrott, *William Sidney Mount: Works in the Collection*, p. 40;

Anneliese Harding, *John Lewis Krimmel* (Wilmington, Del.: Winterthur, 1994), p. 223; and Elizabeth Johns, *American Genre Painting: The Politics of Everyday Life* (New Haven and London: Yale University Press, 1991), pp. 24–25. The German-born artist John Lewis Krimmel (1789–1821) emigrated to Philadelphia in 1807 and spent most of his short life there. He painted copies from engravings after works by Sir David Wilkie and others, as well as admirable original compositions depicting everyday scenes of his adopted city. It has been argued that Mount may have seen Krimmel's work in New York, but Krimmel exhibited at the American Academy in New York only in 1817 (*The Young Bird*, copy after Burnet and *The Jews Harp*, copy after Wilkie) and 1820 (*The Cut Finger*, *The Blind Fiddler* after Wilkie, and *Blindman's Buff* lent by Francis B. Winthrop of New York); Krimmel did not exhibit at the American Academy after 1820. See Cowdrey, *Exhibition Record, 1816–1852*, p. 218. Mount's first visit to the American Academy was in 1825 (Mount, "Autobiography [0.11.3549]," p. 2, MSB). There is no further record to support the claim that Krimmel's *Country Frolic and Dance* was exhibited in New York during the 1820s.

 After Krimmel's death, the painting was sold to Nathaniel Devaltooth of Boston (Hoover, "The Influence," pp. 18–19; Harding, *Krimmel*, p. 179); after Devaltooth's death (1825), the painting seems to have remained in Boston, being shown at the Boston Athenaeum in May 1827 as *Cottage Dance* (Hoover, "The Influence," pp. 19–20, states that the *Cottage Dance* was "almost certainly the *Village Dance* [a.k.a. *Country Frolic and Dance*] purchased from the 1825 Devaltooth sale by another Boston collector"); from 1827 to 1830 the whereabouts of *Country Frolic and Dance* are unknown. The watercolor version apparently remained in Philadelphia, where it served as the basis for a later engraving titled *Dance in a Country Tavern* issued in 1835–36 (Harding, *Krimmel*, p. 158, n12).

 While it has been claimed that Mount visited Philadelphia or Boston during the 1820s and saw *Country Frolic and Dance* on exhibition (Keyes, "The Sources," p. 260; Hoover, "The Influence," p. 22), Mount's meticulous autobiographical accounts record no trips to Philadelphia until September 1836, at which time the engraver Alexander Lawson did show him several of Krimmel's pictures (Mount, "Catalogue [77.22.678]," p. 52, MSB). Mount's first trip to Boston was in June 1837 (Mount, "Autobiography [0.11.3569]," p. 3, MSB), well after he completed *Rustic Dance*. Another possibility, suggested by Hoover ("The Influence," p. 15, n33), is that Mount may have seen Krimmel's *Country Frolic and Dance* in the collections of New Yorkers Pierre Flandin and his business partner Francis B. Winthrop. However, there is no evidence that Flandin or Winthrop ever owned Krimmel's *Country Frolic and Dance* (Harding, *Krimmel*, pp. 177, 179). It is entirely possible that Mount painted *Rustic Dance After a Sleigh Ride* with no awareness of Krimmel's picture.

31. Both works feature multiple figural groups set within rooms with plank floors running from front to back; on the left side of each composition is a hearth, before which sits a principal figure on a wooden chair, while the corners of the rooms are in shadow. For both the sketch and *Rustic Dance*, Mount used the familiar configuration of a second-floor bedroom in the Hawkins-Mount House. Firmly establishing this location is the fact that the artist included in the rear right corner a valued family possession—a tall case clock now in the collection of the Museums at Stony Brook.

32. "National Academy of Design," undated clipping, Setauket Scrapbook, p. 5. Significantly, when Mount next exhibited *Rustic Dance After a Sleigh Ride*, at the American Institute of the City of New York in October 1830, it was again associated with a literary or storytelling context. While Mount's painting won a first premium, the second prize went to John Quidor for his representation of a scene from Washington Irving's *Sketch-Book*.

33. Many seventeenth- and eighteenth-century Dutch genre painters depicted raucous banquets and other festivities featuring a cross section of society. These images were often disseminated in the form of engravings and book illustrations; a good example is *Dancing Party*. See Jane Iandola Watkins, ed., *Masterpieces of Seventeenth-Century Dutch Genre Painting* (Philadelphia: Philadelphia Museum of Art, 1984).

 British artists of the eighteenth and early nineteenth century also frequently painted entertainments. Some, like Hogarth, satirized the contemporary social scene while others observed the customs and pleasures of the working class. One popular theme was the "penny wedding," a subject that often featured lively musicians and frolicking figures; the subject was so prevalent, in fact, that one author has claimed that "virtually every Scottish genre artist produced his own version down to the middle of the nineteenth century." See E.D.H. Johnson, *Paintings of the British Social Scene from Hogarth to Sickert* (New York: Rizzoli, 1986), p. 141.

34. Art historians David Cassedy and Gail Shrott previously noted that Mount's *School Boys Quarreling* is "suggestive of neo-classical paintings such as Jacques-Louis David's celebrated *Oath of the Horatii*." See Cassedy and Shrott, *William Sidney Mount: Works in the Collection*, p. 40.

35. Walter Friedlander, *David to Delacroix* (Cambridge, Mass.: Harvard University Press, 1952), p. 15.

36. See "The National Academy of Design, and Its Surviving Founders," *Harper's New Monthly Magazine* 66 (December 1882–May 1883): 89; and Eliot Clark, *History of the National Academy of Design, 1825–1853* (New York: Columbia University Press, 1954), pp. 32–33.

37. "No. 5. Boys Quarreling After School," *New-York Mirror*, May 7, 1831, p. 350.

38. Undated clipping, Setauket Scrapbook, p. 22.

39. The similarity between the theater sketch and *Dancing on the Barn Floor*, as well as the history of *The Heart of Midlothian* in the New York theater, is noted in Buckley, "'The Place to Make an Artist Work,'" pp. 31–32.

40. Undated clipping, Setauket Scrapbook, p. 4.

41. Ibid.

42. *New-York Mirror*, June 9, 1832; clipping in Setauket Scrapbook, p. 5.

43. Mount, "Autobiography [0.11.3548]," p. 5, MSB.

44. Undated clipping, Setauket Scrapbook, p. 4.

45. Mount later recalled that during the summer of 1833 he was in New York City, studying and painting from "the white plaster figures" at the American Academy "with the consent of the President Col. John Trumbull." According to Mount, "[Trumbull] seemed interested in my studies." The rapport between the two was to continue for several years, until the elder statesman of American art moved to New Haven, Connecticut. Trumbull also presented Mount with three engravings of "his battle pieces." See Mount, "Autobiography [0.11.3548]," p. 5, MSB; also Mount, "Catalogue [77.22.678]," p. 53, MSB.

46. Mount, "Catalogue [77.22.678]," pp. 40–41, MSB. Mount was not a studio-bound artist. In addition to being perhaps the first American artist to work *en plein air*, he also frequently painted in the homes of friends and relatives and in other locations throughout Stony Brook and Setauket. As Mount stated, " A painter's studio should be every where, where ever he finds a scene for a picture in doors or out—In the black smith's shop, the shoe maker's, the tailor's, the church, the tavern, or Hotel, the market, and into the dens of poverty and disipation, high life and low life. . . . For painting is an honorable calling, and the artist will be respected let him sketch where he will" (Mount, "Journal [77.22.675]," pp. 103–4, MSB).

47. Mount, "Journal [0.7.2606]," p. 123, MSB.

48. "Painting. William S. Mount," *Long Island Star*, undated clipping, Setauket Scrapbook, p. 9.

49. Ibid.

50. "No. 49, Long Island Farmer Husking Corn," undated clipping, Setauket Scrapbook, p. 4.

51. Ibid.

52. "There is no doubt that the author [Seba Smith] is *the best painter of Yankee peculiarities that ever wrote*," *New York Courier and Enquirer*, July 3, 1839; quoted in Seba Smith, *My Thirty Years Out of the Senate* (New York: Oaksmith, 1859), p. 11.

53. "Mr. Hackett," *New-York Mirror* 11 (July 20, 1833): 22; quoted in Ella M. Foshay, *Mr. Luman Reed's Picture Gallery* (New York: Harry N. Abrams/New-York Historical Society, 1990), p. 27.

54. Michael Chevalier, *Society, Manners & Politics in the United States* (1839; reprint, New York: Augustus M. Kelley, 1966), pp. 110, 115, 116, and 119.

55. On the symbolic meaning of Yankee farmer, see Elizabeth Johns, "The Farmer in the Works of William Sidney Mount," *Journal of Interdisciplinary History* 17, no. 1 (Summer 1986): 257–81.

56. On the uses of Mount's *Long Island Farmer Husking Corn* as a motif on engraved bank notes, see Bernard F. Reilly, Jr., "Translation and Transformation: The Prints After William Sidney Mount," in this volume. After its exhibition at the National Academy *Long Island Farmer Husking Corn* was purchased by Gouverneur Kemble. However, Kemble evidently did allow Robert Hinshelwood to engrave an image of the picture that was exhibited at the National Academy in 1838; these engravings were undoubtedly the source of the image used on the bank notes. The original painting remained in Kemble's collection until his death and apparently was not exhibited again in the nineteenth century. It descended in the Kemble/Nourse family until the late 1960s or early 1970s, when it was acquired by Ward Melville, who presented it to the Museums at Stony Brook.

57. Seba Smith, *The Wintergreen for 1844* (New York, 1843), p. 47. Robert Hinshelwood's engraving of Mount's farmer that accompanied Smith's story in *The Wintergreen* was titled "Uncle Joshua."

58. "No. 55—The Studious Boy," *New-York Mirror* 12 (May 30, 1835): 379; clipping in Setauket Scrapbook, p. 12. A woodcut by Joseph Adams after Mount's *The Studious Boy* was published as the frontispiece to William Dunlap, *History of New-York for Schools*, vol. I (New York: Collins, Keese, 1837).

59. For discussion of *The Sportsman's Last Visit* and *Courtship* or *Winding Up* (1836) within the broader contexts of the theme, see Sarah Burns, "Yankee Romance: The Comic Courtship Scene in Nineteenth-Century American Art," *American Art Journal* 18, no. 4 (1986): 51–75.

60. "187. Sportsman's Last Visit," *Evening Star*; undated clipping, Setauket Scrapbook, p. 4.

61. John Russell Bartlett, *The Dictionary of Americanisms* (1849; repr., New York: Crescent Books, 1989), p. 105.

62. S. Foster Damon, *The History of Square Dancing* (Barre, Mass.: Barre Gazette, 1957), p. 34, n33.

63. Ibid., p. 33, n32.

64. Mark E. Lender and James K. Martin, *Drinking in America: A History* (New York: Free Press, 1982), pp. 18–19.

65. Ibid., 35–40, 72.

66. Reed had incorporated into his home on 13 Greenwich Street a "picture-gallery" to exhibit the paintings by European and American artists that he began to collect in 1832. See Foshay, *Mr. Luman Reed*, pp. 38–45.

67. Mount used the Hawkins-Mount Homestead as the setting for this picture. The carriage or wagon shed, the corn crib, and, in the distance, the rear of the house can be clearly identified. It is also evident that Mount painted *Bargaining for a Horse* during the summer haying season. Judging from the bits of hay strewn about the ground and the pitchfork leaning against the shed post, it appears that the activities of this farm have been focused on the labor-intensive cutting and removal of the hay from fields to storage in the barn, which is not depicted.

68. Chevalier, *Society, Manners & Politics*, p. 298.

69. Mount made this note to himself: "If I should ever paint another farmers bargaining—I must have one of the figures in the act of cutting towards his body—to clinch the bargain." Mount, "Journal [0.7.2602]," p. 147, MSB.

70. Mount, "Journal [77.66.676]," p. 234, MSB.

71. Luman Reed to William S. Mount, September 24, 1835, MSB. Reed also showed *Bargaining for a Horse* to author Washington Irving, who expressed his desire to meet the artist. Luman Reed to William S. Mount, December 11, 1835, MSB.

72. Seba Smith, "A Leaf from the Journal of a Tourist," *New-York Gazette and General Advertiser*, October 28, 1835; quoted in Foshay, *Mr. Luman Reed*, pp. 167–68, 212, n231. Reed also mentioned the story in a letter to Mount, October 29, 1835, Louise Ochers Collection (copy at MSB).

73. William S. Mount to Luman Reed, November 12, 1835, Louise Ochers Collection (copy at MSB).

74. By the end of December, however, Mount had retrieved the picture to make an alteration requested by his patron. Mount had evidently painted poultry in the foreground of the earlier version, and Reed apparently

felt that this was unrealistic given the purposeful motion of the farmer. The change must have been minor, because the picture was back in the owner's possession by early January 1836, and Reed pronounced it "improved." To Mount, he wrote, "What is left for the imagination, is really pleasing that the hens + chickens have all run under the Barn, at the approach of the old man, + you may easily imagine them there, as the depth under the Barn cannot be seen." Luman Reed to William S. Mount, January 11, 1836, MSB.

75. *Evening Post*, undated clipping, Setauket Scrapbook, p. 3.

76. One party of "gentlemen" traveled from Philadelphia to New York City expressly to see these works. Mount, "Autobiography [0.11.3547]," p. 18, MSB.

77. Luman Reed to William S. Mount, May 4, 1836, MSB.

78. In a letter to Asher B. Durand, Mount mourned the loss of Reed, whom he called "our best friend." William S. Mount to Asher B. Durand, June 13, 1836, New York Public Library. Years later, Mount noted, "His [Reed's] likeness in the New York Gallery by A. B. Durand . . . almost speaks to me." Mount, "Autobiography [0.11.3548]," p. 14, MSB.

79. William S. Mount to Robert Gilmor, Jr., August 20, 1836, Stebbins Collection (copy at MSB).

80. "Twelfth Annual Exhibition of the National Academy of Design," undated clipping, Setauket Scrapbook, p. 11; "National Academy of Design," undated clipping, Setauket Scrapbook, p. 9.

81. Vanderlyn had copied the Correggio as a commission from New York merchant John R. Murray, who later described it to art historian William Dunlap as "indecent" and unsuitable to hang in his home. So Vanderlyn retained *Antiope* and exhibited it publicly for many years at the Rotunda. William Dunlap, *A History of the Rise and Progress of the Arts of Design in the United States* (New York: George P. Scott and Co., 1834), vol. 2, p. 287.

82. Ibid. Mount evidently held Vanderlyn in high regard. He asked Charles Lanman to give every attention in the press to Vanderlyn's portrait of General Taylor and to write Vanderlyn's biography. William S. Mount to Charles Lanman, April 20, 1850, NYHS.

83. This motif is also seen in Duck's *Sleeping Woman* (ca. 1650s), reproduced in *Masters of Seventeenth-Century Dutch Genre Painting*, plate 40, and described in a catalogue entry on pp. 189–90: "His [Duck's] paintings frequently include a figure who tickles the sleeper's nose, a detail taken up by many later genre painters, notably [Gerard] ter Borch." For other artists who used this motif, see ibid., p. 190, n9.

84. See also Jan Steen, *Beware of Luxury* (1663), reproduced in ibid., plate 80, and described in the catalogue entry on pp. 311–12.

85. On African Americans in Mount's work, see Karen Adams, "The Black Image in the Paintings of William Sidney Mount," *American Art Journal* 7, no. 2 (November 1975): 42–59; Albert Boime, *The Art of Exclusion: Representing Blacks in the Nineteenth Century* (Washington, D.C.: Smithsonian Institution Press, 1990), pp. 5–6, 88–101; Guy C. McElroy, *Facing History: The Black Image in American Art, 1710–1940* (San Francisco: Bedford Arts, 1990), pp. xiii, xvi, 19–23; and Johns, *American Genre Painting*, pp. 101, 105–8, 113, 115–27, 135–36.

86. Mount, "Journal, August 15, 1868 [77.22.677]," p. 847, MSB.

87. Documents clearly show that during Mount's life African Americans—slave, free, and indentured—were part of the family environment. Unfortunately, these records offer little indication of the attitudes of the Hawkins-Mount family members toward African Americans or on the subject of "race" in general. In the federal census of 1790, Jonas Hawkins, William's grandfather, is listed with a household comprised of four white males under sixteen, four white females, no free persons, and two slaves, presumably associated with the enterprise of farming. Suffolk County's largely agricultural population that year included 16,440 individuals of which 1,126 (6.8 percent) were free blacks and 1,088 (6.6 percent) were slaves. *Heads of Families at the First Census of the United States taken in the Year 1790, New York* (Baltimore: Genealogical Publishing), p. 162.

As Grania Marcus has noted, the federal census of 1800 for Suffolk County reflected the gradual emancipation of slaves, which began in New York State during the late eighteenth century. Increasing

recognition was accorded to the fact that the principles of liberty were in conflict with the practice of enslavement. In 1800 the county's population was 19,464, with 1,016 (5.2 percent) free persons of color and 886 (4.5 percent) slaves. The household of Thomas Mount Sr. (William's grandfather) was comprised of two white males, three white females, one free person, and no slaves. With Eleazer Hawkins's death in 1791, the census of 1800 reflects a substantial increase in the household of his son Jonas. Six white males and six white females, two free persons, and three slaves are listed. Grania Bolton Marcus, *Discovering the African-American Experience in Suffolk County, 1620–1860* (Mattituck, N.Y.: Amereon House, 1995), p. 14; *United States Census for the Year 1800, New York State, Suffolk County*, reel 27, pp. 27 (Mount), 66 (Hawkins); *Return of the Whole Number of Persons Within the Several Districts of the United States* (Washington, D.C.: House of Representatives, 1800), schedule for Suffolk County, p. 27.

The census of 1810, compiled three years after William Sidney Mount's birth, listed for the household of his father, Thomas Mount, four white male children under age ten, two white males over age twenty-six, three white females, one free person, and no slaves. The household of William Mount's grandfather, Jonas Hawkins, was comprised of three young white males, two white females, two free persons, and one slave. *United States Census for the Year 1810, New York State, Suffolk County*, reel 36, pp. 224 (Mount), 226 (Hawkins). The Records for the Town of Brookhaven contain an entry dated April 6, 1813, wherein Thomas Mount and his brother-in-law, Jonas Hawkins, Jr. (1783–?), "made application . . . to Manumate a Certain Man Slave of theirs Named Harry . . . under the age of fifty years." The application was granted and Harry was "therefore set free," fourteen years before manumission was mandatory in New York State. *Records of the Town of Brookhaven, Suffolk County, N.Y.* (Port Jefferson, N.Y.: Times Steam Job Print, 1888), pp. 171–72.

William Sidney Mount's father and maternal grandfather died in 1814 and 1817, respectively. Thomas Mount's estate records include entries for one Negro man, one Negro woman, two Negro boys, and one Negro girl. It is not known if these persons were slaves or indentured servants. Thomas S. Mount Estate Inventory, May 13, 1815, Suffolk County Records, Surrogate's Office, Riverhead, N.Y., microfiche 1168. The inventory of Jonas Hawkins's estate lists a "Black girl" valued at thirty dollars. Jonas Hawkins Estate Inventory, May 15, 1817, Suffolk County Records, Surrogate's Office, Riverhead, N.Y., microfiche 1338.

Within the Hawkins family there is evidence that individual African Americans were held in esteem. Within the homestead's burial ground a large gravestone was erected in 1814 to commemorate the life of a man named Cane. His epitaph reads: "Beneath this stone was put/the mortal part of Cane,/ a colour'd person./ He was born the 27th of Decr. 1738/ and died the 12th of Jany. 1814,/ in the 77th year of his age./ CANE was an honest man./Tho nature ting'd his skin, and custom mark'd/Him "Slave"! his mind/was fair, free and independent./His life, all though, was such as did command/Esteem from those who knew him and In death, he shew'd examples of/Religion, full/Convincing of his Christian faith,/That his Redeemer liv'd/ And he should see his face."

In 1816, another marker joined Cane's. It was a testament to Anthony Hannibal Clapp, with the epitaph authored by Micah Hawkins. Carved in relief on the upper part of this marker is a violin. The inscription begins with two lines of verse from Alexander Pope, "Epistle IV," *An Essay on Man* (1734): "ENTIRELY TONE-LESS/ Honor and shame from no condition rise/ Act well thy part, there all the honor lies/ ANTHONY HANNIBAL CLAPP/ of African descent./ Born at Horseneck Conn. 14, July 1749/ came to Setauket in 1779,/ Here sojourning until he died 12, Oct. 1816/ Anthony, though indigent, was most content./ Though of a race despis'd, deserv'd he much/ respect=in his deportment modest and polite./ Forever faithfully performing in life's drama/ the eccentrick part assign'd him by his Maker./ His philosophy agreed with his example to be/ happy Himself, and to make others so, being/ selfish, but in the coveting from his acquaintance/ an undivided approbation, which he was so/ Fortunate as to obtain and keep—/ Upon the Violin, few play'd as Toney play'd,/ His artless music was a language universal,/ and in its Effect—most Irrestistible! Ay, and/ was he not of Setauket's-dancing-Steps—/ a Physiognomist, indeed; he was./ Nor old nor young of either sex, stood on/ The Floor to Jig-it, but he knew the gait./ Peculiar of their Hobby, and unasked,/ Plac'd best foot foremost for them, by his Fiddle/ This Emblamatick Lachrymatory, and/ Cenotaph's, the grateful tribute of a few,/ of either sex who knew his worth."

Anthony Clapp made a lasting impression on William Mount. In 1853 he wrote: "In wandering about the Hills the other day, I visited the burial ground on our farm, a place appropriated for the slaves (belonging to our family) years gone by—and was so much struck with the sublimity and originality of one of the monuments to a distinguished fiddler. . . . The violin is carved in the stone the bridge is down the bow & strings are slack—Tone has departed with Toney. . . . I have sat by Anthony when I was a child—to hear him play his

Jigs & Hornpipes—He was a Master in that way—and acted well his part." William S. Mount to C.M. Cady, November 24, 1853, MSB.

With the death of her husband and father, Julia Hawkins Mount, William's mother, was identified as the head of the household at the Stony Brook homestead in the 1820 federal census. Listed were her mother and her three youngest children, Robert, William, and Ruth. No slaves or "free colored persons" were counted as part of the household, but there was one "indentured colored servant." Julia Mount's household enterprise was identified as agriculture. In Suffolk County the 1820 census reveals that what slavery there was was diminishing. From a total population of 21,428, the number of slaves was 329 (1.5 percent), with 1,165 (5.4 percent) free persons, and 342 (1.6 percent) "indentured colored servants." *United States Census for the Year 1820, New York State, Suffolk County*, reel 74, p. 352 (Julia Mount); Suffolk County summary, n.p., last frame. In 1824, William Mount lived in New York City. For his uncle Micah Hawkins's household in the city, the 1820 census listed four members, none of whom were African Americans. *United States Census for the Year 1820, New York State, New York City, 4th Ward*, reel 77, p. 161 (Hawkins). New York State law provided that all remaining slaves would be considered free by 1827. Consequently, in 1830, the year that William painted *Rustic Dance after a Sleigh Ride*, his first picture depicting African Americans, the federal census counted no slaves in Suffolk County. *Returns of the Fifth Census* (Washington, D.C.: Duff Green, 1832), p. 9. With New York State's gradual emancipation laws, a few blacks in Suffolk County had become landowners, but the majority earned a low-wage living in the agricultural and maritime-based economy. Marcus, *Discovering the African-American Experience*, p. 13.

88. "The Fine Arts," *New-York Mirror* (June 13, 1835), p. 395.

89. For such views, see Adams, "The Black Image," p. 47; Boime, *Art of Exclusion*, p. 93; McElroy, *Facing History*, p. 20; and Johns, *American Genre Painting*, pp. 34–35. This criticism is more apt in regard to James G. Clonney's *A Negro Boy Asleep*, 1835 (fig. 36), but this work was not exhibited at either academy in New York, and it is highly doubtful that it had any influence on Mount's *Farmers Nooning*.

90. Johns, *American Genre Painting*, pp. 34–35.

91. Ibid. Figure 6 in Johns's book is a reproduction of Edward C. Clay, "The People Putting Responsibility to the Test, or the Downfall of the Kitchen Cabinet and Collar Presses,"1835, lithograph published by T. W. Whitley, New York (Library of Congress). In this image a black man wears a tam-o'-shanter and talks about "bobolition." On page 216, n. 18, Johns cites another image by Clay (1840) depicting *New York Tribune* editor Horace Greeley in a tam-o'-shanter and kilts.

92. "Cousin Ephrim Explains the Science of Land Speculation, March 4, 1833," in Smith, *My Thirty Years*, pp. 194–97.

93. Chevalier, *Society, Manners & Politics*, p. 305.

94. Bartlett, *The Dictionary of Americanisms*, p. 160.

95. Philip Hone, *The Diary of Philip Hone, 1828–1851*, edited by Allan Nevins (New York: Dodd, Mead, and Co., 1939), p. 259.

96. Upon his return from a trip to Boston in mid-July 1837, Mount began the commission for "one picture cabinet size the subject left entirely to my own fancy." William S. Mount to Robert Gilmor, Jr., August 20, 1836, Archives of American Art.

97. Mildred H. Smith, *Early History of the Long Island Rail Road, 1834–1900* (Uniondale, N.Y.: Salisbury Printers, 1958), pp. 1–22, 57–61.

98. William S. Mount to Robert Gilmor, Jr., December 5, 1837, Archives of American Art. Mount states in this letter that he had received Gilmor's interpretation, but Gilmor's letter to Mount is unlocated.

99. "Mount's pictures give us scenes and personages we have all seen . . . and we are delighted with what before had escaped our observation, or had been forgotten," unsigned review of the Stuyvesant Institution exhibition (1838), *Evening Star*; undated clipping, Setauket Scrapbook, p. 5.

100. One critic called Mount "the greatest artist this country has ever produced in that line of history painting" ("Twelfth Annual Exhibition of the National Academy of the Design," undated clipping, Setauket

Scrapbook, p. 11.). Another wrote, "His great aim is to tell history" ("No. 303. Tough Story. W.S. Mount," undated clipping, Setauket Scrapbook, p. 12.).

101. Compared to Mount's usual "cabinet size" pictures, *Dregs in the Cup* is a large canvas, measuring four feet four inches by three feet six inches. There is no documentation to explain why this subject warranted such a grand presentation. In a letter to his brother, Mount did note that the figures were painted life-size, a feat he had accomplished previously only in portraiture (William S. Mount to Robert N. Mount, February 11, 1838, MSB). But most likely Mount was inspired to try a large canvas after seeing grand works of art by Benjamin West and others in Philadelphia and Boston. Although not much of a traveler, in September 1836, Mount had visited Philadelphia to "see West's picture Christ Healing the Sick," then on exhibition at the Pennsylvania Hospital (Mount, "Catalogue [77.22.678]," p. 52, MSB). Mount's first trip to Boston occurred in late June of 1837. Curiously, he did not call on any artists. Ibid.

102. "No. 95—Dregs in the Cup or Fortune Telling," undated clipping, Setauket Scrapbook, p. 4; "No. 95. Dregs in the cup, or fortune telling," undated clipping, ibid.

103. "No. 95, Fortune Telling," undated clipping, Setauket Scrapbook, p. 4; "No. 95—Dregs in the Cup or Fortune Telling," undated clipping, ibid.; "No. 95 Dregs in the cup or fortune telling," undated clipping, ibid.; "Fortune-Telling," undated clipping, ibid., p. 9; and "Fortune Telling," undated clipping, ibid.

104. Mount painted *The Painter's Triumph* for publisher Edward L. Carey, who had it engraved by Alexander Lawson for *The Gift* in 1839, with a story written by Andrew A. Harwood. Edward L. Carey to William S. Mount, July 28, 1836, MSB; Edward L. Carey to William S. Mount, September 11, 1838, MSB; A.A. Harwood, "The Painter's Study," *The Gift, An Annual* (Philadelphia: Carey and Hart, 1839), pp. 208–21. On this work, see William T. Oedel and Todd S. Gernes, "The Painter's Triumph: William Sidney Mount and the Formation of Middle-Class Art," *Winterthur Portfolio* 23, nos. 2/3 (Summer/Autumn 1988): 111–27.

105. The fencing pose is noted in Jules Prown, *American Painting: From Its Beginnings to the Armory Show* (New York: Rizzoli, 1980), p. 79.

106. Mount, "Journal [0.7.2602]," p. 136, MSB. Mount records that he painted *The Painter's Triumph* in Stony Brook (Mount, "Journal [0.7.2602]," p. 123, MSB). A sketchbook from ca. 1831–37 includes two preliminary studies for the painting, one of the padded Windsor chair and the other a rendering of Mount's Stony Brook studio with a canvas on an easel (Museums at Stony Brook). The room in *The Painter's Triumph* is a slight variation on the spartan and humble studio interior seen in the sketch. In the finished painting, Mount includes an exact rendering of his own easel (now in the collection of the Museums at Stony Brook), and the artist in *The Painter's Triumph*, when compared to self-portraits from this period, is clearly Mount himself (see the self-portraits dating from 1832 and 1833–34 at the Museums at Stony Brook). His farmer-neighbor William S. Williamson modeled for the country gentleman, which he recorded as "sitting for Mr. William S. Mount $1.87." Entry dated June 1838, William S. Williamson Account Book, MSB. Thanks to Laurence W. Ehrhardt, whose research on the Williamson family led to the discovery of this entry.

107. *Catching Rabbits* was the first of three pictures on this theme that Mount composed over a span of twenty-three years. The second, *The Dead Fall (The Trap Sprung)*, 1844 (fig. 45), was commissioned by Edward L. Carey as an image for *The Gift*; the third was *Going Trapping*, 1862 (present location unknown).

108. Jonathan Sturges to William S. Mount, March 2, 1839, MSB.

109. "No. 225, Boys Trapping," undated clipping, Setauket Scrapbook, p. 11; "No. 225.—Boys Trapping," ibid., p. 9.

110. Johns, *American Genre Painting*, pp. 46–50.

111. Ibid., p. 49.

112. "I was at one of Mr. Parker's assembles at Tammany Hall last week about two hours, and danced at few times." William S. Mount to Robert N. Mount, January 30, 1839, MSB. "When you reach N.Y. put up at Tammany Hall, you pay fifty cents a night for a room, and eat where you please, and at what hour you please. I put up there when I am in town." William S. Mount to Robert N. Mount, June 9, 1840, MSB.

113. Alfred Connable and Edward Silberfarb, *Tigers of Tammany, Nine Men Who Ran New York* (New York: Holt, Rinehart and Winston, 1967), pp. 69–103. Other sources on the history of Tammany Hall include Oliver E.

Allen, *The Tiger: The Rise and Fall of Tammany Hall* (New York: Addison-Wesley, 1993), and M.R. Werner, *Tammany Hall* (New York: Doubleday, Doran, 1928). Regarding the 1840 election, Mount speculated, "New York will go for Van Buren 20 thousand not withstanding Log Cabins and hard cider." William S. Mount to Robert N. Mount, July 12, 1840, MSB.

114. Connable and Silberfarb, *Tigers of Tammany*, pp. 101–3, 105–6; Allen, *The Tiger*, pp. 45–48, 53, 62, 93; and Werner, *Tammany Hall*, pp. 42–43. Also useful for this political history are Mark L. Berger, *The Revolution in the New York Party Systems, 1840–1860* (Port Washington, N.Y.: Kennikat Press, 1973), and A. James Reichley, *The Life of the Parties: A History of American Political Parties* (New York: Free Press, 1992).

115. Other examples of such election broadsides are "Federal-Abolitionist-Whig Trap to Catch Voters In," ca. 1840 (Broadside Collection, Library of Congress; reproduced in Johns, *American Genre Painting*, p. 48); and "View of the Bar Room in the Log Cabin," ca. 1840, in which a rooster, the symbol of the Democratic party, is caught in a trap partially covered by the flag of the United States (Collection of Edward W.C. Arnold; reproduced in John A. Kouwenhoven, *The Columbia Historical Portrait of New York* [Garden City, N.Y.: Doubleday, 1953], p. 155).

116. Edward L. Carey to William S. Mount, December 21, 1839, NYHS.

117. Since Mount was in the Catskills, Shepard Mount transcribed Carey's request. Shepard Mount to William S. Mount, September 31, 1843, MSB.

118. Mount, "Journal [77.22.675]," p. 139, MSB.

119. Leith Melder, *Hail to the Candidate* (Washington, D.C.: Smithsonian Institution Press, 1992), pp. 75–89. In April 1840, Robert Mount wrote to his brother from Georgia, "A great revival has been going on here in religion and also in politicks. The voice of their votaries sounds aloud in the Whisky Shop and Church. The cry of 'Hell and Satan' and 'Hard Cider and Harrison' has become familiar to our ears. The fear of Hell has induced many to join the church; and the love of Cider has led many to join the standard of the old General. Both parties have important objects in view—the one to save their souls and the other to save the country." Robert N. Mount to William S. Mount, April 1840, MSB.

120. Recognizing the painting's national import, Robert Mount responded to his brother in January 1841: "I think your last picture 'Cider Making' should have been painted large and placed in one of the vacant squares at the Government House in Washington City." Robert N. Mount to William S. Mount, January 17, 1841, MSB. Mount's *Cider Making* depicts an expansive landscape, inspired by the South Setauket cider press, pond, and surrounding environs, a local landmark known as "The Hole Under the Hill." See Barbara Ferris Van Liew, ed., "The Hole Under the Hill or S. Setauket Cider Mill," *Preservation Notes* (Society for Long Island Antiquities) 10, no. 2 (June 1974): 5. Mount himself stated that *Cider Making* was painted to "call up early associations," a point clarified by his description "Cider Making in the old way." William S. Mount to Benjamin F. Thompson, December 5, 1840, Stebbins Collection (copy at MSB).

121. "The Fine Arts—Brackett—Mount," undated clipping, Setauket Scrapbook, p. 12.

122. "The Fine Arts. Letter from A 'Jaunting Gentleman' enjoying rural life, to his Friend on the Pavement," *New-York American* (April 14, 1841), unsigned clipping, Setauket Scrapbook, p. 13. The article also appeared in pamphlet format; a copy is loosely inserted into the Setauket Scrapbook. Art critics of Mount's day generally limited their remarks to observations of the technical merits or faults of the paintings, comparisons to other American or European artists, or descriptions of the genre subject. Rarely was any extended reference made to the political subtexts of pictures, which they must have recognized. Thus, the text about Mount's *Cider Making* is something of an anomaly, and a bit of evidence that allegorical readings were typically left to "popular" writers.

123. Johns, *American Genre Painting*, 50–54. See also Joseph B. Hudson, Jr., "Banks, Politics, Hard Cider, and Paint: The Political Origins of William Sidney Mount's Cider Making," *Metropolitan Museum of Art Journal* 10 (1975): 107–18.

124. For the interpretation of this painting as representing the Democratic victories over the Whigs, see Johns, *American Genre Painting*, p. 57. In a later journal entry, Mount made explicit the association between hogs and unscrupulous politicians. Writing in 1844, Mount noted a possible subject for a painting: "A farmer feeding hogs—office holder." Mount, "Journal [77.22.675]," p. 139, MSB.

125. Connable and Silberfarb, *Tigers of Tammany*, p. 95; Allen, *The Tiger*, pp. 48–49; and Werner, *Tammany Hall*, p. 33.

126. "No. 184, Scene in a Farm Yard," undated clipping, Setauket Scrapbook, p. 15.

127. William S. Mount to Charles Lanman, January 23, 1841, NYHS.

128. "I am at present boarding with Mr. Elias Smith, West Meadow Creek—taken a view of the same." William S. Mount to Robert N. Mount, August 29, 1841, MSB.

129. Mount, "Autobiography [0.11.3548]," p. 8, MSB.

130. Mount, "Catalogue [77.22.678]," p. 16, MSB.

131. Mount, "Autobiography [0.11.3548]," p. 9, MSB.

132. Edward L. Carey to William S. Mount, undated, MSB.

133. William S. Mount to Edward L. Carey, January 9, 1842, Historical Society of Pennsylvania.

134. Mount, "Catalogue [77.22.678]," p. 20, MSB. The change in title seems to have stemmed from the inadvertent suggestions of critics. One critic described the painting as "an exquisite poetical conception, that most happily illustrates the power of music" ("The Power of Music by Mount," a handwritten transcription of an unsigned review, in Mount, "Autobiography [0.11.3547]," p. 29, MSB). The critic's description of Mount's picture as a "poetical conception" may refer to the prevalence of the theme in Western literature. For example, Lorenzo, in Shakespeare's *The Merchant of Venice*, says, "By the sweet power of music . . . /The man that hath no music in himself,/Nor is not mov'd with the concord of sweet sounds,/Is fit for treasons, stratagems, and spoils; The motions of his spirit are dull as night,/And his affections dark as Erebus,/Let no such man be trusted. Mark the music" *Merchant of Venice* 5.1. William Wordsworth later borrowed Shakespeare's line to immortalize the fiddler in his poem "The Power of Music": "He sways them with harmony merry and loud;/He fills with his power all their hearts to the brim." William Wordsworth *The Power of Music* (Columbia Granger's World of Poetry, CD-ROM, 1995). And, finally, the nineteenth-century American poet John Pierpont also wrote a poem titled "The Power of Music," which includes the lines, "While music throws her silver cloud around,/And bears her votary off in magic folds of sound." John Pierpont, "The Power of Music" (1816), reprinted in Rufus W. Griswald, ed., *The Poets and Poetry of America* (Philadelphia: Carey and Hart, 1842), p. 58. In another review, the critic actually referred to Mount's painting as *The Power of Music* ("The Power of Music," undated clipping, Setauket Scrapbook, p. 19). Mount apparently liked the new title and made the adjustment in his own *Catalogue of Pictures and Portraits*, scratching out "Force" and inserting "Power" (Mount, "Catalogue [77.22.678]," p. 20, MSB). For further discussion of this work, see Bruce Robertson, "The Power of Music: A Painting by William Sidney Mount," *Bulletin of the Cleveland Museum of Art* 79, no. 2 (February 1992): 38–62.

135. Mount, "Journal [0.7.2602], p. 123, MSB.

136. "City Items, National Academy of Design," undated clipping, Setauket Scrapbook, p. 17.

137. Mount records the painting in his *Catalogue*, and it was exhibited at the National Academy, under the title *Recollections of Early Days. Fishing Along Shore*. See "Recollections of Mr. Strong's early days," in Mount, "Autobiography [0.11.3547]," p. 7, MSB.

138. Information about the identity of the figures was provided by Rachel Hart Midgett, granddaughter of Rachel Holland Hart, in 1960; see MSB files. This identification is corroborated by the following entry: "Thomas S. Strong of the Town of Brookhaven in the County of Suffolk being duly sworn deposeth and saith that he owns and possesses four female Children who are slaves and whose names and ages are as follows Viz. Rachel Born 22nd day of August 1805— . . . Sworn the 4th day of December 1821." *Records of the Town of Brookhaven, Suffolk County, N.Y.*, p. 83.

139. Mount's story about Hector was prompted by Lanman's request for information about Long Island flat-fish and fishing methods. William S. Mount to Charles Lanman, November 17, 1847, NYHS.

140. Mount, "Autobiography [0.11.3547]," p. 9, MSB.

141. William S. Mount to Elizabeth Elliot Mount, early to mid-September 1847, MSB. See also William S. Mount to Shepard Mount, November 22, 1847, MSB. One option for Mount was to study art in Europe. Most

artists of Mount's generation spent time in the artistic centers of England, France, and Italy. In the mid-1830s Luman Reed offered to finance a stay abroad; Jonathan Sturges later promoted Italy, offering to assist with expenses (Mount, "Autobiography [0.11.3547]," pp. 13–14, MSB). In 1839 Mount finally seemed to be heading for Europe, but that trip did not materialize (William S. Mount to Robert Nelson Mount, October 14, 1838, MSB). When the International Art-Union announced plans to finance two years of study in Europe for a deserving American student in 1848, Mount, then forty-one years old and well established as an artist, actually applied. The sponsors, Messrs. Goupil and Vibert, responded to Mount's application independently, eagerly offering to pay all of the artist's expenses for a year in Paris if he would paint them four pictures. Mount politely declined this offer, citing "engagements," but to his journal he cited the true reason: "I had rather be free on Long Island—than to be a slave in Paris" (Mount, "Journal [0.7.2602]," p. 68, MSB; for other references to this offer, see William S. Mount to Messrs. Goupil, Vibert, December 13, 1848, NYHS; William S. Mount to Goupil & Vibert, February 14, 1850. NYHS; Wilhelm Schaus to William S. Mount, February 21, 1850, MSB; Mount, "Autobiography [0.11.3547]," p. 14, MSB; Mount, "Autobiography [0.11.3548]," p. 15, MSB. Mount never did travel abroad, earning him the distinction of being a "home-grown" talent. But, as he wrote to a friend at the time, "I have always had a desire to do something before I went abroad. Originality is not confined to one place or country which makes it very consoling *to us Yankees*" (William S. Mount to Charles Lanman, January 8, 1850, NYHS).

142. Mount, "Journal [0.7.2602]," p. 70, MSB.

143. Ibid., p. 34.

144. In early 1850, Mount notified his patron that the painting, which he then called "Reading the Tribune," was almost finished. William S. Mount to Thomas McElrath, February 25, 1850, MSB.

145. The painting of hogs that Mount has copied is Henry Mount's *Girl with Pigs*, ca. 1831, oil on panel, 12½ by 16¾ in., Museums at Stony Brook, Gift of Mr. and Mrs. Ward Melville.

146. See Glyndon G. Van Deusen, *Horace Greeley: Nineteenth-Century Crusader* (New York: Hill and Wang, 1953), pp. 108–14.

147. Wilhelm Schaus to William S. Mount, February 21, 1850, MSB.

148. Mount, "Journal [0.7.2602]," p. 122, MSB. "My friends in New York—again urges me strongly to take up picture painting & not paint anything else—or I must be excommunicated." Mount, "Autobiography [0.11.3547]," p. 28b, MSB.

149. Mount, "Journal [0.7.2602]," p. 22, MSB.

150. William Alfred Jones, "A Sketch of the Life and Character of William S. Mount," *American Whig Review* 14 (August 1851): 125.

151. Edward Buffet, "William Sidney Mount: A Biography," *Port Jefferson Times*, chap. 35.

152. Wilhelm Schaus to William S. Mount, November 9, 1849, MSB.

153. Press release about William S. Mount by Wilhelm Schaus. NYHS. These high-quality productions were offered to the American market in black and white for three dollars, and as limited and colored editions for five dollars. See the subscription notices in the Setauket Scrapbook, pp. 23, 24.

154. "Just in Time," undated clipping, Setauket Scrapbook, p. 32.

155. Wilhelm Schaus to William S. Mount, February 21, 1850, MSB.

156. William S. Mount to Wilhelm Schaus, March 3, 1850, NYHS; Wilhelm Schaus to William S. Mount, March 7, 1850, MSB.

157. "A New Picture, by William S. Mount, Esqr.," undated clipping, Setauket Scrapbook, p. 34.

158. The lithograph of *Right and Left*, by Jean-Baptiste Adolphe Lafosse, flops Mount's image. In an autobiographical account, Mount later complained, "[The painting] represents a left handed fiddler and should have been so represented in the engraving" (Mount, "Autobiography [0.11.3547]," p. 10, MSB). He was, however, evidently pleased with the Goupil lithograph for he painted an elaborate trompe l'oeil frame on his copy (Museums at Stony Brook). Goupil remained in possession of *Right and Left* until it was auctioned in 1857.

David A. Wood purchased the work and was listed as owner when *Right and Left* was exhibited at the National Academy in 1860, nearly ten years after Mount completed it.

159. Richard Nevell, *A Time to Dance: American Country Dancing from Hornpipe to Hot Hash* (New York: St. Martin's Press, 1977), p. 89; Damon, *History of Square Dancing*, pp. 25–26.

160. Wilhelm Schaus to William S. Mount, September 15, 1850, MSB; William S. Mount to Wilhelm Schaus, December 20, 1850, NYHS.

161. Mount had earlier used the symbol of the goose as a sign for a lost man in his painting *The Raffle* (1837), now known as *Raffling for the Goose*, 1837 (fig. 37), which presents the narrative around the speculative raffle as a more conventional genre scene.

162. Reactions to *The Lucky Throw* were mixed and often cryptic. One critic described the African American as "a living transcript from nature, faithful and free" ("A New Picture By W.S. Mount," undated clipping, Setauket Scrapbook, p. 32). The writer for the *Courier and Enquirer*, a Whig newspaper, stated, "The painting in question is not one of which we have any reason to feel particularly proud, although it has much merit as a piece of imitation, but it is not much anything beyond that . . . it is not a subject that an artist of Mr. Mount's power should have concentrated his genius on" ("Fine Arts," *Courier and Enquirer*, February 9, 1851, Setauket Scrapbook, p. 25). From Buffalo, Mount's nephew wrote, "Your picture of the 'Lucky Throw' has made you the prevailing subject of gossip for the last two weeks" (Thomas S. Seabury to William S. Mount, January 25, 1851, quoted in Buffet, "William Sidney Mount: A Biography," chap. 33). And, in response to Schaus's request for more pictures of that kind, the artist himself replied, "I will undertake those large heads for you—although I have been urged not to paint any more such subjects. I had as leave paint the characters of some Negros—as to paint the characters of some *Whites* as far as the Morality is concerned. 'A Negro is as good as a white man—as long as he behaves himself'" (William S. Mount to Wilhelm Schaus, September 9, 1852, NYHS). Elizabeth Johns also situates this picture in the context of the Compromise of 1850, but she interprets it as antiabolitionist. Johns, *American Genre Painting*, pp. 123–27.

163. Mount records that *The Bone Player* was painted in seven days and completed on April 3, 1856. He then started *The Banjo Player* and finished it in eight days. William S. Mount, "Note [0.11.3536]," MSB; Mount, "Journal [0.7.2602]," pp. 139–40, MSB.

164. For reproductions of typical works in this genre, see *Masters of Seventeenth-Century Dutch Genre Painting*, especially Judith Leyster, *Boy with Flute* (ca. 1630), p. xxxiv; Gerrit van Honthorst, *The Merry Fiddler* (1623), pl. 7; Hendrick ter Brugghen, *The Bagpiper* (1624), pl. 9; and an engraving by Cornelis Danckerts, after Abraham Bloemaert, *The Bagpiper* (ca. 1620), p. xxxi.

165. The banjo evolved from an instrument indigenous to Africa that was recreated in America by slaves. See Laurence Libin, *American Musical Instruments in The Metropolitan Museum of Art* (New York: Metropolitan Museum of Art/W.W. Norton & Co., 1985), pp. 35–36, 108.

166. Stage impersonations of blacks by whites emerged in the early nineteenth century. During a tour of the United States in the 1820s, the English comedian Charles Matthews incorporated a solo blackface act into his repertoire and then took it back to London. The American performers George Washington Dixon and Thomas Dartmouth Rice (also called "Daddy" or "Jim Crow" Rice) followed suit, covering their faces with burnt cork, dressing in ragged clothes, singing in a pidgin English dialect, and dancing in the "Negro style." On minstrelsy, see Robert C. Toll, *Blacking Up: The Minstrel Show in Nineteenth-Century America* (New York: Oxford University Press, 1974), pp. 25–104; Gilbert Chase, "The Ethiopian Business," in *America's Music* (Chicago: University of Illinois Press, 1987), pp. 232–47; and Eric Lott, "The Seeming Counterfeit: Racial Politics and Early Blackface Minstrelsy," *American Quarterly* 43, no. 2 (June 1991): 223–51.

167. Wilhelm Schaus to William S. Mount, September 1, 1852, MSB.

168. "Fine Arts," *New York Herald*, July 1, 1856, Setauket Scrapbook, p. 43.

169. "[Hawkins's] 'comic' songs in pseudo-Negro dialect, performed in blackface, anticipated by more than a decade the advent of burnt-cork minstrelsy." Lawrence, "Micah Hawkins, The Piped Piper," p. 140.

170. See the manuscripts in the William S. Mount Music Collection, MSB.

171. On Lane, see Marian Winter, "Juba and American Minstrelsy," *Dance Index* 6 (1947): 23–47. See also

Toll, *Blacking Up*, pp. 43, 196–97; Lott, "The Seeming Counterfeit," pp. 229–30; and Edward Thorpe, *Black Dance* (Woodstock, N.Y.: Overlook Press, 1990), pp. 42–44.

172. Colleen McGuiness, ed., *National Party Conventions, 1831–1988* (Washington, D.C.: Congressional Quarterly, 1991), pp. 38–39.

173. Don C. Seitz, *The James Gordon Bennetts* (Indianapolis: Bobbs-Merrill, 1928), p. 39.

174. Mount, "Autobiography [0.11.3547]," p. 13, MSB.

175. On the initial negotiations, see William S. Mount to Wilhelm Schaus, March 2, 1854, NYHS; and Wilhelm Schaus to William S. Mount, March 4, 1854, MSB. Smith agreed to both the reproduction of the picture as a print and to the exhibition of the work at the National Academy. However, the transaction with Schaus resulted, in Mount's opinion, in some negative criticism of the painter in the press: "The two hundred dollar copyright . . . could not be forgiven—that raised the steel pen against me." William S. Mount to Wilhelm Schaus, April 26, 1854, NYHS.

176. "It is an American violin for Brother Jonathan to play upon." William S. Mount to Charles Lanman, May 3, 1853, NYHS. See also Laurence Libin, "Instrument Innovation and William Sidney Mount's 'Cradle of Harmony,'" in Armstrong, ed., *Catching the Tune*, pp. 56–66.

177. Mount's library included a copy of John Gasper Spurheim, *Outlines of Phrenology* (Boston: Marsh, Capen & Lyon, 1839), inscribed "Wm. S. Mount May 10th 1848," MSB. It is debatable if phrenology manifested itself in Mount's art; he recorded no such correlations himself. However, in 1851, a contemporary, William Alfred Jones had the following to say about *The Power of Music*: "The phrenological hobby of the artist is apparent in the musical bump of the negro, whose organ of tune . . . has been much developed" (Jones, "A Sketch of the Life," p. 124). It is unclear whether this observation reflected the artist's intention or simply the critic's own interpretation. Art historian William T. Oedel discusses phrenology within the context of *The Painter's Triumph* (1838) in Oedel and Gernes, "The Painter's Triumph," pp. 117–19.

178. The names and addresses of mediums and spiritualists are found in Mount's notebooks, and he also corresponded with many persons of similar convictions. See Mount, "Spiritualist Diary [0.7.4588–1]," MSB; Mount, "Journal/Address Book," Smithtown Library, Smithtown, N.Y.; Mount, "Journal [77.22.677]," pp. 299, 538 ("the spirit worlds, a world of progression"), MSB; Mount, "Journal [77.22.679]," pp. 111–12, MSB; Mount, "Journal [0.7.2602]," pp. 131, 133, 138, MSB; William S. Mount to T. H. Hadaway, April 22, 1855, NYHS; and William S. Mount to Charles Partridge, July 4, 1857, MSB. He also owned a key spiritualist tract authored by John W. Edmonds, a New York Court of Appeals judge: "Spiritualism as Demonstrated from Ancient to Modern History," *Spiritual Tracts*, no. 9 (New York: Privately Printed, 1858). In addition, his library included Elias W. Capron, *Modern Spiritualism: Its Facts and Fanaticisms, Its Consistencies and Contradictions* (Boston: Bela Marsh, 1855), inscribed "Wm. S. Mount June 1855"; *The Sacred Circle* (New York) 1, no. 1 (May 1854), inscribed "Wm. S. Mount May 12, 1854"; a undated newspaper clipping titled "A Spiritualist Negress"; and a transcript of the contact with the spirit of Micah Hawkins, November 22, 1854 (0.11.3553), MSB.

179. The documentation that survives includes two spirit letters from Rembrandt (dated January 29, 1855, and March 25, 1855), both John Davis Hatch Collection; and envelope for a spirit letter and a "spirit sketch" of Rembrandt, MSB.

180. "Have *confidence* (says Rembrandt) in your ability, if you wish to shine as a painter." Mount, "Journal [0.7.2602]," p. 172, MSB.

181. McGuiness, ed., *National Party Conventions*, p. 44.

182. Ibid., p. 45. After the Republican party victory, Mount wrote to Frederic Hudson, managing editor of the *New York Herald*: "How to save the Union. Please suggest in the Herald, the importance of having in each house of Congress a *band* of *music*, that when a Union speech is delivered the band shall strike up some stirring National air—to harmonize the debates. If music, prayers and Union speeches, offered up with firm resolve for each State (in the future) to mind it own business—If this I repeat will not tend to keep the glorious Union together==What in the name of heaven will?" William S. Mount to Frederic Hudson, December 14, 1860, NYHS.

183. Various entries, Mount, "Journal [77.22.677]," MSB; selected works, Mount, "Catalogue [77.22.678]," pp. 34, 36b, MSB.

184. Mount, "Journal [77.22.677]," p. 11, MSB.

185. William S. Mount to Samuel P. Avery, February 12, 1864, NYHS; William S. Mount to D.C. Polharmus (?), March 30, 1864, NYHS; Mount, "Journal [77.22.677]," pp. 50, 56, 65, MSB.

186. John M. Gardner to Martin E. Thompson, May 19, 1863, quoted in Buffet, "William Sidney Mount: A Biography," chap. 53.

187. William S. Mount to John M. Gardner, May 28, 1863, NYHS.

188. John M. Gardner to William S. Mount, June 1, 1863, MSB.

189. William S. Mount to John M. Gardner, June 6, 1863, quoted in Buffet, "William Sidney Mount: A Biography," chap. 53.

190. William S. Mount, "Notes: Excerpts from John Marshall, *Life of Washington* II (1804) [0.11.5706–2]," MSB.

191. Richard W. Dodson, after Daniel Huntington, *Washington Crossing the Allegheny*, reproduced in *The Gift of 1845* (Philadelphia: Carey and Hart, 1844), opposite p. 277.

192. John M. Gardner to William S. Mount, March 1, 1865, MSB.

193. John M. Gardner to William S. Mount, May 29, 1865, quoted in Buffet, "William Sidney Mount: A Biography," chap. 53.

194. Mount, "Journal [77.22.677]," p. 33, MSB.

195. McGuiness, ed., *National Party Conventions*, p. 47.

196. Mount, "Journal [77.22.677]," p. 561, MSB.

197. Mount, "Journal [77.22.677]," p. 38, MSB.

198. Mount, "Journal [77.22.677]," p. 562, MSB.

199. Mount, "Journal [77.22.677]," p. 119, MSB.

200. Paul Elmer More, ed., *The Complete Poetical Works of Byron* (Boston: Houghton, Miflin, 1933), pp. 722–44.

201. For key sources on Johnson's presidency and Reconstruction, see Hans L. Trefousse, *Andrew Johnson: A Biography* (New York: W. W. Norton, 1989), and Eric Foner, *Reconstruction: America's Unfinished Revolution, 1863–1877* (New York: Harper and Row, 1988).

202. William S. Mount, Note, Smithtown Library, Smithtown, N.Y.

203. William S. Mount to unknown correspondent, November 11, 1867 (0.11.3533), MSB; Mount, "Journal [77.22.677]," pp. 301–3, MSB.

204. Ibid, p. 315.

205. William S. Mount to the editor of the *Long Island Star*, November/December 1867, MSB.

206. Mount, "Journal [77.22.677]," pp. 303–4, 311, 313–14, MSB.

207. Mount, "Journal/Address Book," p. 1, Smithtown Library, Smithtown, N.Y.

208. August Belmont to William S. Mount, August 30, 1868, MSB.

209. William S. Mount to August Belmont, August 30, 1868, MSB.

210. Mount, "Journal [77.22.677]," p. 599, MSB.

211. Ibid., p. 431.

212. Ibid., p. 151.

213. William S. Mount to Charles B. Wood, June 1, 1862, NYHS.

214. Samuel P. Avery to William S. Mount, March 8, 1862, MSB.

215. Mount, "Journal [77.22.677]," pp. 201, 203–6, 249, 265, MSB.

216. J. Alden Spooner, "Reminiscences of Artists: William S. Mount and Sheppard [*sic*] A. Mount," *Evening Post* (New York), December 16, 1868, p. 1.

217. "W.S. Mount," undated clipping, Setauket Scrapbook, p. 22.

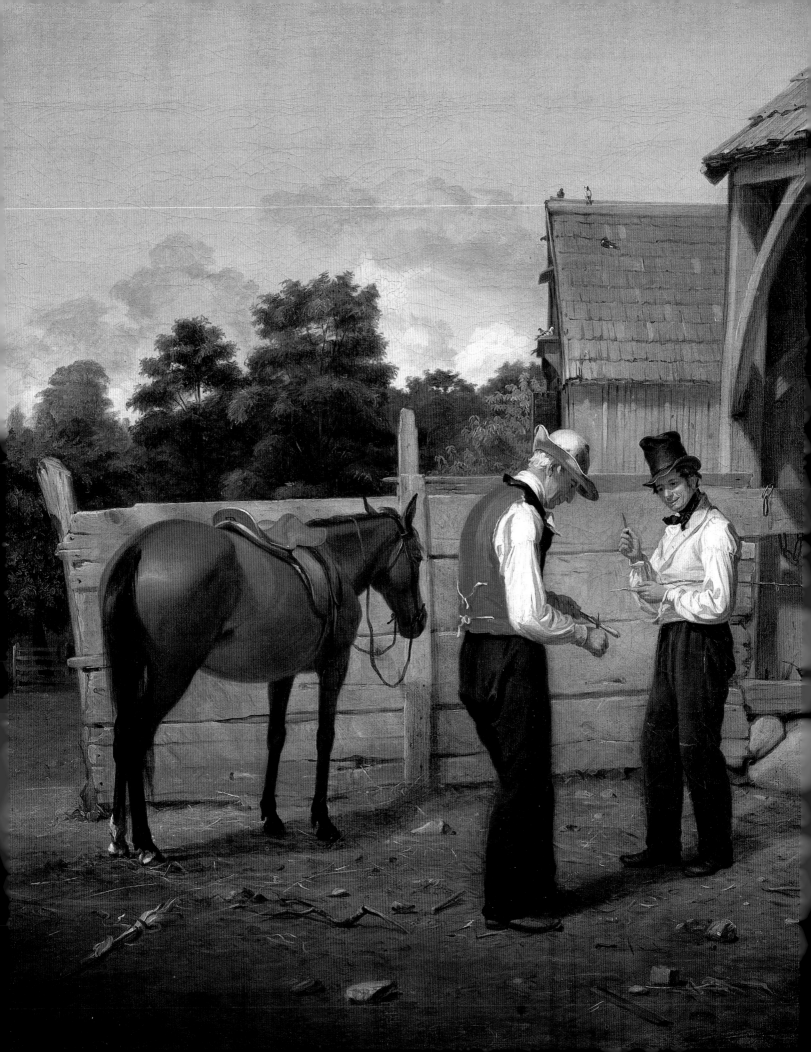

Franklin Kelly Mount's Patrons

During the second quarter of the nineteenth century, the years in which William Sidney Mount rose to prominence as America's leading painter of genre subjects, the collecting of art by Americans changed dramatically. As art historian Alan Wallach has shown in his studies of the patrons of Mount's friend, landscape painter Thomas Cole, there was a decisive move at that time away from the dominance of old-guard, aristocratic collectors and toward the patronage of an ascendant class of wealthy bourgeois merchants and businessmen.[1] Cole's arrival on the New York art scene in 1825 came at a moment when the elite—epitomized by men like Philip Hone, Giulian Verplanck, Charles Wilkes, and David Hosack—still retained a strong grip on cultural authority. But by the time of Cole's death in 1848, the rule of that class had been broken.[2] The full story of that collapse of power is, of course, complex and multilayered, but in this context I want to stress that the 1830s and 1840s, the key decades during which the shift largely occurred, were precisely the years in which Mount created the majority of his most acclaimed and admired works. These paintings appealed especially to a small group of patrons—both aristocratic and bourgeois—who were among the most important and influential cultural figures of the era. This essay will investigate some of the individuals who commissioned paintings from Mount and will examine the nature of their interactions with him.[3]

Art collectors were rare in colonial America, and the formation of substantial collections of paintings—particularly paintings by living American artists—was almost entirely a phenomenon of the first half of the nineteenth century.[4] To be sure, there were the exceptions, such as Thomas Jefferson, who assembled a large collection of paintings, including several by contemporary Americans. On the whole, however, John Singleton Copley's well-known complaint that his fellow colonials considered painting equivalent to "any other usefull trade . . . like that of a Carpenter tailor or shew maker, not as one of the most noble Arts in the World" was an apt assessment of the eighteenth-century context for art collecting.[5] But during the early nineteenth century a number of factors contributed to the development of significant art collections in the new republic. After the upheavals of the Revolution and the War of 1812, America enjoyed a relatively stable period during which important urban centers underwent substantial growth. Through commerce, land speculation, the development of industries and railroads, and other means, sizeable fortunes were made (not just inherited). And as the financial means to acquire art increased, so did the social pressures to do so.

In this new democratic society, collecting works of art, like owning property generally, became a prime way to establish and to advance one's social standing. Furthermore, many Americans who were proud of their own accomplishments and those of their young nation were sensitive to the fact that the country had not yet developed its own vital artistic culture. A number of widely read accounts of visits to the United States by foreigners, such as Frances Trollope, Harriet Martineau, and Alexis de Tocqueville, made precisely that point. Initially, the aristocratic elite claimed for itself the position of leadership in the encourage-

ment of the fine arts. The artist John Trumbull, who played an important role in advising patrons such as Daniel Wadsworth and Robert Gilmor, Jr., to support young American artists, summed up the situation in an address to the American Academy of the Fine Arts in New York in 1833: "It has been proved by all experience and, indeed, it is a truism, that the arts cannot flourish without patronage in some form; it is manifest, that artists cannot interchangeably purchase the works of each other and prosper; they are necessarily dependent upon the protection of the rich and the great."[6] Such patronage by "the rich and the great," of course, assumed a stable social order in which the aristocratic elite could comfortably inhabit the upper register while encouraging and supporting the efforts of artists who were deemed of lower social standing (with rare exceptions, like Trumbull).[7] The efforts of the patrons offered them multiple rewards: feelings of altruism and good citizenship, the acquisition of fine works of art, and honor and status among their fellow elites. For the artist, on the other hand, the rewards were principally income and prestige. But these were accompanied by all the drawbacks inherent in any system of aristocratic patronage.

The prime dangers of aristocratic patronage, from the point of view of the artist, were economic and social abuse and interference by the patron, usually in the form of paternalistic "advice" on style or content. Working for "the rich and the great" need not necessarily result in improper compensation, humiliation, and creative stifling, but the very fact that it might seemed increasingly intolerable in American democratic society. Early in his career Cole encountered just such a patron, who, according to Cole's biographer, Louis Legrand Noble, "lured him away by fine promises to the upper waters of the Hudson, there to toil, through the solitude of the cold months, for a person who had neither the mind to appreciate, nor the honesty to reward the ability he had entrapped into his service."[8] As Noble continued, "To this cruel injustice his heartless employer added the grossest insult. He caused his apartments to be rendered cold and cheerless, and not infrequently embarrassed, and mortified him at table. For the kind of picture which Cole delighted to paint he affected a contempt, and advised him to turn his pencil to the bullocks of his farm-yard."[9] Although Cole did fare better with other aristocratic patrons (especially Daniel Wadsworth, who was generally pleased with whatever he received, and Robert Gilmor, Jr., who may have offered incessant artistic advice but nevertheless provided essential economic support to the artist), he unquestionably felt more at ease with and more appreciated by merchants and businessmen such as Luman Reed, whom he considered "a true, a generous, and noble friend."[10]

The shift toward bourgeois patronage in the 1830s and 1840s did not change the patterns of collecting overnight. Not only did many members of the aristocracy continue to commission works of art during this period (Cole, for example, did major works for the Van Rensselaer and Stuyvesant families) but also, as Wallach has shown, the new patrons generally emulated the cultural proclivities of the old elite.[11] There were, of course, important differences: men like Reed, who had not grown up in cultured circumstances, lacked confidence in their own aesthetic judgments and were, therefore, often less inclined to impose their will on artists. They also tended to deal with artists as social equals. The changing patterns of patronage were also evident in the fortunes of New York's leading art institutions. The influence and prestige of the American Academy of Fine Arts, founded in 1802 and long favored by the

aristocracy, waned during the 1830s, while the rival National Academy of Design, organized in 1826 by artists dissatisfied with the American Academy and supported by wealthy businessmen such as Jonathan Sturges and Charles Leupp, flourished. From the beginning, the National Academy stood in direct opposition to the aristocratic idea of patronage. As an article from 1831 observed, "The individuals who have fostered and reared the Academy of Design have been threatened with the loss of patronage; they have been told that an Academy must be supported by gentlemen of fortune; and that artists are incapable of conducting an institution of the kind . . . the founders of the Academy are assailed . . . as fools for not pretending to yield to the possessors of wealth. . . . But the National Academy seeks no patron but the public."[12] The National Academy offered many advantages to its artist members, not the least of which were its annual exhibitions, which provided much-needed exposure for new works of art and a market for selling them. Thus, during the 1830s and 1840s, the National Academy helped artists escape "the paternalism of the patrician elite, while simultaneously avoiding a fall into the clutches of an aggressive democracy bent on denying the existence of privilege or distinction, whether economic or intellectual."[13]

How did these key cultural shifts affect the career of William Sidney Mount? Like Cole, Mount was in New York early on, first living with one of his uncles and then, by 1824, working as an apprentice in his brother Henry's sign-painting shop. But by 1827, Mount had returned home to Stony Brook. Thus, even though he maintained close ties with the art world in New York and returned there occasionally, Mount chose as his home base a place that was far removed, literally and emotionally, from America's rising cultural capital. Cole, on the other hand, remained in New York for the first several years of his career and, even after settling in Catskill in 1834, was frequently in the city and actively involved in artistic matters. Mount's separation from New York, from its art institutions and its patrons, was an important element in how he and his art were perceived and, equally, how he manipulated both his own image as an artist and his audience's understanding of his subject matter.

In 1828 Mount made his professional debut, showing *Christ Raising the Daughter of Jairus* (fig. 6) at the National Academy of Design's annual exhibition. No owner is listed in the catalogue and the work was presumably for sale. The following year he showed three works at the National Academy: *Crazy Kate*, 1829 (location unknown), *Celadon and Amelia*, 1829 (fig. 11), and *Saul and the Witch of Endor*, 1828 (fig. 8). All were listed "for sale," and at least one, *Saul and the Witch of Endor*, eventually found a buyer.[14] By 1829 Mount had begun painting genre subjects, presumably because his history paintings were not selling but perhaps also because he was aware of the increasing popularity of prints after such European genre painters as the Scotsman David Wilkie.[15]

From the first, Mount's genre paintings took their themes from the supposed simplicity and innocence of American rural life. *Rustic Dance After a Sleigh Ride*, 1830 (fig. 12), which Mount showed at the National Academy in the spring of 1830 and then again at a trade fair in New York that fall (where it won first prize in the art section), established what would become his basic repertoire of country types: yeoman farmers, young white women, and African Americans.[16] The painting was so well received that it seems to have established Mount's reputation as a genre painter virtually overnight. Although during the early 1830s

Mount devoted much of his work to painting portraits on commission, he always managed to have one or more genre pictures ready for the National Academy's annual exhibition or for display elsewhere. And the genre pictures gradually began to find buyers. *A Man in Easy Circumstances,* 1832 (location unknown), which "represented a 'loafer' lying asleep on a bench in front of a low groggery common to many Long Island towns," was purchased in 1833 by the picture framer Lewis P. Clover for $30, which was then considered "a good price for a picture."[17] Clover framed the picture, lent it to the 1833 exhibition of the National Academy, and then sold it for $100 to a New York merchant, who is reported to have said, "I intend to hang this in my parlor as a companion to my Teniers."[18] *Long Island Farmer Husking Corn,* 1833–34 (fig. 22), shown the following year at the National Academy, was purchased by the politician and businessman Gouverneur Kemble, who was well known in literary and artistic circles and who subsequently purchased two more pictures by the artist, *The Breakdown (Bar-room Scene),* 1835 (fig. 26), and *The Disappointed Bachelor,* 1840 (location unknown). There were more than a few other sales by Mount in these same years, but, more importantly, by the mid-1830s he had reached a new stage in his career and was beginning to receive direct commissions for paintings. Over the next decade and a half Mount enjoyed a steady demand for his pictures. In fact, the market for his works was so strong through the 1830s and 1840s that for much of the time he was simply unable to meet the demand.

Before moving on to consider the men who commissioned Mount's pictures, it is worth pausing for a few general observations about what it was that made his works so appealing. In the most general sense, genre paintings depict (or supposedly depict) the commonplace events of "everyday life," documenting for their audiences the social interactions of ordinary people. As such, they are particularly sensitive to and influenced by contemporary events far more than other types of painting, such as history painting, landscape, or still life. As art historian Elizabeth Johns has observed, "Genre painting might best be studied . . . as a systemic cultural phenomenon that develops in certain economic and social circumstances and meets social needs peculiar to a specific audience."[19] Artists, according to Johns, "typically produced genre paintings during times of great change, most prominently in the economic sphere."[20] Certainly, economic and social change was a constant throughout the nineteenth century in America, but developments in the 1830s and 1840s were especially dramatic because of the rise and fall of Jacksonian democracy.[21] As historians Christine Stansell and Sean Wilentz have observed,

> *The classic accounts of the Jacksonian era focus on a few great themes: the spread of political democracy, the settlement of new western territories, the rapid expansion of commerce and industry, and the ferment of humanitarian reform. Yet numerous paradoxes also cloud those triumphs: the exclusion of blacks and women from the democratic franchise; the displacement of American Indians; the growth of southern slavery amid celebrations of "the common man"; the economic and political inequalities that worsened with commercial growth; the outcries, from both ends of the political spectrum, that the nation, for all its newfound wealth, was lurching toward a social and moral catastrophe.*[22]

Such tensions and conflicts played out differently in different regions of the country, but the Northeast was particularly hard hit in certain ways. Rapid surges in population, especially in New York City, made the city more and more unlike the country. In these new urban environments, changes in the conduct of business, in the relationships between the sexes and the races, and countless other cultural transformations made individuals increasingly alienated from and mistrustful of those outside their own socioeconomic groups.[23]

How were Mount's works received during these tumultuous years? Our evidence comes largely from contemporary criticism, and it is remarkably consistent, as a few examples will make clear. Writing of *Long Island Farmer Husking Corn*, a critic for the *New York Evening Post* stated in 1834, "Mr. Mount is the only artist that we know of who has taken the rustic habits of this country as subjects for the *easel* . . . he has invested them with a charm that will prove a passport to the gallery of every man of taste."[24] This critic went on to observe that Mount's full-length portrait of Bishop Onderdonk, shown the year before, was proof that the artist was "capable of executing subjects of a higher class." In 1834 the *New-York Mirror* described *Country Lad on a Fence* as "very simple; merely a country lad sitting upon a fence on his way home after the labours of the day; waiting, perhaps, for some loitering companion—or it may be, listening in rapt suspense, to the rural music that floats upon the air in summer evenings; the tinkle of the distant cow-bell, the faint cawing of the homeward-journeying crows, the wild, but not unpleasing scream of the night-hawk, and the melancholy wailing cry of the whip-poor-will."[25] The writer concluded, "The painter, Mount, is fast and justly rising in the public estimation, and the day is not far distant when his rural scenes will be looked upon as treasures." In 1836 *Bargaining for a Horse*, 1835 (fig. 27), and *Undutiful Boys*, now called *The Truant Gamblers*, 1835 (fig. 28), were cited as evidence that the "genius of this artist is of a most eccentrick kind, delighting in the ludricous [sic] scenes of a rustick life."[26] In 1837 *Farmers Nooning*, 1836 (fig. 30), and *The Raffle*, now called *Raffling for the Goose*, 1837 (fig. 37), were characterized as "superb in design and execution; full of comic expression; and very carefully finished."[27] Mount was hailed in 1845 as "the most purely original and characteristic [o]f all of the painters America has produced. . . . He is a man of genius, and altogether unimpeachable in his peculiar field of labor. . . . His small pictures of American common life are among the finest things that we have ever produced in Art."[28] In 1848 *Caught Napping*, 1848 (fig. 59), and *Loss and Gain*, 1848 (fig. 60), were described as typical of "Mr. Mount's peculiar class of subjects, in which he has acquired such high reputation."[29] And, by 1851, it was noted that *Just in Tune*, 1849 (fig. 63), and *Who'll Turn the Grindstone?* 1851 (Museums at Stony Brook), were "sketches of American Life, in that style of which [Mount] enjoys almost a monopoly."[30]

Reviews such as these isolate what were surely the essential components of Mount's appeal. His works were admired for technical accomplishment and for a subject matter that was particularly (even peculiarly) his own; he had no real competitors. But what most distinguished his paintings were their rural subjects, which had "charm," because they were "simple," "eccentric," "common," "rustic," and "comic." In short, Mount's audience in the city perceived the people in his paintings as fundamentally different from themselves. They were from the country, and being from the country in this era when the urban and the rural were

fast becoming symbols of vastly different lifestyles implied being simple, unsophisticated, and given to comically silly acts. It meant being of a different—and unquestionably lower—class. This would have been plainly evident to those who wished to purchase or commission paintings by Mount, regardless of whether they were themselves aristocratic or bourgeois. Mount's rapid rise in popularity in the 1830s was a direct result of the way in which his paintings played to the sense of superiority and sophistication held by his urban audience. What Elizabeth Johns has observed of genre painting generally in pre–Civil War America is true of Mount's painting specifically, namely, that they "encouraged viewers to invest in social hierarchies, in their convictions that certain 'others' in the community were or should be revealed as deficient, and in their need to assert that a genuine community of warm feeling existed among (unequal) members of society."[31]

The matter of the "comic" and "rustic" character of Mount's subjects deserves further attention. As Americans struggled to come to terms with their national identity during the early decades of the nineteenth century, they increasingly came to identify, and subsequently celebrate, characteristics that seemed peculiarly or uniquely their own.[32] Many such characteristics—such as the American fondness for boasting and exaggeration or the tendency to use the English language in novel ways—were first pointed out pejoratively by European authors chronicling their travels in the new country. But in an act of swift cultural appropriation, American writers, actors, and others soon developed their own repertoire of native "types." Chief among these were the Yankees and country men of the Northeast, who were characterized as self-reliant, self-taught, prone to skepticism, and fond of making up words and phrases that suited the subject of the particular moment.[33] Lacking formal education and cultural sophistication, these types could be laughed at for their colloquial speech, their unfashionable dress, and the absurdity of their observations and actions. But they could also be admired for their independence, their stubborn refusal to be cowed or outsmarted by a higher culture, and their shrewdness and cleverness. In this way Americans could make a national virtue of their cultural deficiencies. Indeed, as art historian Joshua C. Taylor has pointed out, "It was this shrewd Yankee with his ill-fitting striped trousers, pinched tailcoat, and high hat, who would eventually be accepted as Uncle Sam. He took on many names . . . Jebadiah Homebred, Jonathan Plowboy, Soloman Swap, or Hiram Dodge."[34]

During the 1830s and 1840s, as the aristocracy and the bourgeois were competing for dominance in the world of American art, these comic characters managed to appeal to both camps. For the high-born connoisseur they were reassuring representatives of a lower and inferior social class, an American peasantry that by its very existence confirmed society's hierarchies. For those of new wealth, they were appealing not only because they could be perceived as social inferiors but also because their supposed shortcomings and deficiencies could themselves be admired as positive national traits. For a self-made merchant or businessman in New York to enjoy a good laugh at a comic figure in a genre painting (or in a play or a book) but then to feel a covert admiration for (and identification with) his self-reliance and ingenuity was to have it both ways. He could admire himself both as culturally sophisticated and as properly "American" in his fundamental good sense. William Sidney Mount was the first artist to perceive the market for paintings that satisfied these seemingly

divergent issues of taste, and he was by far the most successful at exploiting that market.

Mount's early experiences with patronage were more fortunate than were Cole's, for his first important patron was Luman Reed (1785–1836), whom he met around 1834.[35] Reed was born in rural New York to a farming family that eventually moved to Coxsackie and built a business around the storing and transporting of goods and foods. The younger Reed soon opened his own produce and freight business, and in 1815 he set up a store in New York. He prospered in the dry-goods trade and his business interests expanded rapidly. Considered by his contemporaries the very model of an honest, hard-working, straightforward self-made man, Reed had by 1832 amassed a fortune large enough to allow him to retire. He built a fine three-story house and set about filling it with art. Although he was initially attracted to European Old Masters, Reed soon began concentrating on works by contemporary Americans. The shift in his collecting was the result not so much of a disenchantment with European art as of a strong feeling of cultural nationalism: he believed that American artists were capable of creating works at least as good as those by their foreign counterparts. As he wrote to Mount in 1835, "[t]his is a new era in the fine arts in this Country, we have native talent + it is coming out as rapidly as is necessary."[36] And Reed's ambition was to have the finest collection of works by contemporary artists: "The fact is I must have the best pictures in the Country."[37] The artists who Reed was particularly interested in commissioning works from were Thomas Cole, Asher B. Durand (later famous as a landscape painter, but in the 1830s painting primarily portraits and literary subjects), George W. Flagg (a painter of historical and literary subjects), and Mount.

Reed's patronage of Cole is worth considering briefly here to provide a context for his relationship with Mount. Reed and Cole probably met around 1833, and Reed immediately commissioned a work from Cole, who was newly returned from a European trip (*Landscape Composition: Italian Scenery*, 1833, New-York Historical Society). Cole was eager to secure support for a planned five-part series of pictures and had already tried, with no success, to interest Robert Gilmor, Jr., in the project, no doubt because he thought it would only appeal to and be understood by a thoroughly educated connoisseur. Reed eagerly agreed to commission Cole's series *The Course of Empire*, completed in 1836 (New-York Historical Society). Moreover, from the first, he allowed Cole complete artistic freedom, insisting that he follow his own ideas and inclinations in completing it. Deeply appreciative, Cole wrote to his new patron, "your liberality has opened an opportunity, & I trust that nothing will now prevent me from completing what I have so long desired."[38] Reed acquired, both by commission and purchase, other works by Cole during this time, and doubtless would have continued to do so had he lived; he was equally supportive of Durand and Flagg.

Reed must have seen Mount's paintings on view at the National Academy, for in their earliest surviving correspondence he already indicated how strongly he admired the painter's work, "I feel as if your pictures were to be in the first rank of my Gallery of their kind as well as our friend Cole's in Landscape. Your truth of expression + natural attitudes are to me perfectly delightfull, and really every day Scenes where the picture tells the story are the kinds most pleasing to me and must be to every true lover of the Art."[39] Although it can be reasonably assumed that part of Reed's appreciation for Mount's subjects was based on nostalgia

for his own rural background, it would be wrong to conclude that he understood them only as uninflected transcriptions of reality. After all, Reed was already well familiar with works that operated on a serious intellectual plane, whether the allegorical landscapes of Cole or the literary and historical pictures of Flagg and Durand. And Reed seems to have understood immediately that Mount's pictures had meanings that went beyond their surface appearances. In 1835, having received *Bargaining for a Horse*, the first work he commissioned from Mount (and for which he paid $200), Reed wrote, "The subject 'comick' is a pleasing one + I would rather laugh than cry any time . . . you have hit off the character to a charm."[40] There is little doubt that Reed, given his own success in the world of business, would have appreciated Mount's distillation of the essentials of commerce into a single instance of "horsetrading." Whether he would, on the other hand, have fully grasped the intricate political message that Elizabeth Johns reads in the painting is more difficult to know, though he could easily have participated in working out its program, reveling in the complex series of puns and wordplays on Democratic politicking.[41] The very fact that Reed characterized Mount's work as "comick" clearly demonstrates that he understood the work as satirical, and that alone makes it entirely conceivable that he was instrumental in its conception.[42]

Even before he received *Bargaining for a Horse*, Reed had already apparently commissioned a second work from Mount, and, in fact, he attempted to convince the painter to paint solely for him. "I want you to write me when I may expect the next picture," he wrote in September 1835, "+ hope you will not take any commissions for any body until you paint a few more pictures for me."[43] Mount rather tactfully ducked this suggestion in a November letter to Reed: "I think your plan of getting original pictures a good one and I wish you success with all my heart. Your picture takes all my attention and I take pleasure in painting it."[44] Undaunted, Reed attempted to interest Mount in painting the panels for one of the doors to his picture gallery, forcing Mount to decline in no uncertain terms: "In one of your interesting letters I find you intend having your Gallery doors painted by different Artists and I am pleased you wish me to paint one of them. In consequence of my having commissions that must be attended to, I am sorry to say, I can not further your views at present."[45]

With this letter Mount sent his second picture to Reed, *The Truant Gamblers (Undutiful Boys)*, charging a price of $220. Although Reed initially pronounced himself pleased with the picture, he soon had second thoughts. Within two weeks of receiving it, Reed must have written or somehow communicated (no correspondence survives) to Mount that he wished the picture altered. This is the only known instance in which the collector requested a change in a commissioned picture.[46] Mount came to New York, retrieved the picture from Reed's house, and returned with it to his Long Island studio. Reed, with a touch of apprehension, wrote, "I miss the picture from the Gallery + shall be very happy when I see it placed there again. If there was any thing that could have made my attachment to you any stronger it was that generous and prompt proposition of yours to make the alteration in the picture that I suggested, that willingness to gratify me in an alteration when the painting was good enough + perfectly satisfactory without it."[47] That Reed felt compelled to ask for this change —completely uncharacteristically—suggests that Mount's work was the subject of particularly intense scrutiny by the collector. Mount's subject matter, one must conclude, was not

only something that Reed understood but also something about which he cared very deeply indeed.[48]

Reed's dealings with Mount make it clear that he would have ordered other pictures—perhaps many others—if he had not died unexpectedly in June 1836. Upon learning of Reed's death, Mount wrote, "How well he understood the feelings of the Artists."[49] By this time, however, Mount was already busily working on commissions from other patrons. Given the lack of documentation, we cannot be sure of the exact sequence of commissions Mount received in 1836 and 1837, but we do know that he painted *Farmers Nooning*, 1836 (fig. 30), for Jonathan Sturges (priced at $270), *The Raffle*, now called *Raffling for the Goose*, for Henry Brevoort, Jr. (priced at $250), and *The Tough Story*, now called *The Long Story*, 1837 (fig. 38), for Robert Gilmor, Jr. (priced at $224).[50] This list tells us that Mount was successful with both aristocratic and bourgeois patrons in the mid-1830s. Henry Brevoort, Jr., and Robert Gilmor, Jr., epitomized the aristocratic collector/connoisseur, while Jonathan Sturges, the young partner of Luman Reed, was the model merchant businessman.

Sturges (1802–1874) was born in Southport, Connecticut, tended sheep and worked other farm chores as a boy, but came to New York in 1821 to work as a clerk for Reed.[51] He eventually rose to prominence as one of the city's most respected businessmen. After Reed's death, Sturges took up art collecting where his mentor had left off. He closely followed Reed's example, commissioning and acquiring works by many of the same artists. He ordered a picture from Mount almost immediately following Reed's death, though there is no surviving correspondence to indicate the nature of the commission or whether Sturges gave Mount any guidance regarding the painting's subject. That Sturges was greatly pleased with the work he received, *Farmers Nooning*, is, however, made clear in his letter to Mount of December 14, 1837: "I was sitting opposite the 'Farmers Nooning' *last evening* and enjoyed myself so much I really felt quite anxious to get a peep at some other scene in the same line, and I determined I would write you to day and ask you if I could not be gratified soon."[52] But, as was increasingly the case during the late 1830s, Mount already had too many orders for pictures to allow him to take on this new one from Sturges. In February 1839 Sturges wrote again, requesting a specific type of picture: "I am desirous of having a picture from you to match the one you painted for me—I should prefer an interior. Perhaps you may have a subject in your mind that might be connected with the first picture and still be an *interior* scene. I should not object to a *kitchen* scene. I merely throw out the above hints to give you something of my views, without intending to restrict you to any particular subject."[53] Interestingly, two years later, Sturges did purchase an interior scene, but it was by Francis Williams Edmonds, perhaps the only other American genre painter working in the 1830s and 1840s who offered any real competition for Mount. That picture, *The Bashful Cousin*, ca. 1841–42 (National Gallery of Art), may well have served for Sturges as the companion to *Farmers Nooning*.[54] In 1842, when Mount finally supplied the second picture to Sturges, *Scene in a Long Island Farm-Yard*, now called *Ringing the Pig* (fig. 47), it was, in fact, an exterior scene. Sturges must nevertheless have been pleased with the painting, for he gave Mount $300, which was $30 more than the asking price. Sturges secured a third picture from Mount in 1851, *Who'll Turn the Grindstone?* again enduring a considerable delay; "I thank

you for waiting so patiently for your picture," the artist wrote to the collector in March 1851.[55] Later that same year Mount summed up his feelings for Sturges in a toast given at the annual dinner of the National Academy of Design: "Since the death of Luman Reed, no man in this city, holds a more prominent place in the affections of artists & the public, than . . . Jonathan Sturges. He has apartments richly decorated with paintings, and busts, by native artists, and I believe, has but *one mirror*, which reflects well his taste—He reminds me of some of our good, old farmers, I know him to be one, by the fact, that I have *sanded his rifle*, *rung his* hogs, and *turned* his grindstone."[56]

Henry Brevoort, Jr. (1791–1874) inherited an enormous and extremely valuable estate on Manhattan and led a comfortable life of leisure. He involved himself in literary and artistic circles and was a lifelong friend of the writer Washington Irving.[57] He was also acquainted with other aristocratic patrons of the arts, including Robert Gilmor, Jr. His preferences in art tended toward the Old Masters, although he did own some works by Americans, including the sculptor Horatio Greenough, from whom he commissioned several "Chimney Pieces" in 1837.[58] As Johns has shown, the painting Brevoort commissioned from Mount, *Raffling for the Goose*, functioned beyond its "everyday" reality as a warning against the dangers of engaging in speculation rather than honest, hard work.[59] Real-estate speculation was especially rampant in New York and elsewhere in the 1830s; those few who got lucky stood to make a great deal of money, but the many who were not so fortunate risked financial ruin. Even though Brevoort was no stranger to speculation, reckless risk taking in the real-estate market must have seemed like a threat both to himself and his family and to the very stability of Amer-ican society and class structure. As with Luman Reed's insight into the political undertones of *Bargaining for a Horse*, Brevoort must surely have understood and approved of the cautionary message in *Raffling for the Goose*. What we do not know, however, is whether the subject was his suggestion or Mount's, because no correspondence concerning the commission has survived.

Like his friend Brevoort, Robert Gilmor, Jr. (1774–1848) of Baltimore was also born to a wealthy family. Having inherited his father's profitable shipping business, he substantially expanded it and his personal fortune. Well educated and well traveled, Gilmor was one of the most knowledgeable collectors in America during the first half of the nineteenth century. The collection he formed was extremely wide-ranging, embracing European Old Master paintings, decorative arts and sculpture, manuscripts, and contemporary American paintings.[60] Like other aristocratic collectors, he felt he could play a positive role in the development of art in the United States by supporting artists he deemed worthy; he also clearly enjoyed interacting with them, corresponding with them, and critiquing their works. Gilmor had a particular fondness for landscape painting, and was an early patron of the pioneering American landscape painter Thomas Doughty, to whom he gave a number of commissions. He also was an early supporter of Cole, from whom he commissioned four pictures.

Although it is sometimes said that Gilmor first learned of Mount's work by visiting Reed's gallery and seeing *Bargaining for a Horse* and *The Truant Gamblers* in 1836, in fact, he had by then already acquired Mount's *Country Lad on a Fence (Boy on a Fence)*, 1831 (location unknown).[61] In any event, by August 1836, Gilmor had commissioned from Mount a

picture of "cabinet size the subject left entirely to [the artist's] own fancy."[62] Mount told Gilmor that he would get to the picture as soon as he could, but that he was engaged with other commissions; almost a year later he admitted that he had not even started it, but promised to "in a few days."[63] Finally, in late November 1837 Gilmor received his painting, *The Long Story*, for which he paid a total of $224 ($200 for the painting, $22 for the frame, and $2 shipping). As was usual with him, Gilmor immediately wrote to the artist, offering his opinion of the picture and, it seems (Gilmor's letter is lost), offering his interpretation of it. Mount replied in a well-known letter that he was "happy to find with but a slight difference your impressions of my intentions are what I intended them." He then proceeded to offer his own description of the painting, identifying each of the people in the scene and explaining their significance.[64]

Gilmor, like other members of his social class, was proud of the role he felt he was playing in the encouragement of American-born artists. However, by the late 1830s and early 1840s, tensions between old aristocratic patrons and the increasingly powerful bourgeois collectors were building, and men like Gilmor began to see themselves cast as embodiments of all that was wrong with the traditional system of patronage. In 1844 the *New York Herald* published an article that spoke glowingly of the philanthropic spirit of Benjamin Coleman Ward, a Baltimore businessman who was compared as a patron to Luman Reed and Edward L. Carey of Philadelphia.[65] In the same article, Gilmor was characterized as one who did not open his house and collection to artists and other interested parties and who had obtained his pictures not by paying fair prices but by "haggling with the artist, or by an attempt to exchange some worthless daub." Incensed, Gilmor wrote a long letter to a friend and business associate in which he vehemently defended his reputation as a collector: "This was the reward for patronising when no one else in their native city would do it. Cole, Weir, Mount, Ingham, Inman, Dunlap, Trumbull & to all of whom I could refer to show that I had paid them large sums in advance & told them to paint me a picture *such as they care*."[66] Citing several specific examples, Gilmor included Mount, "whose first pictures of the boy getting over the fence I bought in the presence of Trumbull at the academy, when it was left alone unsold, because I had discovered merit in the *boy's painter* as he was then, & afterwards sent him 200 D. to paint what he pleased." Gilmor had reason to protest, because, certainly in the case of Mount and numerous other artists whose work he collected, the records show that he paid prices that were perfectly in line with those paid by other patrons. Moreover, he often allowed painters to paint subjects of their own choosing for him, as he had done with Mount. Gilmor clearly hoped that other prominent aristocrats with influence in cultural circles, such as Philip Hone of New York, would help vindicate him, but what Gilmor doubtless could not know was that the tide had turned against him and others of his class.

As we have seen, Mount had through these years managed to satisfy commissions from both aristocratic and bourgeois patrons, and that pattern would continue in the 1840s. In 1838 he received the first of what would ultimately be four commissions from the Philadelphia book publisher Edward L. Carey (1805–1845).[67] Although Carey was born to wealth (his father had emigrated from Ireland to Philadelphia in 1784 and founded the family's successful publishing business) and well connected in artistic and literary circles, his interest in collecting art developed from a different perspective than that of traditional aristocratic patrons.

Influenced by the taste of his father and that of his brother-in-law, the American painter Charles Robert Leslie, who was then living and working in London, Carey acquired a number of important English pictures. But he also firmly believed in promoting the work of contemporary American artists, and early on he realized that his publishing firm could play an important role. Given his literary background, it is hardly surprising that Carey was drawn to works with a storytelling or narrative focus. He especially liked genre paintings, which were ideally suited for use as illustrations in "gift books," one of the mainstays of his publishing business. These illustrated volumes of short stories and poetry generally came out at Christmas time and were enormously popular in nineteenth-century America; Carey's annual, *The Gift*, was one of the most admired of them all. For its illustrations he had engravings made from works in his own collection and from those of other collectors, and he often commissioned stories to embellish them.

Carey was almost certainly aware of Mount's work quite early. In *The Gift for 1840* (published in 1839) two works by Mount were included: *The Painter's Triumph* (fig. 41), which had been painted for Carey, and *Bargaining for a Horse*. Carey was eager to continue the relationship with Mount; in December 1839 he sent the artist a copy of the gift book and wrote, "We have just concluded to publish a volume next year + should like much to have an illustration for. Sir—Have you any pictures on hand which you could loan us or could we obtain one from any of your friends?"[68] Although Carey hoped to secure *Catching Rabbits* or *Boys Trapping*, 1839 (fig. 43), which Mount had just exhibited at the National Academy, he was unsuccessful. Not until the publication of *The Gift for 1842* were works by Mount once again included, this time Gilmor's *The Long Story* and Brevoort's *Raffling for the Goose*. In 1843, having failed to obtain the rights to engrave *The Truant Gamblers* from Luman Reed's estate, Carey commissioned a variant from Mount called *Boys Hustling Coppers*, originally called *The Disagreeable Surprise*, 1843 (fig. 50), which appeared in *The Gift for 1844*. Carey next ordered *The Dead Fall*, originally called *The Trap Sprung*, 1844 (fig. 45), a winter scene related to *Catching Rabbits*, and used it in *The Gift* in 1845. He apparently liked *The Dead Fall* so much that he commissioned a companion painting, *Bird Egging* (Museums at Stony Brook), which represented a summer scene.

Charles Augustus Davis (1795–1867), who in 1839 commissioned from Mount the *Catching Rabbits* that Carey so admired, was a wealthy New York merchant, newspaperman, and humorist. A staunchly conservative Whig and member of New York's aristocratic elite, Davis was also the author (as the fictional J. Downing) of a widely read series of humorous anti-Jackson letters published in the New York *Daily Advertiser* beginning in 1833.[69] Written in affected country language and employing homespun metaphors, Davis's letters managed to analyze complex contemporary social and political events in a way similar to what Mount had already done in such paintings as *Bargaining for a Horse* and *Raffling for the Goose*. In fact, *Catching Rabbits* has been read by Johns as making a visual and verbal pun on the Whig Party's successes in converting (trapping) voters. That it was commissioned by Davis, a prominent Whig (although, once again, no evidence survives to tell us how the commission came about) suggests that its satire cut across party lines as an "ironic assessment of politics . . . aimed at the whole system."[70] Although no contemporary reviewers commented

on that aspect of the painting's meaning, at least one took the opportunity to chide Mount for not producing more pictures: "We are only sorry that we have not more pictures by this admir-able artist, in his peculiar walk of art. May we not hope to see an evidence of greater industry in this gentleman, at the next exhibition of the Academy?"[71]

Certainly the political content of *Cider Making*, 1841 (fig. 46), the second painting that Mount executed for Davis, would have been all but impossible to miss. As has been painstakingly demonstrated, this elaborate work was conceived as an allegory of the American presidential campaign of 1840, and was fully explained as such in an article published in the *New York American* in 1841, the year Mount executed the painting.[72] Once again, however, no evidence exists regarding the actual circumstances of the commission. This is particularly frustrating, for, in spite of Davis's own staunchly conservative Democrat/Whig views, the painting can be read both as celebrating the victory of Whig presidential candidate William Henry Harrison and criticizing his party's questionable campaign tactics. Perhaps, as in *Catching Rabbits*, the overall ironic tone of *Cider Making* was meant to cut across party lines and to constitute a general satire of American democracy. Certainly Davis, whose J. Downing letters express a thoroughgoing disrespect for the whole political system and for the intelligence of general citizens, may well have found the meaning of *Cider Making* comforting to his own sense of moral, social, and intellectual superiority.[73]

Although the general pattern we have seen in Mount's patronage thus far—that it was spread between both old and new money and embraced both sides of the political fence—held true into the mid-1840s, he increasingly created his most important works for wealthy bourgeois patrons. Charles Mortimer Leupp (1807–1845), one of the artist's most significant backers in these years, came from a background very similar to that of Luman Reed and Jonathan Sturges.[74] Like them, he was considered by his contemporaries to be an ideal self-made man; hard working and honest, he was also generous in his support and encouragement of others. Leupp was born in Brunswick, New Jersey, and came to New York at an early age to apprentice in the leather business. He prospered in the business world, eventually serving as a director of the New York and Erie Railroad and on the board of directors of two banks. In the 1840s and 1850s he was very wealthy, and his elegant house at Twenty-fifth Street and Madison Avenue was considered one of the city's finest. He formed a large art collection consisting primarily of works by American artists, with only about one third of the paintings by Europeans. In quality and scope Leupp's collection in many ways prefigured the enormous holdings that would be formed by New York's merchant princes in the second half of the nineteenth century. His collection gathered together from historical scenes, such as Emanuel Leutze's *Mrs. Schuyler Burning Her Wheat Fields on the Approach of the British*, 1852 (Los Angeles County Museum of Art); landscapes, such as Thomas Cole's *The Mountain Ford*, 1846 (Metropolitan Museum of Art), and John F. Kensett's *The Upper Mississippi*, 1855 (St. Louis Art Museum); and genre and literary subjects, such as Francis Edmonds' *Facing the Enemy*, 1845 (Chrysler Museum) and *Gil Blas and the Archbishop*, 1849 (private collection). According to an article published just after his death, "the patronage bestowed by Mr. Leupp on American art was as judicious as it was generous. He strove to realize the capacity of native painters to illustrate the brilliant scenery and rich physical life of the land, and suc-

ceeded in grouping within a select circle, as many charming and characteristic pictures as are to be found, perhaps, in any gallery extant."[75] Like his close friend Sturges, Leupp also knew many of the artists represented in his collection personally and enjoyed socializing with them.[76]

We do not know precisely when Leupp ordered his first painting from Mount, but, as was the case with other patrons, he apparently had to wait a considerable time. In March of 1845 the painter wrote to Leupp, "I am pleased to say that the order you so kindly gave me, has interested my feelings for some time. You have waited with great patience and I sincerely hope that the picture will have sufficient merit to pay you for the delay."[77] Mount also told the collector that he was hoping to exhibit the painting at the upcoming National Academy of Design exhibition. Leupp replied that he was glad that Mount had not forgotten him and that he would have no objection to the work being exhibited. The resulting painting, *Dance of the Haymakers*, 1845 (fig. 51), is justly considered one of Mount's finest. Leupp was obviously pleased, for as Mount recorded in his autobiographical notes: "He generously paid me twenty five dollars more than my charge."[78] The collector also ordered for his mother-in-law, Isabella Williamson Lee, a companion painting from Mount, *The Power of Music*, 1847 (fig. 52). Mount recorded Leupp's reaction to the new painting: "He stood a long time looking at it until I began to think I had made a failure, & observed to him, If you think this picture will not suit Mrs. Lee, I will paint her another with pleasure— 'Why man,' he said, 'I only wish the picture belonged to *me*.' When I mentioned to him the price, he said it was not enough, and generously gave me twenty five dollars more than my charge."[79] Leupp was apparently able to keep the picture for at least a time in his own possession, for it is recorded as being in his gallery in an article written in 1856.[80] Before his untimely death in 1859, Leupp would acquire another painting by Mount, *The Banjo Player*, 1856 (fig. 69), which had been painted for William Schaus.[81]

George Washington Strong (1783–1855), a prominent New York lawyer whose family had a long history in the Setauket area of Long Island, had his portrait painted by Mount in 1844. He also commissioned two genre pictures from Mount in the 1840s. Both *Eel Spearing at Setauket*, 1845 (fig. 55) and *Caught Napping* were, according to Mount, based on Strong's "recollections of early days."[82] *Eel Spearing*, in fact, represents the Strong family estate in the background. Mount based *Eel Spearing* on his patron's own apparently treasured childhood memory, so it is not surprising that the painting is devoid of the "comic" tone so often present in his work.[83]

In 1847, the same year that he received Leupp's commission for *The Power of Music*, Mount also had an order from the American Art-Union, which purchased works for its annual distribution by lottery. As the patterns of patronage shifted in American during the 1840s, the Art-Union increasingly became an important source of financial support for many artists. But Mount had a low opinion of it. As he wrote in 1848, "I have never sold but two pictures to the Art-Union, and was beat down in my price on one of those . . . The Art-Union does not give orders this year, but intend to buy pictures at low *prices*—to grind the Artist down. I am convinced that such a system will in the end produce poor pictures, and the insulted public (that pay their personal subscription of membership, *five dollars*) will inquire why they, and

the artist are not better treated."[84] Until its demise in the early 1850s, the Art-Union was an important springboard for the careers of many artists, but Mount was not one of them.

In fact, by the late 1840s Mount was unable to keep up with the orders he already had for pictures, not so much because of their numbers, but because he was often incapable of working. As he noted in 1848, "I have often spent days, & weeks, and months without painting. There is a time to think and a time to labour. My health would never allow me to bone down to labour a great while at one time."[85] To be sure, he did manage to create some notable works during the late 1840s and early 1850s and even into the 1860s. There were, for example, *Turning the Leaf* (Museums at Stony Brook), a small picture painted in 1848 for the wealthy New York art collector and bibliophile James Lenox (1800–1880); *California News* (fig. 62) of 1850, one of two pictures commissioned by Thomas McElrath (1807–1888), the copublisher with Horace Greeley of the *New-York Daily Tribune*; Sturges's *Who'll Turn the Grindstone?* painted in 1851; and *Catching Crabs* (fig. 80) of 1865, one of several paintings done for the New York carriage manufacturer Charles B. Wood (dates unknown). But by the early 1850s Mount's most important work as a painter of multifigure genre scenes was behind him. Other painters of genre subjects such as George Caleb Bingham were mining rich new territory in their depictions of the characters of the American frontier, and landscape painters were increasingly winning favor from both collectors and the public.[86] Mount's "comic" pictures, with their lowly Long Islanders and their barbed political humor, were more and more out of fashion. During the years in which aristocratic and bourgeois patrons contested for dominance in the world of American art, Mount's art had successfully functioned by addressing issues and concerns that were pertinent and relevant to both groups. But by the 1850s, with the aristocracy in retreat, increasing numbers of wealthy bourgeois collectors were causing pronounced shifts in American artistic tastes.

Although the regrettable lack of full documentation concerning Mount's interactions with his patrons of the 1830s and 1840s makes it impossible to draw firm conclusions, certain general observations are supported by the available evidence. It is clear that Mount managed to appeal to a wide-ranging group of collectors, aristocratic and bourgeois, conservative and liberal. But, with very few exceptions, those who bought his pictures all lived in cities, and primarily in New York. Mount, of course, lived and worked most of his career in Stony Brook, and he was perceived by his patrons as thus having a close association with and understanding of the people he painted. The painter encouraged such thinking by referring to himself as a country boy (when, in fact, he had spent much of his early life in the city) and by affecting country-style language and sayings. He continually resisted the temptation to leave Long Island and, in fact, traveled relatively little. Even though collectors such as Reed and Sturges offered to pay for Mount to travel and study in Europe, he refused, fearing he would lose what he called his "nationality."[87] Clearly Mount recognized that a crucial ingredient in his success was his subject matter, which, as reviewer after reviewer pointed out, was particularly his own. By staying in Stony Brook he maintained the monopoly while it lasted, even though he was single-handedly unable to keep up with the demand for his pictures. Also, it would seem that the prices Mount asked for his works were relatively modest. Several times, as we have seen, patrons actually felt compelled to pay him more than his given price.

And certainly in comparison to Cole, who by the mid- to late 1830s was receiving as much as $500 for pure landscapes and much more for his imaginary pictures, Mount's prices do seem low.

But what most clearly emerges from any consideration of Mount's patrons is that during the two decades or so that he was most active as a genre painter he attracted the interest of a very high percentage of the relatively few serious collectors of contemporary American paintings. The names of men such as Reed, Sturges, Gilmor, Brevoort, Carey, and Leupp loom large in the history of collecting in pre–Civil War America. From differing social and economic backgrounds, these men were among the most discerning judges of artistic quality of their day. So far as we can tell from the surviving evidence, Mount did relatively little to promote himself or bring his work to these collectors' attention, beyond showing regularly at the National Academy of Design. That they wanted pictures by Mount, that they were willing to wait for them, and that they were often perfectly happy to let him choose his own subjects are all testaments to the high measure of respect that these patrons reserved for him. The history of art may abound with examples of painters who were little appreciated by their contemporaries and whose works seldom found buyers, but in the case of William Sidney Mount precisely the opposite was true.

Notes

The abbreviation MSB denotes the collection of The Museums at Stony Brook, Stony Brook, N.Y.; NYHS denotes the collection of the New-York Historical Society, New York, N.Y.; and NYPL denotes the collection of the New York Public Library, New York, N.Y.

1. See, most recently, Wallach's essays in William H. Truettner and Alan Wallach, eds., *Thomas Cole: Landscape into History*, exh. cat. (Washington, D.C.: National Museum of American Art, 1994); see also Alan Wallach, "Thomas Cole and the Aristocracy," *Arts Magazine* 56 (November 1981): 94–106.

2. Treuttner and Wallach, *Thomas Cole*, p. 34.

3. Although much has been written on American genre painting generally, and on Mount particularly, relatively little scholarly attention has been paid to specific issues of patronage. Elizabeth Johns's important study *American Genre Painting: The Politics of Everyday Life* (New Haven: Yale University Press, 1991), although primarily focused on the meanings of paintings by Mount and others, does in several instances consider the social and political concerns of individual patrons. In preparing this essay I have been guided by Johns's observations about Mount and his patrons, in particular, as well as more generally by Alan Wallach's work on Cole. I am grateful to Laurette E. McCarthy, for assisting me with research.

I have chosen to focus here only on selected individuals known to have *commissioned* genre paintings from Mount. An appendix included at the end of these notes gives a list of all the individuals known to have been first owners (whether through commission or purchase) of genre paintings by Mount.

4. On the general history of collecting in America, see W.G. Constable, *Art Collecting in the United States of America: An Outline of a History* (London: Nelson Publishers, 1964); Lillian B. Miller, *Patrons and Patriotism: The Encouragement of the Fine Arts in the United States, 1790–1860* (Chicago: University of Chicago Press, 1966); Neil Harris, *The Artist in American Society: The Formative Years, 1790–1860* (New York: George Braziller, 1966); Frederick Baekland, "Collectors of American Painting, 1813 to 1913," *American Art Review* 3 (November–December 1976): 120– 66; and Wayne Craven, "Introduction: Patronage and Collecting in America, 1800–1835," in Ella M. Foshay, *Mr. Luman Reed's Picture Gallery: A Pioneer Collection of American Art* (New York: New-York Historical Society, 1990), pp. 11–18.

5. Copley to Benjamin West or Captain R. G. Bruce (?), in Gurnsey Jones, ed., *Letters and Papers of John Singleton Copley and Henry Pelham* (Boston: Massachusetts Historical Society, 1914; 1972), pp. 65–66; quoted in Emily Ballew Neff, *John Singleton Copley in England,* exh. cat, (Houston: Museum of Fine Arts), 1995, p. 12.

6. Quoted in Charles E. Baker, "The American Art-Union," in Mary Bartlett Cowdrey, *American Academy of Fine Arts and American Art-Union* (New York: New-York Historical Society, 1953), p. 95; see also Constable, *Art Collecting*, p. 3.

7. See the discussion in Treuttner and Wallach, *Thomas Cole*, pp. 33–34.

8. Louis L. Noble, *The Life and Works of Thomas Cole* (1853), ed. Elliot S. Vesell (Cambridge, Mass.: Harvard University Press, 1964), p. 37. For an account of Cole's encounter with this man, George William Featherstonhaugh (1780–1866), see Ellwood C. Parry III, *The Art of Thomas Cole: Ambition and Imagination* (Newark: University of Delaware Press, 1988), pp. 28–30, 34. As Wallach has pointed out, William Cullen Bryant in his *Funeral Oration Occasioned by the Death of Thomas Cole* (New York, 1848), pp. 12–13, seized upon this unfortunate episode as epitomizing the evils of aristocratic patronage.

9. Noble, *Thomas Cole*, p. 34.

10. Quoted in ibid., p. 163.

11. Treuttner and Wallach, *Thomas Cole*, p. 38.

12. T., "The Progress of the Arts in Our Country," *New York Evening Post*, May 9, 1831.

13. Thomas Bender, *New York Intellect* (New York: Alfred A. Knopf, 1987), p. 130; quoted in Treuttner and Wallach, *Thomas Cole*, p. 38.

14. Mount sold the picture to the naval officer Theodorus Bailey for $20. In October 1852 Bailey commissioned a portrait of himself from Mount. In December of that year, Bailey wrote to Mount, "The Painting of the Witch of Endor raising Samuel which I purchased of you some years since has to me a peculiar value as one of the early fruits of your Genius. But I would like to have from you an account of your first efforts at

drawing, Colouring, Shading + Painting. What induced you to turn your attention to Historic painting. The History of the painting in my possession with a narrative of the circumstances, trials, troubles, advantages + disadvantages + encouragements which you met with in painting this one of your earliest pictures, + why you abandoned the Historic Style for the one in which you have become so eminent. In short I want a brief history of your life as connected with painting." Theodorus Bailey to William S. Mount, December 28, 1852, MSB. Mount not unreasonably declined, replying in his best affected country style language: "Now Capt. that is asking a little too much—why it would take me three months to shell it all out—to clean the cob all off, and who would feed me with pudding & milk all that while." William S. Mount to Theodorus Bailey, January 5, 1852[3], MSB.

15. Johns, *American Genre Painting*, p. 24.

16. Ibid., p. 25.

17. T. B. Thorpe, "New-York Artists Fifty Years Ago," *Appleton's Journal* (May 25, 1872), p. 574.

18. Ibid. The allusion is to the popular seventeenth-century genre painter David Teniers the Younger (1610–1690).

19. Johns, *American Genre Painting*, p. xi.

20. Ibid., p. xii.

21. A useful summary of this period is found in Christine Stansell and Sean Wilentz, "Cole's America," in Truettner and Wallach, *Thomas Cole*, pp. 3–21.

22. Ibid., p. 4.

23. Ibid., p. 10.

24. "National Academy of Design, No. 4," *New York Evening Post*, June 3, 1854.

25. "The Picture of a Boy on a Fence," *New-York Mirror* 12, no. 18 (November 1, 1834).

26. "National Academy of Design," *New York Evening Post*, May 25, 1836.

27. "The National Academy," *New-York Spectator*, May 18, 1837.

28. "The Fine Arts. The Art Union Pictures," *Broadway Journal*, January 18, 1845, p. 36.

29. "National Academy of Design. Twenty-third Annual Exhibition," *New York Evening Post*, June 21, 1848.

30. "The Festival of the National Academy," *New York Evening Post*, April 7, 1851.

31. Johns, *American Genre Painting*, p. xiii.

32. My discussion here is indebted to Joshua C. Taylor's *America As Art*, exh. cat. (Washington, D.C.: National Collection of Fine Arts, 1976), esp. "The American Cousin," pp. 37–94; and his *The Fine Arts in America* (Chicago: University of Chicago Press, 1979), esp. "An American Mythology and a Colloquial Art," pp. 66–81.

33. Taylor, *The Fine Arts*, p. 69.

34. Ibid., p. 70.

35. Reed's activities as a collector of American painting have been extensively discussed. See, most recently, Foshay, *Mr. Luman Reed*, and "Luman Reed, A New York Patron of American Art," *Antiques* 138 (November 1990): 1074–85; Wayne Craven, "Luman Reed, Patron: His Collection and Gallery," *American Art Journal* 12 (Spring 1980): 40–59; and Russell Lynes, "Luman Reed, a New York Patron," *Apollo* 107 (February 1978): 124–29.

36. Luman Reed to William S. Mount, November 23, 1835, MSB.

37. Luman Reed to William S. Mount, September 24, 1835, MSB.

38. Letter of September 18, 1833, Thomas Cole papers, New York State Library, Albany; quoted in Foshay, "Luman Reed," p. 1079.

39. Luman Reed to William S. Mount, July 25, 1835, MSB.

40. Luman Reed to William S. Mount, September 24, 1835, MSB.

41. Johns, *American Genre Painting*, pp. 28–33.

42. Certainly Reed was soon perfectly well aware of a political reading of the painting, for an article in the *New-York Gazette* published the month after he received the picture made the connections specific. Reed sent the

article to Mount, saying that it "hits it exactly." Luman Reed to William S. Mount, October 29, 1835, Louise Ochers Collection. Mount replied that he was "perfectly delighted with his [i.e., the writer's] conception." William S. Mount to Luman Reed, November 12, 1835, Louise Ochers Collection.

43. Luman Reed to William S. Mount, September 24, 1835, MSB.

44. William S. Mount to Luman Reed, November 12, 1835, Louise Ochers Collection.

45. William S. Mount to Luman Reed, December 4, 1835, Louise Ochers Collection.

46. See Foshay, *Mr. Luman Reed*, p. 170.

47. Luman Reed to William S. Mount, December 26, 1835, MSB. Reed went on to say, "I suppose you took fast hold of my good feelings. If the alteration when made does not please you I hope you will restore it to its original state and send it back again."

48. The only evidence concerning Mount's alterations to *The Truant Gamblers* is found in Reed's letter to the artist of January 11, 1836 (MSB), in which he expresses his satisfaction with the results: "I have now one live Man, four live Boys, the inside and outside of a Barn with the Barn door nearly swung back, + what is left for the imagination, is really pleasing that the hens + chickens have all run under the Barn, at the approach of the old man, + you may easily imagine them there." Luman Reed to William S. Mount, February 29, 1836, MSB. Reed sent Mount an additional $50 in payment for the alteration.

49. William S. Mount to Asher B. Durand, June 13, 1836, NYPL.

50. In 1836 Mount also painted *Courtship* or *Winding Up* (fig. 29) for John Glover of Fairfield, Connecticut (priced at $200). Little is known about Glover's activities as a collector, but the fact that he was the president of the American Academy of Fine Arts from 1828 to 1835 and its treasurer in 1830 suggests that his tastes and sympathies would have most likely been aligned with the aristocracy (see Cowdrey, *American Academy*, p. 165).

51. On Sturges and his collecting, see "Our Private Collections, No. II," *The Crayon* 3 (February 1856): 57–58; Benson J. Lossing, *History of New York City* (New York: 1884), pp. 618–19; Joanne August Dickson, "Patron-age of Nineteenth-Century American Painters: Jonathan Sturges and His Associates," unpublished paper, 1973; copy in curatorial files, National Gallery of Art, Washington, D.C. Also useful is *Complimentary Dinner to Jonathan Sturges* (privately printed, 1868), which includes testimonials to Sturges and a personal reminiscence of his life in business.

52. Jonathan Sturges to William S. Mount, December 14, 1837, NYHS.

53. Jonathan Sturges to William S. Mount, February 22, 1839, MSB.

54. On the Edmonds, see John Davis's entry in Franklin Kelly, et al., *American Paintings of the Nineteenth Century, Part I (The Collections of the National Gallery of Art Systematic Catalogue)* (Washington, D.C.: National Gallery of Art, 1996), pp. 189–96. Sturges purchased a second painting by Edmonds, *Stealing Milk* (location unknown) in 1843.

55. William S. Mount to Jonathan Sturges, March 14, 1851, NYHS.

56. Mount, in a "memorandum" to himself on April 6, 1851 (NYHS), recalling the events of the previous evening. The artist was making wordplays based on the three paintings he had done for Sturges (a "rifle" in this instance being the scythe sharpener employed by one of the figures in *Farmers Nooning*).

57. On Brevoort, see *Appleton's Cyclopedia of American Biography*, vol. 1 (New York: 1888), p. 369; and "Famous New York Families; XXXVII—The Brevoorts," *New York Evening Post*, November 2, 1901.

58. See Nathalia Wright, ed., *Letters of Horatio Greenough, American Sculptor* (Madison, Wisc.: University of Wisconsin Press, 1972), pp. 216–17, 235. Brevoort also lent Robert Edge Pine's *General Washington* to an exhibition of the Boston Athenæum in 1829; see Robert F. Perkins, Jr. and William J. Gavin III, *The Boston Athenæum Art Exhibition Index, 1827–1874* (Boston: Library of the Boston Athenæum, 1980), p. 110.

59. Johns, *American Genre Painting*, p. 38–41.

60. On Gilmor and his collection, see Anna Wells Rutledge, "One Early American's Precocious Taste," *Art News* 48 (March 1949): 28–29, 51; Anna Wells Rutledge, "Robert Gilmor, Jr. Baltimore Collector," *Journal of the Walters Art Gallery* 12 (1949): 18–39; Barbara Novak, "Thomas Cole and Robert Gilmor," *Art Quarterly* 25 (Spring 1962): 41–53; and *The Taste of Maryland: Art Collecting in Maryland, 1800–1934*, exh. cat. (Baltimore:

Walters Art Gallery: 1984), pp. 1–7. Lance Humphries of the University of Virginia is currently completing a dissertation on Gilmor.

61. Frankenstein argues that Gilmor first learned of Mount by seeing Reed's pictures. Frankenstein, *Mount*, p. 74.

62. William S. Mount to Robert Gilmor, August 20, 1836, Archives of American Art.

63. William S. Mount to Robert Gilmor, July 14, 1837, Historical Society of Pennsylvania.

64. William S. Mount to Robert Gilmor, December 5, 1837, Archives of American Art. Frankenstein deemed this passage "the longest and most programmatic thing of its kind to survive from Mount's pen" (Franken-stein, *Mount*, p. 74).

65. Ariel, "An Account of the Grand Musical Soirée which took place on the night of the 14th inst.," *New York Herald*, March 27, 1844; quoted and discussed in Alan Wallach, "'This is the Reward of Patronising the Arts': A Letter from Robert Gilmor, Jr., to Jonathan Meredith, April 2, 1844," *American Art Journal* 21 (1989): 76–77. Ariel actually referred to Henry Carey of Philadelphia, but he surely meant his brother Edward, whose collecting is discussed in this essay. Upon Edward's death in 1845 Henry and his sister did receive the bulk of Edward's collection.

66. Quoted in Wallach, "This is the Reward," p. 76.

67. On Carey, see Susan Danly, "The Carey Collection at the Pennsylvania Academy of the Fine Arts," *Antiques* 140 (November 1991): 839–45.

68. Edward L. Carey to William S. Mount, December 21, 1839, NYHS.

69. See Steven H. Gale, ed., *Encyclopedia of American Humorists* (New York and London: Garland Publishing Inc., 1988), pp. 111–12; and Walter Blair, *Horse Sense in American Humor* (Chicago: University of Chicago Press, 1942), pp. 51–76.

70. Johns, *American Genre Painting*, p. 50.

71. E., "National Academy of Design, No. III" *New York Commercial Advertiser*, June 7, 1839.

72. See, especially, Joseph B. Hudson, Jr., "Banks, Politics, Hard Cider, and Paint: The Political Origins of William Sidney Mount's *Cider Making*", *Metropolitan Museum Journal* 10 (1975): 107–18, and Johns, *American Genre Painting*, pp. 50–54.

73. See Johns, *American Genre Painting*, pp. 50–54.

74. See James T. Callow, "American Art in the Collection of Charles M. Leupp," *Antiques* 118 (November 1980): 998–1009.

75. "Sale of Works of Art," *New York Daily Tribune*, November 14, 1860.

76. Callow, "Leupp," p. 998.

77. William S. Mount to Charles Leupp, March 11, 1845, MSB.

78. Mount, "Autobiography [0.11.3548]," p. 10, MSB.

79. Ibid., pp. 10–11.

80. "Our Private Collections, No. IV," *The Crayon* 3 (June 1856): 186. "There are two pictures by Mount, 'Music is Contagious' [i.e., *Dance of the Haymakers*] and 'The Power of Music.'"

81. Leupp committed suicide, believing that his partner, the infamous Jay Gould, had ruined him; see the account in Denis Tilden Lynch, *"Boss" Tweed: The Story of a Grim Generation* (New York: Boni and Liveright, 1927), pp. 103–5.

82. Mount, "Autobiography [0.11.3547]," pp. 7, 9, MSB.

83. On Mount's portrayal of African Americans in this and other works, see Johns, *American Genre Painting*, pp. 116–21.

84. William S. Mount to George Pope Morris, December 3, 1848, MSB.

85. Mount, "Autobiography [0.11.3548]," p. 11, MSB.

86. On the shifting fortunes of Mount's later career, see Johns, *American Genre Painting*, pp. 54–59.

87. Mount, "Autobiography [0.11.3548]," p. 15, MSB.

Patrons of William Sidney Mount's Genre Subjects

Compiled by Laurette E. McCarthy

Henry Brevoort, Jr. (1791–1874), New York City, landowner and financier
Raffling for a Goose (The Raffle), 1837, commissioned in 1837

Henry Brooks (1806–1854), New York City, merchant, Brooks Brothers
Pick Nick, commissioned in 1854, unfulfilled commission

Edward L. Carey (1805–1845), Philadelphia, publisher
The Painter's Triumph (Artist Showing His Own Work), 1838, commissioned in 1837
Boys Hustling Coppers (The Disagreeable Surprise), variation of *The Truant Gamblers (Undutiful Boys)*, 1843, commissioned in 1843
The Dead Fall (The Trap Sprung), 1844, commissioned in 1844
Bird Egging (Summer), 1844, commissioned in 1843 as companion to *The Dead Fall (The Trap Sprung)*

Lewis P. Clover (1819–1896), New York City, painter, picture framer, clergyman, and author
A Man in Easy Circumstances, 1832, purchased in 1833

Charles Augustus Davis (1795–1867), New York City, humorist and merchant
Catching Rabbits or *Boys Trapping*, 1839, commissioned in 1839
Cider Making, 1841, commissioned in 1841

John Mackie Falconer (1820–1903), New York City, painter
Mischievous Drop, 1857, commissioned
Peach Blossoms, 1864, purchased

Robert F. Fraser, New York
Loss and Gain, 1848, commissioned in 1847

Robert Gilmor, Jr. (1774–1848), Baltimore, banker and shipping merchant
Country Lad on a Fence, Sketch From Nature (Boy on a Fence; Boy Getting Over a Fence, Throg's Point, New York), 1831, purchased by November 1833
The Long Story (The Tough Story), 1837, commissioned in 1837

John Glover (1800–1830s), New York City and Fairfield, Conn., merchant
Mother and Child, 1834, purchased
Courtship or *Winding Up*, 1836, commissioned in 1836

Gouverneur Kemble (1786–1875), New York City, manufacturer and congressman
(D-N.Y., 1837–41)
Long Island Farmer Husking Corn, 1834, purchased
The Breakdown (Bar-room Scene), 1835, purchased
The Disappointed Bachelor, 1840, purchased

Isabella Williamson Lee (1800–1870), New York City, wife of Gideon Lee, Mayor, New York
City (1834) and congressman (D-N.Y., 1835–37)
The Power of Music (The Force of Music), 1847, commissioned in 1846

James Lenox (1800–1880), New York City, bibliophile and philanthropist
Turning the Leaf (Surprise with Admiration), 1848, purchased

Charles Mortimer Leupp (1807–1859), New York City, merchant
Dance of the Haymakers, 1845, commissioned in 1845
The Banjo Player, 1856, purchased in 1858 (originally commissioned by Wilhelm Schaus)

Thomas McElrath (1807–1888), New York City and Lancaster, Pa., copublisher of the *New
York Daily Tribune*, lawyer and state legislator
The Ramblers, 1847, purchased
California News, 1850, commissioned in 1850

George Pope Morris (1802–1864), New York City, journalist, publisher of *The New-York
Mirror*, dramatist, and poet
The Studious Boy, 1834
The Sportsman's Last Visit, 1835, purchased in 1835
Woodman Spare that Tree, commissioned in 1848, unfulfilled commission

George James Price, Sr., Glen Cove, N.Y.
Just in Tune, 1849, purchased in 1849

Luman Reed (1785–1836), New York City, merchant
Bargaining for a Horse (Farmers Bargaining), commissioned in June 1835, completed in
September 1835
The Truant Gamblers (Undutiful Boys), commissioned in August 1835, completed in
November 1835

Adam R. Smith (1850–1890s), Troy, N.Y.
Coming to the Point, 1854, commissioned in 1854

George Washington Strong (1783–1855), New York City and Setauket, Long Island, N.Y., lawyer

Eel Spearing at Setauket (Recollections of Early Days—"Fishing Along Shore"), 1845, commissioned in 1845

Caught Napping, 1848, commissioned in 1847

Jonathan Sturges (1802–1874), New York City and Fairfield, Conn., merchant and philanthropist

Farmers Nooning, 1836, commissioned

Ringing the Pig (Scene in a Long Island Farm-Yard), 1842, commissioned

Who'll Turn the Grindstone? (An Axe to Grind?), 1851, commissioned in 1850

Edward S. Windust (1798–1877), New York City, restauranteur

Rustic Dance After a Sleigh Ride, 1830, purchased in 1830

Charles B. Wood (dates unknown), New York City and Brooklyn, N.Y., carriage manufacturer

The Tease, 1859, purchased in 1864

Peace, 1861, purchased in 1865

Boys Going Trapping, 1862, purchased in May 1864

Catching Crabs, 1865, purchased in 1865

Early Impressions Are Lasting, purchased in 1865

Loitering by the Way, 1865, purchased in 1865

Peace or *Muzzle Down*, purchased in 1865

Before the War, 1865, purchased

Rock on the Green, 1865, purchased

David A. Wood, Brooklyn, N.Y., and Bridgeport, Conn., carriage manufacturer

Right and Left, 1850, purchased at auction in 1857

Any Fish Today? 1857, purchased

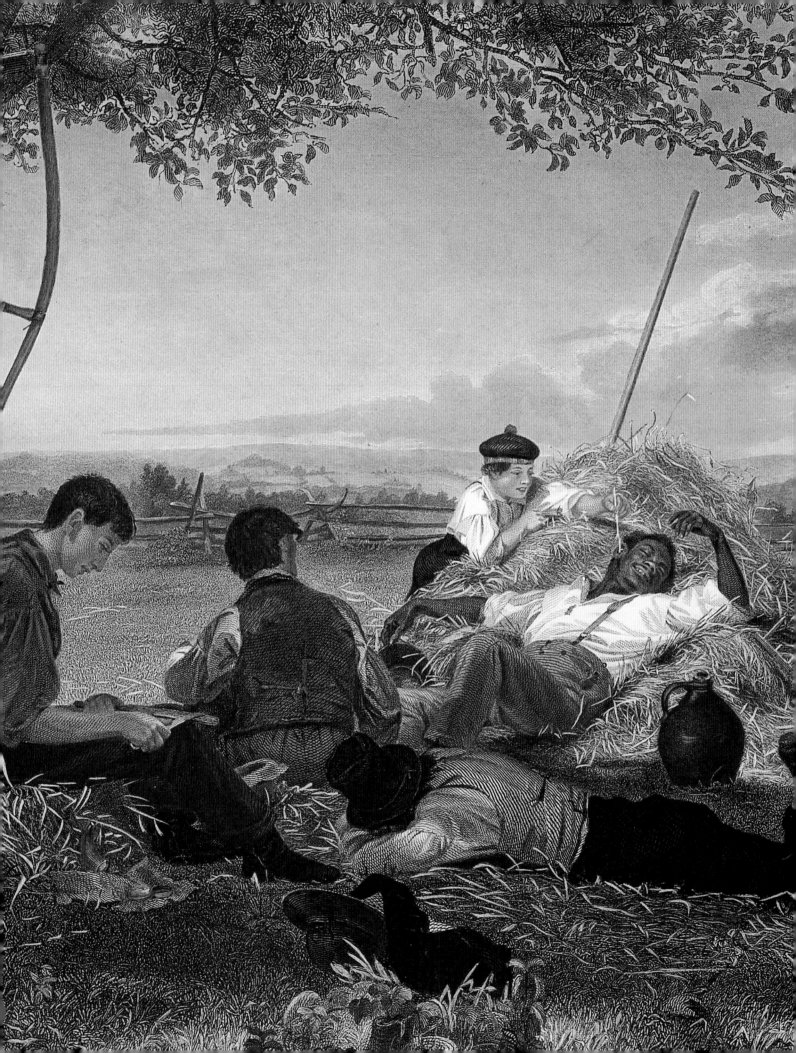

Bernard F. Reilly, Jr. # Translation and Transformation

The Prints After William Sidney Mount

During his lifetime the painter William Sidney Mount saw many of his works copied as prints. Although his canvasses were widely exhibited, it was the engravings, woodcuts, and lithographs that reproduced them that reached the largest audience. In fact, printmaking allowed Mount's works to achieve an exposure far greater than that of all but a few of his contemporaries. Yet, art-historical scholarship on Mount has focused almost exclusively on the creation, iconography, meaning, and impact of Mount's paintings and drawings, rather than on the graphic work that reproduced them. Since the 1960s, Mount studies have been dominated by attempts to fathom the artist's intent and frame of reference in a number of his more problematic works. What scholarly attention has been given to Mount's prints has devolved strictly on their role in disseminating his painted oeuvre.

This is so for two reasons. First, reproductive prints are generally accorded a marginal status in art-historical scholarship, which regards them as, at best, merely imitative of the originals from which they derive. In Mount's case, the scholarly disinterest in his prints may also be due to the fact that the artist himself had relatively little to do with the production of the prints made from his paintings. Like most artists of his time, Mount typically relinquished his claim to control of his paintings upon their sale. He then stood by as patrons and owners of his paintings, publishers, and others undertook to publish—and to profit from—prints reproducing those works. Until the 1850s, when he formed a working partnership with publisher's agent Wilhelm Schaus, Mount had neither a controlling interest in the production of these prints nor a financial stake in their sale.[1] It was only through his liaison with the enterprising Schaus that the artist gained any active agency over the dissemination of his work.

The prints, then, represent a body of work quite separate from Mount's oeuvre, offering little insight into the artist's own thought. And yet, the prints shed a great deal of light on how Mount's work was received and experienced in the United States during the artist's lifetime. Indeed, since they were the medium through which his work was most frequently viewed, the prints seem indispensable to any understanding of what Mount's art meant to his contemporaries. While this work may add little to our grasp of Mount's own intellectual contributions, it does illuminate his role in the popular culture and public discourse of his age.

For Mount, the prints after his paintings served two closely allied purposes: to disseminate knowledge of his works and thereby enhance his artistic reputation; and to generate revenue to supplement that earned from the sale of the paintings themselves. It is clear

from Mount's own comments that he viewed printmaking as a strictly reproductive medium, that is, one whose function was to replicate his paintings as faithfully as possible. He saw the engravings and lithographs of his paintings as facsimiles, rather than as creative works with any inherent value.[2] Similarly, most art critics of Mount's time saw engravings and lithographs as reproductions; to them, the more transparent the medium, the better.[3]

In fact, the medium was not transparent, but transformative. When Mount's works were reincarnated as engravings and lithographs, certain factors came into play that affected the ways they were viewed. For one thing, prints in antebellum America served quite different purposes than did paintings. Since prints were made of more fugitive materials than their models, they were expected to have a relatively brief life span. Prints were also considerably less expensive than paintings, so they could reach a wider, more economically diverse, and geographically disparate audience. For these reasons, the purposes prints served were often more immediate, mundane, and overtly political than paintings. Aside from informing the uses to which they were put, these factors also determined the expectations of the respective audiences for the various reproductions of Mount's works, and conditioned their responses. In Mount's case, the print versions of his paintings were a source of new meanings and associations, informed not only by their new function but also by other printed works with which they circulated and which they at times addressed.

The most widely disseminated painting in Mount's oeuvre was *Long Island Farmer Husking Corn*, 1833–34 (fig. 22). Shortly after being exhibited at the National Academy of Design in 1834, the work was engraved by the New York security-engraving firm of Rawdon,

Wright & Hatch, and it appeared on a number of bank notes produced for various state and local banks as early as 1838 (fig. 82).[4] The image enjoyed a long career on engraved bank notes from the late 1830s to the 1860s.

During the first half of the nineteenth century, currency was issued not by one national treasury but by hundreds of state and local banks and jurisdictions in the United States. (The federal government did not begin printing its own currency until the Civil War.) Bank-note or security-engraving companies supplied these banks with fine bills and certificates ornamented with small-scale, engraved vignettes. The minute, detailed designs made these notes extremely difficult to replicate. The premium that banks paid for this protection against counterfeiting made bank-note engraving extremely lucrative, and the flourishing bank-note engraving industry subsidized the growth of a native school of copper- and steel-engraving in the United States. Figures and compositions by many distinguished American artists were used as the bases for the bank-note designs marketed by these firms during the early nineteenth century. Henry Inman, Thomas Sully, Asher B. Durand, John Casilear, Francis W. Edmonds, F.O.C. Darley, and many others produced designs expressly for translation into engraved vignettes, as a source of income.[5] The work of other artists was copied, quite possibly without authorization, and silently made its way into the repertoire of stock images maintained by these firms. Even for commissioned artists this was uncredited work—their names seldom appeared on the

Figure 82
Currency , One Dollar, The Branch County Bank, Michigan Branch, Plate A, n.d.

finished vignettes—and their contributions to the process do not seem to have been valued very highly by the bank-note firms, who invested considerably more money in the engraving and other technical aspects than in content. Engravers were paid considerably more than artists, and often owned or operated the engraving firms themselves. Although Mount might have produced a copy of *Long Island Farmer Husking Corn* for use by the bank-note engraver (since he was indeed aware of the use of his design on bank notes) there is no record of his having authorized or having received any compensation for the work.[6]

In his study of the bank-note versions of Mount's work, John Muscalus points out that *Long Island Farmer Husking Corn* was the "most widely circulated and widely handled" of all the reproductions of Mount's paintings prior to 1865. As one might imagine, bank notes were turned out by the thousands. Circulation then multiplied the number of individuals who came into contact with Mount's design since each note changed hands numerous times during its existence, which was as long as the paper—or the financial standing of its issuing authority—endured.

In the process of its adaptation to this new context, Mount's work was transformed. Art historian Elizabeth Johns has characterized Mount's farmer as the Jeffersonian ideal of the independent yeoman, individuated with comic overtones as a blend of "amiability and sharpness."[7] However, the anonymous bank-note engraver recast Mount's farmer as a more erect and sober figure. On bank notes, he is often paired with Ceres, the antique goddess of the Harvest, or with a female farm worker who serves as Ceres's contemporary incarnation. During the first several decades of the nineteenth century, the mythological deities and emblematic figures that had in eighteenth-century art and printmaking represented such abstract political ideas as Liberty (Minerva), Agriculture (Ceres), Industry (Vulcan), and Commerce (Mercury) were gradually replaced by the human practitioners or exemplars of those forces. Mercury was transformed into a merchant sailor, Vulcan became the village blacksmith, and Ceres was turned into a milkmaid or farm woman.[8] In this new context Mount's congenial rustic was elevated to a symbolic realm and imbued with the seriousness of the allegorical tradition. In the process he was stripped of his regional associations and quotidian particularity, shorn of all the human ambiguity he projected in Mount's painting. Like Ceres, he was made to represent Agriculture as a force or an ideal.[9]

If the cornhusker in Mount's painting epitomized the then-vanishing independent farmer, on bank notes he assumed an even more purely symbolic meaning, standing for agriculture as an economic force in American society. Interestingly, Mount's figure seems to have appeared most frequently on bank notes issued by Southern banks and jurisdictions. The image would have been even more laden with political meaning in the South, where agriculture was still the engine that drove the region's economy, and, hence, the chief economic characteristic distinguishing that region from the increasingly industrial and mercantile North. Mount's figure gained a wider audience and a larger stature as a symbol of Southern agricultural society than as a genre painting appreciated by a small group of Northeastern urban art cognoscenti, overturning and exceeding the painter's original expectations for the work.

Apart from its use on bank notes, the art of engraving was associated with the qualities of rarity and even preciousness during the first few decades of the nineteenth century. Even rela-

tively small engravings appearing as frontispieces and illustrations in books rendered the volumes they adorned more highly prized by their owners. Among the most coveted of these works were the so-called "gift books," annual compendia of poetry, stories, and illustrations published under such titles as *The Gift, The Jewel, The Casket,* and *The Token.* There, the emphasis on rarity and expense was inextricably bound to the Victorian rituals of courtship and friendship then practiced by the young urban elite who traded and received these books.[10]

Several of Mount's paintings appeared in gift books issued by Edward L. Carey in Philadelphia. *The Painter's Study* (fig. 83) was engraved by Alexander Lawson, and *Bargaining for a Horse,* by Joseph Andrews. Both engravings were included in *The Gift for 1840* (Philadelphia: Carey and Hart, 1839). *The Long Story* (fig. 38), painted in 1837 for Baltimore merchant Robert Gilmor, Jr., was engraved by Joseph Ives Pease and issued in *The Gift: A Christmas and New Year's Present for 1842* (Philadelphia: Carey and Hart, 1841) under the title *The Tough Story.* This engraving was accompanied by a story by Seba Smith titled "The Tough Yarn; or the Cause of Jack Robinson's Lameness." In the same number of *The Gift* was an engraving by Alexander Lawson after Mount's *The Raffle* (now called *Raffling for the Goose*), painted in 1837 for Henry Brevoort, Jr., and accompanied by a story of the same name by John

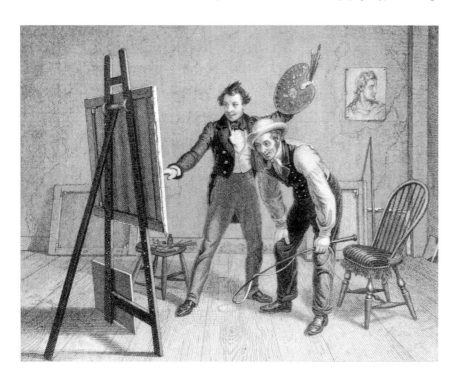

Figure 83
Alexander Lawson (1773–1846)
The Painter's Study, 1840
After William Sidney Mount
The Painter's Triumph (Artist Showing His Own Work), 1838

Frost. These engravings were considerably smaller than the original paintings, and their precious scale conformed to the gemlike quality of the books. This reduction in size, however, was not the only concession to the published context. Their pairing with fictional texts made Mount's images, in effect, a pretext for the sermonizing of Carey's authors. Although Mount's paintings served as the point of departure for the stories, in each case the tales differed markedly from the pictures, prompting the reader to imagine a wholly different scenario from that originally intended by Mount.

Mount's painting *The Long Story,* for example, was, like most of his works, set on Long Island. But the tale accompanying it in the gift book, Seba Smith's "The Tough Yarn," tells of a wager made in a Maine barroom between a prosperous Massachusetts landowner and a Maine doctor; the subject of the wager is Jack Robinson, a local farmer and yarn spinner.[11] The tale accompanying *Raffling for the Goose* also takes place far from Long Island in a rural tavern on the outskirts of Boston. Three students from Harvard, stopping there en route to a country holiday, are duped by a wily farmer who makes a tidy profit by raffling off a twelve-year-old goose. At one point in the proceedings, the author observes wryly, "The group, while

the business of drawing was proceeding, would have furnished an excellent subject for the humorous pencil of Mount."

But in the Frost story, the interlude in the tavern is only a small part of the story, serving as a metaphor for the financial speculation that is the larger subject of the work. Mount probably intended his painting to be an allusion to financial speculation (particularly in the context of the financial crash of 1837, which burst the speculative bubble and ruined thousands), but Frost clearly took liberties and expanded his tale well beyond the limited information contained in the small painting.[12] In Frost's version, the student Tom Norris, the most enthusiastic partaker of the rural experience, is eventually ruined financially, while Alfred Murray, cautiously holding his blank is saved. Like Seba Smith, Frost inverted the conventional relationship between text and image. Mount's friend and patron Charles Lanman referred to this inversion in a letter to the artist: "I have just received the Gift for 1842, and am glad to see two first rate engravings from your pictures—'The Tough Story' and 'The Raffle.' The former is illustrated by an article from one of my most intimate friends—Seba Smith, Esq. the original Jack Downing."[13]

Mount himself seemed to encourage such elaborations on his works when he proposed in 1842 that his publisher, Edward L. Carey, purchase *Dregs in the Cup* or *Fortune Telling* (fig. 39). "It would open rich for the Gift—a good story can be written for it."[14] The gift-book authors, however, not only imposed on Mount's work a specific narrative, but in so doing conditioned the reader's interpretation of the image. For instance, both Frost and Smith style their narratives as encounters between members of an educated elite and poor, rustic folk. Since the stories are told from the perspective of the upper-class protagonists, the encounters take the form of adventures or comic interludes in an otherwise urban or genteel existence. Certainly, Mount's paintings of rural subjects also offered his affluent, largely urban patrons a vicarious foray into the world of rustic life. But while Mount's pictures tried to give viewers a vivid and immediate image of rural life, the stories by Frost and Seba Smith effectively reinforced the social and economic distance between the viewer and the subject, and, hence, between the two classes. Like the precious character and scale of the gift books themselves, this enforced distance between urbane viewer and rustic subject may have been considered more appropriate to the intimate milieu for which the volumes were intended. Whatever the reason, the meaning of Mount's work was transformed by its presentation there in a new, imagined narrative context.[15]

The most straightforward rendition of a Mount painting in engraved form is the large-plate engraving of *Farmers Nooning*, produced by Alfred Jones for the Apollo Association in 1843 (fig. 84).[16] The Apollo Association was organized in 1839, and operated under that name until 1844, when it was rechristened the American Art-Union. The organization's purpose was to encourage the growth of the fine arts in the United States, which it did through various activities, including an annual lottery of paintings and the commission of engravings after works by American artists. The engravings were distributed by the association to its members, who paid an annual subscription fee of five dollars. Works selected for engraving included, among others, John Blake White's *General Marion in His Swamp Encampment* (distributed in 1840); John Vanderlyn's *Marius Amidst the Ruins of Carthage* (distributed in 1842); and Francis W. Edmonds's *Sparking* (distributed in 1844).

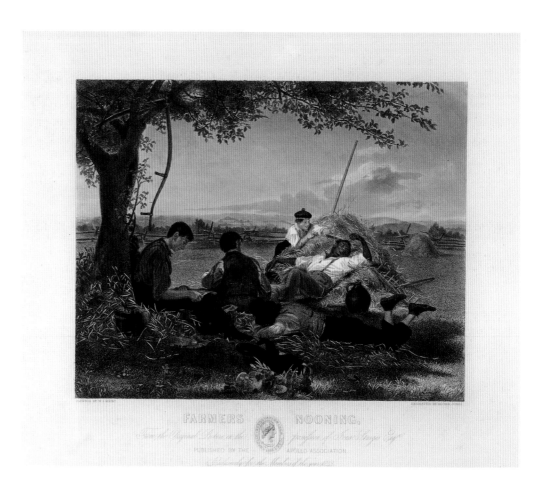

Mount's *Farmers Nooning*, painted in 1836 for Jonathan Sturges, was selected as the Apollo Association premium for 1843.[17] Despite the attention that such distribution brought to their work, the artists whose paintings were copied made very little money on the Art-Union enterprise. In fact, the engravers made far more. For engraving George Caleb Bingham's *The Jolly Flatboat Men* for the Art-Union, John Sartain was paid almost ten times the sum that Bingham had received for the painting itself.[18] Of course, the creation of engraved plates on the scale of those produced by the Apollo Association was an extremely expensive and labor-intensive undertaking; some plates took over a year to engrave. More-over, the skills needed to execute such plates were still rare in America, despite the immigration from England of master engravers like William James Bennett and John Rubens Smith during the early decades of the century. Artists like Mount and Bingham frequently complained of the scarcity of competent engravers.

Collectors were also scarce since the acquisition of such engravings was no small matter. Only a relatively small number of impressions could be printed (or "pulled") from a single plate, therefore, the individual purchasers had to bear a larger share of the publication cost. For all but the most affluent, these large engravings represented a considerable investment and a significant part of the buyer's overall capital activity. As a result, a certain significance was attached to the purchase of engraved works during the 1840s. The purchaser of such prints was, in effect, making a statement of solidarity with the rather bold aesthetic mission of advancing American art.[19]

The vote of confidence that such purchases implied must have made all the more repugnant to Mount the sale and reissue of the plate for *Farmers Nooning*. In 1854 he complained bitterly of the Art-Union's sale of the plate and its reissuance that year by the New York publisher Appleton:

> . . . *they did dispose of the old plate of the "Farmers Nooning"—and what miserable impressions Mr. Appleton has thrown out to the world,—a lie in comparison to the original and a disgrace to his taste—how a man can pick up dollars from a worn out plate—it is like a crow picking up a few pieces from an old dead carcase.*[20]

Appleton's act in some ways signaled a change in print publishing that had begun to occur in the United States during the late 1840s. On the surface this change involved the assumption by lithography of the role previously occupied by engraving in reproducing works of art. But underneath were more fundamental changes in the imagery of artistic prints, effected by the vernacular tradition and associations of lithography. The mongrel of the printmaking world, lithography fundamentally altered the nature of print publishing in the United States in the 1840s.[21] Lithography, which made a truly popular print trade possible in the United States, had its origins in Germany in the 1790s.[22] Although used in England earlier by the American expatriate artist Benjamin West, the medium was not introduced in the United States until the second decade of the nineteenth century, and then only on an experimental basis. The medium in America first became commercially viable in the mid-1820s with the appearance of a number of lithographic printers in the major Eastern cities—Pendleton in Boston, Inman in Philadelphia, Endicott in New York. Since lithography was easy to master and inexpensive to practice compared to engraving, it was eminently practical, even for ephemeral purposes. It became the workhorse of print production, associated with such uses as tradecards and labels, sheet music covers, and book illustration.

Its rapid production time and its capacity for yielding tens of thousands of impressions from a single design, made lithography more responsive than engraving to the ever-changing winds of politics. Abolitionists and temperance advocates—and their opponents—employed the medium to circulate their reformist propaganda. But the prevailing ideological orientation of lithographic subject matter during this period was Whig, perhaps a function of the job-printing's natural linkage to the new urban mercantile interests and banks. Most of the presses were actively involved in producing letterheads, tradecards, and stationery items for the manufacturers and merchants of the urban Northeast. During the Bank Wars of the 1830s these presses unleashed a torrent of anti-Jackson and anti-Van Buren cartoons.

When the steam lithographic press was introduced in the 1840s the production of prints became industrialized, like the manufacture of clocks, shoes, or textiles. In quick order, the medium's capabilities were expanded, most notably its capacity to print images in multiple colors. In the late 1840s, various print publishers, including Currier and Ives and Goupil, Vibert & Co., began to revise the fundamental economics of print publishing and the relationship between consumer and product. This was a change from producing all work on a commission, or "job," basis to developing, on speculation, a standing stock of prints that could be advertised and sold. This new reliance on building a bank of images was made

Figure 85
Alphonse-Leon Noel (1807–1884)
The Power of Music, 1848
After William Sidney Mount
The Power of Music (The Force of Music), 1847

Figure 86
Alphonse-Leon Noel (1807–1884)
Music Is Contagious, 1849
After William Sidney Mount
Dance of the Haymakers, 1845

THE POWER OF MUSIC

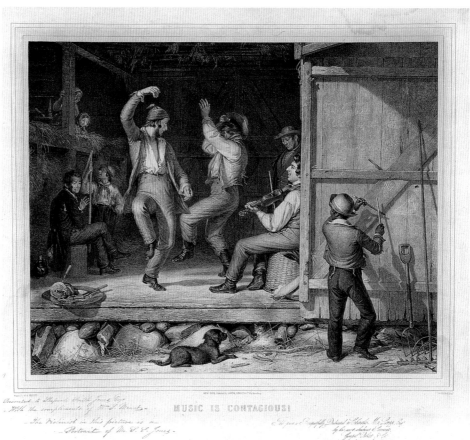

MUSIC IS CONTAGIOUS!

possible by the cheaper per-item cost of lithographs, and it engendered a more detached, purely aesthetic, relationship of the consumer to the object. Such "off the shelf" merchandise represented a smaller choice, and commitment, on the part of the purchaser than the funding of the far more expensive engraved prints. The ephemerality of the medium became an asset, as stocks could be continually refreshed with new subjects or with restyled treatments of existing subjects. This had an effect on subject matter.

The new lithographic firms that moved into lower Manhattan in the late 1840s, like the Paris-based firm of Goupil, Vibert and Co. and Williams, Stevens and Co., were equipped with greater financial resources than the Art-Union and they targeted a much broader clientele. One measure of their success in competing with the existing art establishment was Goupil's acquisition in 1852 of Emanuel Leutze's *Washington Crossing the Delaware*; Goupil had also published Richard Caton Woodville's *Politics in an Oyster House*. While these publishers maintained the pretense of producing fine prints, their subject matter was, in fact, less high-minded than that found in engravings. Catering to more worldly interests, these publishers' offerings ranged from boudoir imagery of courtesans to sentimental scenes of family life.[23]

For William Sidney Mount, this shift in publishing coincided with the more "proactive" phase of his involvement with prints. Between 1848 and 1857 no fewer than seven of his paintings were reproduced as lithographs, all under the imprints of Goupil, Vibert and Co. or Goupil and Co. Mount's painting *The Power of Music*, owned by Isabella Williamson Lee, was lithographed by Alphonse-Leon Noel for Goupil, Vibert and Co. and published in 1848 (fig. 85); *Dance of the Haymakers*, painted for Charles Mortimer Leupp, was retitled *Music Is Contagious* when it was issued as a print in 1849 (fig. 86); *Catching Rabbits*, published by Goupil and Co. followed in 1850. *Just in Tune*, painted and sold to George James Price in 1849, was lithographed by Emile Lassalle for Goupil and Co. and issued in 1850 (fig. 87).[24] *Right and Left*, commissioned by Wilhelm Schaus for Goupil in 1850, was lithographed by Jean-Baptiste Adolphe Lafosse for Goupil and issued in 1852 (fig. 66). *The Lucky Throw* completed in December 1850, was lithographed by Lafosse for Goupil, and issued as *Raffling for a Goose* in 1851 (fig. 67). *The "Herald" in the Country*, painted in 1853 and immediately sold to Goupil, was lithographed by Claude Thielly and issued by Goupil in 1854. *Coming to the Point*, painted in 1854 and sold to Adam R. Smith, was lithographed by Louis-Emanuel Soulange Tessier and issued by Wilhelm Schaus in 1855. *The Banjo Player* and *The Bone Player* were painted in 1856, on commission from Wilhelm Schaus, lithographed by Lafosse, and issued as prints by Schaus in 1857 (figs. 88, 89).

The 1850s also marked a new, mature stage in Mount's use of printmaking. Under the tutelage of Wilhelm Schaus, Mount became considerably more adept at developing his work commercially. Various financial arrangements were conceived by the two men to market Mount's works. In a letter of May 25, 1854, to Edward P. Mitchell, Mount asserted that Schaus paid him $200 for the copyright to *Coming to the Point*; the work itself had been sold to Adam R. Smith for $300. Mount later thanked Smith for making the work available for the exercise of the copyright:

By your kindness in loaning the picture to be engraved, I have received from Mr. Wm. Schaus—two hundred dollars, for the right of Copy. This is the first interest I have ever received in any of the publications of my works. Mr. Schaus has promised me an additional sum if the engraving proves successful = which is my hope—[25]

A different, more speculative arrangement with Schaus covered *The Banjo Player* and *The Bone Player*. In commissioning these paintings, Schaus offered to pay Mount $200 for each, and, should Mount find another buyer for the paintings, $100 apiece for the copyrights.[26] *The Bone Player* actually sold for $200 to John D. Jones, Esq.; *The Banjo Player* went to Charles Leupp for $200.

Financial arrangements notwithstanding, the paintings produced from 1850 onward for Goupil and Co. and for Wilhelm Schaus, constitute a distinct body of work by Mount, differing from his earlier works in nature and motivation. Many, if not all, of these paintings were produced specifically with reproduction in mind, and, hence, were intended for a vastly enlarged audience. Mount himself seems to have viewed these commissions as a related, if not cohesive, group. In a September 1850 journal entry, he listed together all of the subjects to be painted for Schaus and Goupil:

Pictures for Wm. Schaus Esqr. one picture (life size head) 25 x 30 an old man of the Revolutionary times reading an account of the battle of Bunker Hill—Paper & costumes of the times— / One picture negro—african—head life size—laughing showing his white teeth & holding

Figure 88
Jean-Baptiste Adolph Lafosse
(1810–1879)
The Banjo Player, 1857
After William Sidney Mount
The Banjo Player, 1856

Figure 89
Jean-Baptiste Adolph Lafosse
(1810–1879)
The Bone Player, 1857
After William Sidney Mount
The Bone Player, 1856

something funny in his hand, size 25 x 30 / Goose a Duck or a squirrel &c. / One picture cabi-net size—Negro asleep in a barn—While a little boy is . . . tickling his foot / Another—a group of figures Reading the Herald—painted—/ A group of figures Talking— seated around in a circle, / Courtship / A negro popping the question . ./ only think of that —/ Bone Player. Banjo player. Painted. / For Goupil & Co. Sept 1853—one picture as a companion to the Lucky throw.[27]

All of these paintings seem to have been suggested by Schaus specifically for consideration for publication as prints by the Maison Goupil.

A number of scholars have commented upon the marked contrast in Mount's presenta-tion of African Americans between *Farmers Nooning* of 1836 and his works of the 1850s such as *The Lucky Throw*. Certainly the concentration on African American subjects during this later period is much higher than at any other time in Mount's career. Art historian Elizabeth Johns makes the case that it was the newly charged climate of American sectional politics and an increased antipathy toward African Americans in the wake of the Compromise of 1850 and the passage of the Fugitive Slave Act that led to Mount's conspicuous presentation of blacks in a negative light in these later works.[28] In actuality, while the boy in *The Lucky Throw* is indeed a near caricature compared with the farmhand in *Farmers Nooning*, Mount's portrayals of African Americans in this period are not consistently negative. *The Banjo Player*, *The Bone Player*, and *Right and Left*, all painted during the 1850s, are in fact strong and subtle portraits.

The determining influence on Mount's work during this period seems to have been a calculated consideration of the viability of each new work in what was for him the new arena of popular printmaking. For decades, the largely Northern middle-class, Whig audience to which the popular print trade typically catered had shown a perennial fascination with African American life and culture. Edward Williams Clay's *Life in Philadelphia* series (1828 and 1829), which featured a caricature of black city dwellers, went through numerous editions and spawned many imitations. These, like Clay's several apologies in graphic form for slavery, appealed to Whig merchants and others in the North whose interests were comfortably compatible with the slave system.[29] It may have been Mount's new acquaintance with this popular print market that induced him to focus on the production of African American "heads" for this trade, without adversely influencing his treatment of them. Instead of mirroring a new political climate, then, Mount's work during the 1850s may simply have reflected his new attentiveness to an established market.

The role of Mount's agent and later publisher Wilhelm Schaus in shaping the artist's work in the 1850s has been duly noted by scholars. From 1848 Schaus served as Mount's representative and advocate with the Maison Goupil. After his break with Goupil in August 1852 Schaus immediately struck up a new business relationship with Mount, as an independent agent and publisher.[30] Mount's 1850 painting *The Lucky Throw* was a commission that Schaus had brokered with Goupil.[31] The following month Schaus wrote to solicit Mount's permission to publish "Raffling for a goose, negro asleep, Hay Making, Bargaining for a horse," for which he offered royalties: "I would also give you an order for some large heads same size about of 'Just in Tune,' 'Right & Left' & 'Raffling;' the subjects to be something like the above and representing 'Negro playing the Banjo & singing' / 'Negro playing with bones.' How soon can I have one or both of these pictures?"[32]

For almost a decade Schaus seems to have been Mount's guide not only in financial matters but also with regard to the content of his work. Mount sought Schaus's counsel on the subject of potential works many times. In 1850 Schaus suggested the subject of *Right and Left* in response to Mount's question "Do you think a negro man, or a white man as a companion to the picture 'Just in Tune'?"[33] Schaus replied, "I think a Negro would be a good companion to 'Just in tune', the size I think is good also." Given Schaus's role, it is clear that Mount's work in the 1850s was motivated and shaped, at least in part, by the opportunities for revenue that printmaking—lithography in particular—presented in the decade preceding the Civil War.

Whatever Mount's motivation during this period, his work, translated into graphic form, was transformed again by its new context. Presented in the modish, ephemeral environment of Goupil/Schaus production, these works would have found an audience more desirous of—and more conditioned to experience—content of a more immediate, accessible, and even sensual character, rather than enduring and edifying in nature.

Mount's works, appearing when and where they did, would have entered public consciousness in relation to these other prints, regardless of the intentions of Mount or his publishers. In being published as lithographs during the 1850s, Mount's portraits of black Long Islanders would have been viewed in a vernacular realm inhabited by a variety of works on

the topic of African American life. For this audience they would have been seen in the same frame of reference as the lithographs of "Master James Crow" and "Miss Jemima Crow," and other racist characterizations of American slaves and freemen.[34] In short, the other prints on African American subjects in circulation in the same milieu during the 1850s would have conditioned and informed the viewer's perception of Mount's prints.

Nonetheless, while Mount worked in an idiom teeming with ideological content, and was quite responsive to the desires of his audience in that context, he avoided in his own work the polemical overtones that infused much of the other work in that milieu. Though Mount's treatment of African Americans was certainly conditioned by the rising acrimony of the national debate over slavery, he deftly avoided in his works any ideological categorization of blacks as either persecuted victims or servile brutes. In this way, through his prints and his paintings, Mount contributed new matter to the national public dialogue over slavery.

The lithographs produced for Goupil and Schaus were the last significant reproductions of Mount's work issued during his lifetime. The great watershed in American history and culture formed by the Civil War also marks the divide between the artistic popular lithographs of the antebellum period and a vastly different postwar production. After the war, the reproductive capabilities of photomechanical technology on the one hand and the cult of authenticity of the etching revival on the other spelled the end of reproductive printmaking as Mount and his patrons had known it.

Notes

The abbreviation MSB denotes the collection of the Museums at Stony Brook, Stony Brook, N.Y.; NYHS denotes the collection of the New-York Historical Society, New York, N.Y.

1. Although Schaus is almost universally cited in the secondary literature on Mount as William Schaus, his calling card in the collections of the Museums at Stony Brook (83.14.16) gives his Christian name as Wilhelm. I am indebted to Deborah Johnson for calling my attention to this document.

2. Mount's own comments on the relative merits of various attempts to replicate his works in graphic form reflect this view.

3. Despite the number of his works reproduced in those mediums, Mount never seems to have engaged in the process of lithography or engraving himself. Several American artists of his own and earlier generations (including Inman, Durand, Cole, and William Morris Hunt), as well as artists of the succeeding generation (like Whistler and Homer), did produce original work in those mediums. But Mount never evinced any interest in printmaking as an original pursuit. Nor does he seem to have involved himself in the transfer of his designs to the plate or lithographic stone, leaving that to the publishers who financed the prints.

4. John A. Muscalus, *Popularity of Wm. S. Mount's Art Work on Paper Money, 1838–1865* (Bridgeport, Pa.: Historical Paper Money Research Institute, 1965).

5. Numerous drawings in pencil and wash prepared as models for bank notes do exist by Henry Inman, John Casilear, and others. There is an album of drawings and bank-note proofs based upon them by Asher B. Durand in the print room of the New York Public Library.

6. Robert N. Mount to William S. Mount, July 28, 1840, MSB. "I have in my possession the margin of one dollar City Council of Macon Bill on which is engraved your picture — the Corn Husker. by Rawdon, Righs [*sic*] and Hack."

7. Elizabeth Johns, "The Farmer in the Works of William Sidney Mount," *Journal of Interdisciplinary History* 17, no. 1 (Summer 1986): 257–81.

8. Despite its importance to the history of American engraving and artistic iconography, the imagery of American bank notes of the nineteenth century has not received comprehensive study.

9. A comparable figure often appearing as a pendant to the farmer in bank-note engraving of the period was the blacksmith, who represented the newer force of industry or the mechanical arts then being subsumed by foundries and factories.

10. The best analytical study of gift books and their engraved decorations is Katherine Martinez, "Messengers of Love, Tokens of Friendship: Gift Books by John Sartain," in Gerald R. Ward, ed. *The American Illustrated Book in the Nineteenth Century* (Wilmington, Del.: Winterthur Museum, 1978), pp. 89–112.

11. Mount's letter of December 5, 1837, to Robert Gilmor, Jr. (Archives of American Art) expounds in detail on the painting's subject. See also Stuart P. Feld, "In the Midst of High Vintage." *Metropolitan Museum of Art Bulletin* (April 1967): 292–307.

12. Elizabeth Johns, for instance, has convincingly explicated Mount's *Raffling for the Goose* as a pointed commentary on the financial speculation that led to the Panic of 1837. See Elizabeth Johns, *American Genre Painting: The Politics of Everyday Life* (New Haven: Yale University Press, 1991), pp. 38–40.

13. Charles Lanman to William S. Mount, September 25, 1841, MSB.

14. William S. Mount to Edward Carey, January 9, 1842, Historical Society of Pennsylvania.

15. To be sure Mount's paintings were also subjected to narrative readings by contemporary reviewers, but in his characteristic reticence about explaining his works, the artist normally left interpretation to the viewers. Alfred Frankenstein dismissed a comparably imaginative elaboration in a review of Mount's painting *Cider Making* in the *New York American* as "indicative of the over-riding stress on narrative characteristic of the criticism of Mount's time (but not at all characteristic of Mount's own views and intentions)." Frankenstein, *Mount*, p. 31.

16. Jay Cantor, "Prints and The American Art-Union," in John Morse, ed., *Prints in and of America to 1850* (Charlottesville: University of Virginia Press, 1970), pp. 297–326.

17. Jonathan Sturges, in a letter to Mount in 1841, mentions a request from Rawdon, Wright and Co. to engrave the painting, which he declined "upon the ground that the copyright belonged to you and I would not consent to have it engraved unless it could be done to your satisfaction, and that you could receive a suitable compensation for the right at same time." Jonathan Sturges to William S. Mount, February 9, 1841, NYHS.

18. On Bingham and the American Art-Union, see John Francis McDermott, "George Caleb Bingham and the American Art-Union," *New-York Historical Society Quarterly* 42 (January 1958): 60–69; and Bernard F. Reilly, "Prints of Frontier Life," *American Frontier Life* (New York: Abbeville Press, 1987), pp. 186–91.

19. A similar advancement of a cause through "subscription," albeit quite different in nature, was fostered by various American antislavery organizations. During the 1830s and 1840s various American abolition societies sponsored publication and sale of a number of large-plate engravings of heroic blacks and scenes of African American life. Notable among these was John Sartain's mezzotint after Nathaniel Jocelyn's portrait of the *Amistad* leader Cinquez, and Rippingville's *The Emancipated Family*. See Bernard F. Reilly, "The Art of the Antislavery Movement," in Donald M. Jacobs, ed., *Courage and Conscience: Black and White Abolitionists in Boston* (Bloomington: Indiana University Press, 1993).

20. William S. Mount to Jonathan Sturges, March 14, 1854, NYHS.

21. Peter Marzio, *The Democratic Art: Pictures for a 19th-Century America* (Boston: David R. Godine, 1979), pp. 49–63.

22. The most authoritative study of the origins of lithography in Europe and Great Britain is Michael Twyman's *Lithography 1800–1850: The Techniques of Drawing on Stone in England and France and Their Application in Works of Topography* (London: Oxford University Press, 1970).

23. Sometimes the genres merged: Deborah Johnson points out in her comparison of Shepard Alonzo Mount's painting *Rose of Sharon (The Artist's Daughter)* with Jean-Baptiste Adolphe Lafosse's colored lithograph rendition of the work in Goupil's series *Etudes Choises* the markedly coquettish character taken on by the subject in the translation. Deborah J. Johnson, *Shepard Alonzo Mount: His Life and Art* (Stony Brook, N.Y.: Museums at Stony Brook, 1988), p. 48. Elizabeth Johns notes the eroticized quality of Lafosse's lithographs after Lilly Martin Spencer's paintings of children; see Johns, *American Genre Painting*, pp.172ff.

24. With the death of one of the firm's partners late in the summer of 1850, the name Goupil, Vibert and Co. was changed to Goupil and Co.

25. William S. Mount to Adam R. Smith, March 4, 1854, NYHS.

26. Mount, "Journal [0.7.2602]," March 5, 1857, p.165, MSB.

27. Ibid., September 15, 1850.

28. Johns, *American Genre Painting*, pp. 123–24.

29. On Edward Williams Clay, see Nancy R. Davison, "E.W. Clay and the American Political Caricature Business," in David Tatham, ed. *Prints and Printmakers of New York State, 1825–1940* (Syracuse: Syracuse University Press, 1986), pp. 91–110.

30. Wilhelm Schaus to William S. Mount, August 10, 1852, MSB; and September 1, 1852, MSB.

31. "The commission you gave me—a negro holding something funny in his hand, I have almost completed—" (William S. Mount to Wilhelm Schaus, December 20, 1850, NYHS).

32. Wilhelm Schaus to William S. Mount, September 1, 1852, MSB.

33. William S. Mount to Wilhelm Schaus, March 3, 1850, NYHS.

34. *The Banjo Player* and *The Bone Player*, Gail Shrott points out, portrayed African Americans playing instruments associated with minstrel shows of the period. Schrott notes that the images are much more natural than those depicting African Americans on the minstrel posters of the day. Gail Shrott, "The Banjo Player," in David Cassedy and Gail Shrott,. *William Sidney Mount: Works in the Collection of the Museums at Stony Brook* (Stony Brook, N.Y.: Museums at Stony Brook, 1983), p. 73.

Works in the Exhibition

Unless otherwise indicated, all works are by William Sidney Mount.

Paintings and Works on Paper

"Drawn from Hogarth's works," ca. 1826
Pencil on paper
10 x 8^1/$_{16}$ inches
The Museums at Stony Brook; Bequest of Dorothy DeBevoise Mount (x59.4.34)
(Fig. 1)

"Apollo—Drawn from an engraving," 1826
Pencil on paper
14^1/$_2$ x 9^1/$_2$ inches
The Museums at Stony Brook; Bequest of Dorothy DeBevoise Mount (x59.4.21)
(Fig. 3)

Family Group with Child Reciting on a Stool, ca. 1826–27
Ink wash on paper
5^3/$_4$ x 5^1/$_4$ inches
The Museums at Stony Brook
(Fig. 14)

Christ Raising the Daughter of Jairus, 1828
Oil on panel
18^1/$_8$ x 24^3/$_4$ inches
The Museums at Stony Brook; Gift of Mr. and Mrs. Ward Melville (x58.9.3)
(Fig. 6)

Study for *Christ Raising the Daughter of Jairus,* 1828
Ink on paper
8 x 13 inches
The Museums at Stony Brook; Bequest of Ward Melville (77.22.102)
(Fig. 7)

Saul and the Witch of Endor, 1828
Oil on canvas
36 x 48 inches
The National Museum of American Art, Smithsonian Institute, Washington, D.C.; Gift of IBM Corporation (1966.48.1)
(Fig. 8)

Girl with a Pitcher, 1829
Oil on canvas
20^1/$_4$ x 15^3/$_4$ inches
The Museums at Stony Brook; Gift of Mrs. F. Henry Berlin (79.23)
(Fig. 13)

Rustic Dance After a Sleigh Ride, 1830
Oil on canvas
22 x 27^1/$_4$ inches
The Museum of Fine Arts, Boston; Bequest of Martha C. Karolik for the M. and M. Karolik Collection of American Paintings, 1815–1865
(Fig. 12)

School Boys Quarreling, 1830
Oil on canvas
20^1/$_4$ x 25 inches
The Museums at Stony Brook; Museum purchase made possible by an earlier gift of Mr. and Mrs. Ward Melville (84.15)
(Fig. 16)

Scene from *"The Heart of Midlothian,"* ca. 1830
Pencil on paper
4^1/$_2$ x 6^1/$_2$ inches
The Museums at Stony Brook; Gift of Caroline Miller (0.1.66-83)
(Fig. 20)

Dancing on the Barn Floor, 1831
Oil on canvas
25 x 30 inches
The Museums at Stony Brook; Gift of Mr.
and Mrs. Ward Melville (x55.64)
(Fig. 19)

Self-Portrait, 1832
Oil on canvas
24 x 20 inches
The Museums at Stony Brook; Gift of Mr.
and Mrs. Ward Melville (x50.3.2)
(half-title page)

Long Island Farmer Husking Corn, 1833–34
Oil on canvas
21 x 17 inches
The Museums at Stony Brook; Gift of Mr.
and Mrs. Ward Melville (75.16.8)
(Fig. 22)

After Dinner, 1834
Oil on panel
$10^{7/8}$ x $10^{15/16}$ inches
Yale University Art Gallery; Stanley B. Resor,
B.A. 1901, Christian A. Zabriskie, and
John Morgan, B.A. 1893, Funds
(Fig. 23)

The Breakdown (Bar-room Scene), 1835
Oil on canvas
$22^{1/4}$ x $27^{3/8}$ inches
The Art Institute of Chicago; William Owen
and Erna Sawyer Goodman Collection
(Fig. 26)

The Sportsman's Last Visit, 1835
Oil on canvas
$21^{1/4}$ x $17^{1/4}$ inches
The Museums at Stony Brook; Gift of Mr.
and Mrs. Ward Melville (x58.9.7)
(Fig. 25)

Bargaining for a Horse (Farmers Bargaining),
1835
Oil on canvas
24 x 30 inches
The New-York Historical Society
(Fig. 27)

The Truant Gamblers (Undutiful Boys), 1835
Oil on canvas
24 x 30 inches
The New-York Historical Society
(Fig. 28)

Courtship or *Winding Up*, 1836
Oil on panel
$18^{1/4}$ x $14^{7/8}$ inches
The Nelson-Atkins Museum of Art, Kansas
City, Missouri; Gift of the Enid and Crosby
Kemper Foundation
(Fig. 29)

Farmers Nooning, 1836
Oil on canvas
$20^{1/4}$ x $24^{1/2}$ inches
The Museums at Stony Brook; Gift of
Frederick Sturges, Jr. (x54.8)
(Fig. 30)

Study for *Farmers Nooning*, ca. 1836
Oil on canvas
$4^{3/8}$ x $5^{3/8}$ inches
The Museums at Stony Brook; Bequest of
Ward Melville (77.22.555)
(Fig. 31)

The Long Story (The Tough Story), 1837
Oil on panel
17 x 22 inches
The Corcoran Gallery of Art,
Washington, D.C.
(Fig. 38)

Dregs in the Cup or *Fortune Telling*, 1838
Oil on canvas
42 x 52 inches
The New-York Historical Society
(Fig. 39)

Catching Rabbits or *Boys Trapping*, 1839
Oil on panel
18 x $21^{3/4}$ inches
The Museums at Stony Brook; Gift of Mr.
and Mrs. Ward Melville (x58.9.11)
(Fig. 43)

John Frederick Kensett (1816–1872)
The Cottage Door, ca. 1840
After William Sidney Mount
The Studious Boy, 1834
Oil on paperboard
7¾ x 6¼ inches
The Museums at Stony Brook; Bequest of
Ward Melville (77.22.529)
(Fig. 24)

Cider Making, 1841
Oil on canvas
27 x 34⅛ inches
The Metropolitan Museum of Art, Purchase,
Charles Allen Munn Collection; Bequest of
Charles Allen Munn, by exchange, 1966
(66.126)
(Fig. 46)

Crane Neck Across the Marsh, 1841
Oil on panel
13 x 17 inches
The Museums at Stony Brook; Gift of Mr.
and Mrs. Carl Heyser, Jr. (0.3.4673)
(Fig. 49)

*Ringing the Pig (Scene in a Long Island
Farm-Yard)*, 1842
Oil on canvas
31½ x 36½ inches
New York State Historical Association,
Cooperstown
(Fig. 47)

"Trying to back out"
Study for *Ringing the Pig (Scene in a Long
Island Farm-Yard)*, ca. 1842
Pencil on paper
7¾ x 10¼ inches
New York State Historical Association,
Cooperstown
(Fig. 48)

*Eel Spearing at Setauket (Recollections of Early
Days—"Fishing Along Shore")*, 1845
Oil on canvas
28½ x 36 inches
New York State Historical Association,
Cooperstown
(Fig. 55)

Dance of the Haymakers, 1845
Oil on canvas
24 x 29 inches
The Museums at Stony Brook; Gift of Mr.
and Mrs. Ward Melville (x50.3.1)
(Fig. 51)

Study for *Eel Spearing at Setauket
(Recollections of Early Days—"Fishing Along
Shore")*, ca. 1845
Oil on paper
5 x 6½ inches
The Museums at Stony Brook; Bequest of
Ward Melville (77.22.573)
(Fig. 57)

Study for *Eel Spearing at Setauket
(Recollections of Early Days—"Fishing Along
Shore")*, ca. 1845
Pencil on paper
6³⁄₁₆ x 7¼ inches
The Museums at Stony Brook; Bequest of
Ward Melville (77.22.194)
(Fig. 58)

Studies for *Dance of the Haymakers* and *The
Power of Music (The Force of Music)*, ca. 1845
Pencil on paper
9 x 5½ inches
The Museums at Stony Brook; Bequest of
Ward Melville (77.22.91)
(Fig. 53)

The Power of Music (The Force of Music), 1847
Oil on canvas
17⅛ x 21 inches
The Cleveland Museum of Art; Leonard C.
Hanna Jr. Fund (1991.110)
(Fig. 52)

Loss and Gain, 1848
Oil on canvas
24 x 20 inches
The Museums at Stony Brook; Bequest of
Ward Melville (77.22.546)
(Fig. 60)

Caught Napping, 1848
Oil on canvas
29 x 36 inches
The Brooklyn Museum of Art; Dick S.
Ramsey Fund (39.608)
(Fig. 59)

Farmer Whetting His Scythe, 1848
Oil on canvas
24 x 20 inches
The Museums at Stony Brook; Gift of Mr.
and Mrs. Ward Melville (x55.6.5)
(Fig. 61)

Just in Tune, 1849
Oil on canvas
29¼ x 25 inches
The Museums at Stony Brook; Gift of Mr.
and Mrs. Ward Melville (x55.6.7)
(Fig. 63)

California News, 1850
Oil on canvas
21½ x 20¼ inches
The Museums at Stony Brook; Gift of Mr.
and Mrs. Ward Melville (x55.6.3)
(Fig. 62)

Right and Left, 1850
Oil on canvas
30 x 25 inches
The Museums at Stony Brook; Museum
Purchase (x56.19)
(Fig. 65)

*The "Herald" in the Country (Politics of 1852—
or, Who let down the bars?),* 1853
Oil on panel
17 x 21½ inches
The Museums at Stony Brook; Gift of Mr.
and Mrs. Ward Melville (x55.6.6)
(Fig. 71)

Coming to the Point, 1854
Oil on canvas
25 x 30 inches
The New-York Historical Society (S141)
(Fig. 72)

The Mount House, 1854
Oil on canvas
8 x 10 inches
The Museums at Stony Brook; Bequest of
Ward Melville (77.22.550)
(Fig. 5)

The Banjo Player in the Barn, ca. 1855
Oil on canvas
25 x 30 inches
The Detroit Institute of Arts; Gift of Dexter
M. Ferry Jr. (38.60)
(Fig. 54)

The Banjo Player, 1856
Oil on canvas
36 x 29 inches
The Museums at Stony Brook; Gift of
Mr. and Mrs. Ward Melville (x55.6.1)
(Fig. 69)

Catching Crabs, 1865
Oil on canvas
18¼ x 24½ inches
The Museums at Stony Brook; Gift of
Mr. and Mrs. Ward Melville (x58.9.12)
(Fig. 80)

Fair Exchange, No Robbery, 1865
Oil on canvas
25½ x 33 inches
The Museums at Stony Brook; Gift of
Mr. and Mrs. Ward Melville (x58.9.2)
(Fig. 75)

Study for *Fair Exchange, No Robbery,* ca. 1865
Oil on paper
5¾ x 8½ inches
The Museums at Stony Brook; Bequest of
Ward Melville (77.22.563)
(Fig. 76)

Catching the Tune, 1866–67
Oil on canvas
21¾ x 26½ inches
The Museums at Stony Brook; Museum
Purchase (x53.8)
(Fig. 81)

Reproductions after Works by William Sidney Mount

Joseph Alexander Adams (1803–1880)
Boy on a Fence
New-York Mirror 12, no. 18 (November 1, 1834)
After William Sidney Mount
Country Lad on a Fence, 1831
Engraving
The Museums at Stony Brook
(Fig. 18)

Alexander Lawson (1773–1846)
The Painter's Study
After William Sidney Mount
The Painter's Triumph (Artist Showing His Own Work), 1838
Engraving
6⅛ x 8 inches
Reproduced in *The Gift for 1840*
Published by E. L. Cary and A. Hart, Philadelphia, 1839
The Museums at Stony Brook (00.472)
(Fig. 83)

Alfred Jones (1819–1900)
Farmers Nooning, 1843
After William Sidney Mount
Farmers Nooning, 1836
Colored engraving
18 x 21 inches
Published by The Apollo Association, New York, 1843
The Museums at Stony Brook; Bequest of Ward Melville (77.22.44)
(Fig. 84)

Alphonse-Leon Noel (1807–1884)
The Power of Music, 1848
After William Sidney Mount
The Power of Music (The Force of Music), 1847
Colored lithograph
20 x 24 inches
Published by Goupil, Vibert & Co., Paris, 1848
The Museums at Stony Brook; Museum Purchase (67.12.1)
(Fig. 85)

Alphonse-Leon Noel (1807–1884)
Music Is Contagious, 1849
After William Sidney Mount
Dance of the Haymakers, 1845
Lithograph
20½ x 23 inches
Published by Goupil, Vibert & Co., Paris, 1849
The Museums at Stony Brook; Museum Purchase (81.36)
(Fig. 86)

Emile Lassalle (1813–1871)
Just in Tune, 1850
After William Sidney Mount
Just in Tune, 1849
Colored lithograph
28 x 20 inches
Published by Goupil & Co., Paris, 1850
The Museums at Stony Brook; Bequest of Ward Melville (o.6.85)
(Fig. 87)

Jean-Baptiste Adolphe Lafosse (1810–1879)
Raffling for a Goose, 1851
After William Sidney Mount
The Lucky Throw, 1850
Colored lithograph
29 x 23¾ inches
Published by Goupil & Co., Paris, 1851
The Museums at Stony Brook; Gift of Richard M. Gipson (x51.3)
(Fig. 67)

Jean-Baptiste Adolphe Lafosse (1810–1879)
Right and Left, 1852
After William Sidney Mount
Right and Left, 1850
Colored lithograph
35 x 24 inches
Published by Goupil & Co., Paris, 1852
The Museums at Stony Brook; Gift of Ward Melville (o.6.98)
(Fig. 66)

Jean-Baptiste Adolph Lafosse (1810–1879)
The Bone Player, 1857
After William Sidney Mount
The Bone Player, 1856
Colored lithograph
28 x 25 inches
Published by W. Schaus, New York, 1857
The Museums at Stony Brook; Bequest of
Ward Melville (77.22.47)
(Fig. 89)

Jean-Baptiste Adolph Lafosse (1810–1879)
The Banjo Player, 1857
After William Sidney Mount
The Banjo Player, 1856
Colored lithograph
30 x 21 inches
Published by W. Schaus, New York, 1857
The Museums at Stony Brook; Bequest of
Ward Melville (0.6.87)
(Fig. 88)

Currency, One Dollar, The Branch County
Bank, Michigan Branch, Plate A, n.d.
Engraved by Rawdon, Wright & Hatch,
New York
Collection Eric P. Newman
(Fig. 82)

Select Bibliography

In addition to the published sources listed below, important archival materials are to be found at the Archives of American Art, Smithsonian Institution, Washington, D.C.; the Emma S. Clark Memorial Library, Setauket, N.Y.; the Historical Society of Pennsylvania, Philadelphia; the museum at the Manor of St. George, Mastic, N.Y.; the Museums at Stony Brook, Stony Brook, N.Y.; the New-York Historical Society, New York, N.Y.: the New York Public Library, New York, N.Y.; the Smithtown Historical Society, Smithtown, N.Y.; the Smithtown Public Library, Smithtown, N.Y.; and the Three Village Historical Society, Setauket, N.Y.

Books and Journals

Adams, Karen. "The Black Image in the Paintings of William Sidney Mount." *American Art Journal* 7, no. 2 (November 1975): 42–59.

Armstrong, Janice Gray, ed. *Catching the Tune: Music and William Sidney Mount*. Stony Brook, N.Y.: Museums at Stony Brook, 1984.

Boime, Albert. *The Art of Exclusion: Representing Blacks in the Nineteenth Century*. Washington, D.C.: Smithsonian Institution Press, 1990.

Brown, Thomas, *Politics and Statesmanship; Essays on the American Whig Party*. New York: Columbia University Press, 1985.

Buechner, Alan C. "The W.S. Mount Music Collection at Stony Brook." Paper presented at the Sonneck Society Bicentennial Conference, Queensborough Community College, City University of New York, May 28–30, 1976.

_____. "Music and Dance in the Paintings of William Sidney Mount." Paper presented at the Forty-Second Annual Meeting of the American Musicological Society, Washington, D.C., Nov. 5, 1976.

_____. "William Sidney Mount's 'Cradle of Harmony': A Unique 19th-Century American Violin." *Journal of the Violin Society of America* 3, no. 2 (1977): 35–71.

Buckley, Peter G. "'The Place to Make an Artist Work': Micah Hawkins and William Sidney Mount in New York City." In Janice Gray Armstrong, ed., *Catching the Tune: Music and William Sidney Mount*. Stony Brook, N.Y.: Museums at Stony Brook, 1984, pp. 22–39.

Buffett, Edward P. "William Sidney Mount: A Biography." *Port Jefferson Times*, December 1, 1923–June 12, 1924 (fifty-six installments).

_____. "William Sidney Mount and His Environment." *New-York Historical Society Quarterly Bulletin* 7 (1923): 83.

Burns, Sarah. "Yankee Romance: The Comic Courtship Scene in Nineteenth-Century American Art." *American Art Journal* 18, no. 4 (1986): 51–75.

Callow, James T. *Kindred Spirits: Knickerbocker Writers and American Artists, 1807–1855*. Chapel Hill: University of North Carolina Press, 1967.

_____. "American Art in the Collection of Charles M. Leupp." *Antiques* 118 (November 1980): 998–1009.

Cassedy, David, and Gail Shrott. *William Sidney Mount: Works in the Collection of The Museums at Stony Brook*. Stony Brook, N.Y.: Museums at Stony Brook, 1983.

_____. *William Sidney Mount: Annotated Bibliography and Listings of Archival Holdings of The Museums at Stony Brook*. Stony Brook, N.Y.: Museums at Stony Brook, 1983.

Clark, Eliot. *History of the National Academy of Design, 1825–1853*. New York: Columbia University Press, 1954.

Cowdrey, [Mary] Bartlett, ed. *National Academy of Design Exhibition Record, 1826–1860*. 2 vols. New York: New-York Historical Society, 1943.

_____. *American Academy of Fine Arts and American Art-Union: Exhibition Record, 1816–1852*. 2 vols. New York: New-York Historical Society, 1953.

_____, and Hermann Warner Williams, Jr., *William Sidney Mount, 1807–1868: An American Painter*. New York: Columbia University Press, 1944.

Craven, Wayne. "The Grand Manner in Early Nineteenth-Century American Painting: Borrowing from Antiquity, the Renaissance, and the Baroque," *American Art Journal* 11, no. 2 (April 1979): 5–43.

_____. "Luman Reed, Patron: His Collection and Gallery." *American Art Journal* 12, no. 2 (Spring 1980): 40–59.

Dunlap, William. *A History of the Rise and Progress of the Arts of Design in the United States*. New York: George P. Scott and Co., 1834.

Falk, Peter Hastings, ed. *The Annual Exhibition Record of the Pennsylvania Academy of the Fine Arts, 1807–1870*. Madison, Conn.: Soundview Press, 1988.

Feld, Stuart P. "In the Midst of 'High Vintage.'" *Metropolitan Museum of Art Bulletin* 25 (1967): 292–307.

Flexner, James Thomas. *That Wilder Image: The Paintings of America's Native School from Thomas Cole to Winslow Homer*. Boston: Little, Brown, and Company, 1962.

Foshay, Ella M. *Mr. Luman Reed's Picture Gallery*. New York: Harry N. Abrams/New-York Historical Society, 1990.

Frankenstein, Alfred. *Painter of Rural America: William Sidney Mount, 1807–1868*. Stony Brook, N.Y.: Suffolk Museum at Stony Brook, 1968.

_____. *William Sidney Mount*. New York: Harry N. Abrams, 1975.

Hessler, M. Hunt. "'Rusticity and Refinement': Music and Dance on Long Island, 1800–1870." In Janice Gray Armstrong, ed., *Catching the Tune: Music and William Sidney Mount*. Stony Brook, N.Y.: Museums at Stony Brook, 1984, pp. 40–55.

Hills, Patricia. *The Painter's America: Rural and Urban Life, 1810–1910*. New York: Praeger Publishers/Whitney Museum of American Art, 1974.

Hoover, Catherine. "The Influence of David Wilkie's Prints on the Genre Paintings of William Sidney Mount." *American Art Journal* 13, no. 3 (Summer 1981): 4–33.

Hudson, Joseph B., Jr. "Banks, Politics, Hard Cider, and Paint: The Political Origins of William Sidney Mount's Cider Making." *Metropolitan Museum of Art Journal* 10 (1975): 107–18.

Johns, Elizabeth. *American Genre Painting: The Politics of Everyday Life*. New Haven: Yale University Press, 1991.

_____. "The Farmer in the Works of William Sidney Mount." *Journal of Interdisciplinary History* 17, no. 1 (Summer 1986): 257–81.

Johnson, Deborah J. *Shepard Alonzo Mount: His Life and Art*. Stony Brook, N.Y.: Museums at Stony Brook, 1988.

Jones, William Alfred. "A Sketch of the Life and Character of William S. Mount." *American Whig Review* 14 (August 1851): 122–27.

Keyes, Donald D. "The Sources for William Sidney Mount's Earliest Genre Paintings." *Art Quarterly* 32, no. 13 (Autumn 1969): 258–68.

_____. "William Sidney Mount Reconsidered." *American Art Review* 4 (August 1977): 117–28.

Lawrence, Vera Brodsky. "Micah Hawkins, The Piped Piper of Catherine Slip." *New-York Historical Society Quarterly* 62, no. 2 (April 1978): 138–65.

Libin, Laurence. "Instrument Innovation and William Sidney Mount's 'Cradle of Harmony.'" In Janice Gray Armstrong, ed., *Catching the Tune: Music and William Sidney Mount*. Stony Brook, N.Y.: Museums at Stony Brook, 1984, pp. 56–66.

McElroy, Guy C. *Facing History: The Black Image in American Art, 1710–1940*. San Francisco: Bedford Arts, 1990.

Miller, Douglas T. *Jacksonian Aristocracy: Class and Democracy in New York, 1830–1860*. New York: Oxford University Press, 1967.

Muscalus, John A. *Popularity of Wm. S. Mount's Art Work on Paper Money, 1838–1865*. Bridgeport, Pa.: Historical Paper Money Research Institute, 1965.

Naylor, Maria, ed. *The National Academy of Design Exhibition Record, 1861–1900*. New York: Kennedy Galleries, 1973.

North, Douglas C. *The Economic Growth of the United States, 1790–1860*. Englewood Cliffs, N. J. : Prentice-Hall, 1961.

Norton, Anne. *Alternative Americas: A Reading of Antebellum Political Culture*. Chicago: University of Chicago Press, 1986.

Novak, Barbara. *American Painting of the Nineteenth Century: Realism, Idealism, and the American Experience*. New York: Preager Publishers, 1969.

Oedel, William T., and Todd S. Gernes. "The Painter's Triumph: William Sidney Mount and the Formation of Middle-Class Art." *Winterthur Portfolio* 23, nos. 2/3 (Summer/Autumn 1988): 111–27.

Perkins, Robert F., Jr., and William J. Gavin III, eds. *The Boston Athenaeum Art Exhibition Index, 1827–1874.* Boston: Library of the Boston Athenaeum, 1980.

Pike, Martha V. "Catching the Tune: Music and William Sidney Mount." In Janice Gray Armstrong, ed., *Catching the Tune: Music and William Sidney Mount.* Stony Brook, N.Y.: Museums at Stony Brook, 1984, pp. 8–21.

Prown, Jules. *American Painting: From its Beginnings to the Armory Show.* New York: Rizzoli International Publications, Inc., 1980.

Robertson, Bruce. "The Power of Music: A Painting by William Sidney Mount." *Bulletin of the Cleveland Museum of Art* 79, no. 2 (February 1992): 38–62.

Rutledge, Anna Wells. *Cumulative Record of Exhibition Catalogues: The Pennyslvania Academy of Fine Arts, 1807–1870; The Society of Artists, 1800–1814; The Artists' Fund Society, 1835–1845.* Philadelphia: American Philosophical Society, 1955.

———. *Index to American Art Exhibition Catalogues: From the Beginning through the 1876 Centennial Year.* Boston: G.K. Hall, 1986.

———. "Robert Gilmor, Jr., Baltimore Collector." *Journal of the Walters Art Gallery* 12 (1949): 18–39.

Spooner, J. Alden. "Reminiscences of Artists: William S. Mount and Sheppard [*sic*] A. Mount." *Evening Post* (New York), December 16, 1868, p. 1.

Taylor, Joshua C. *America As Art.* Washington, D.C.: National Collection of Fine Arts, Smithsonian Institution, 1976.

———. *The Fine Arts in America.* Chicago: University of Chicago Press, 1979.

Index

The American Federation of Arts

National Patrons

Mrs. James W. Alsdorf
Mrs. Milton Avery
Mr. and Mrs. Glenn W. Bailey
Mr. and Mrs. Robert A. Belfer
Mr. and Mrs. Frank B. Bennett
Mr. and Mrs. Winslow W. Bennett
Nancy L. Benson
Mrs. George F. Berlinger
Mr. and Mrs. Sheldon Berlow
Joanne Stroud Bilby
Mr. and Mrs. Steven Biltekoff
Mr. and Mrs. Leonard Block
Mr. and Mrs. Donald J. Blum
Adele Bodzin
Mr. and Mrs. Duncan E. Boeckman
Mr. and Mrs. Bruce Calder
Mr. and Mrs. George M. Cheston
Mrs. Paul A. Cohen
Elaine Terner Cooper
Catherine G. Curran
Dr. and Mrs. David R. Davis
Sandra Deitch
Beth Rudin DeWoody
Mr. and Mrs. Charles M. Diker
Mr. and Mrs. Herbert Doan
Mr. and Mrs. John C. Duncan
Mr. and Mrs. Raymond T. Duncan
Stefan Edlis and Gael Neeson
Dr. and Mrs. Selig Eisenberg
Mr. and Mrs. William Farley
Mr. and Mrs. Miles Fiterman
Mrs. Gerald Frankel
Mr. and Mrs. Stanley Freehling
Mr. and Mrs. Robert Freudenheim
Mr. and Mrs. Michel Fribourg
Mr. and Mrs. Howard L. Ganek
Mr. and Mrs. Robert W. Garner
Barbara Goldsmith
Mr. and Mrs. Gerald Grinstein
Mr. and Mrs. Jack Guthman
Leo S. Guthman
Mr. and Mrs. Frederic C. Hamilton
Mrs. Wellington S. Henderson
Mr. and Mrs. Samuel Heyman
Mr. and Mrs. Irwin Hochberg
Mrs. Allan H. Kalmus
William W. Karatz
Elaine P. Kend
Mr. and Mrs. Robert P. Kogod
Nanette L. Laitman
Mr. and Mrs. Anthony M. Lamport
Natalie Ann Lansburgh

Mrs. Robert H. Levi
Mr. and Mrs. Joel Levin
Barbara S. Linhart
Mrs. Richard Livingston
Mr. and Mrs. Jeffrey M. Loewy
Mr. and Mrs. Lester B. Loo
Mrs. Mark O.L. Lynton
Mr. and Mrs. Cargill MacMillan, Jr.
Mr. and Mrs. Richard Manoogian
Mr. and Mrs. Jeffrey Marcus
Mr. and Mrs. Alan M. May
Mrs. Robert B. Mayer
Mr. and Mrs. Paul Mellon
Mr. and Mrs. Robert Menschel
Mr. and Mrs. Eugene Mercy, Jr.
Mary S. Myers
Judy Neisser
Mrs. Peter Roussel Norman
Mr. and Mrs. George P. O'Leary
Patricia M. Patterson
Mr. and Mrs. Mark Perlbinder
Elizabeth Petrie
Mr. and Mrs. Nicholas R. Petry
Mr. and Mrs. Charles I. Petschek
Mr. and Mrs. Edward M. Pinsof
Mr. and Mrs. John W. Pitts
Mr. and Mrs. Harvey R. Plonsker
Mr. and Mrs. Lawrence S. Pollock, Jr.
Howard E. Rachofsky
Edward R. Roberts
Mr. and Mrs. Elihu Rose
Mr. and Mrs. Jonathan P. Rosen
Mr. and Mrs. Richard L. Rosenthal
Felice T. Ross
Mr. and Mrs. Lawrence Ruben
Diane Schafer
Mr. and Mrs. Paul C. Schorr, III
Lowell M. Schulman and Dianne Wallace
Adriana Seviroli
Elaine D. Siegel
Mr. and Mrs. Michael R. Sonnenreich
Dr. and Mrs. Paul Sternberg
Mrs. James G. Stevens
Mr. and Mrs. Harry F. Stimpson, Jr.
Joseph M. Tanenbaum
Rosalie Taubman
Mrs. Norman Tishman
Mr. and Mrs. William B. Troy
Mrs. Robert C. Warren
Mr. and Mrs. Alan Weeden
Mrs. Richard Weil
Mr. and Mrs. Guy A. Weill
Mr. and Mrs. T. Evans Wyckoff

Benefactors Circle

Arthur G. Altschul
Mr. and Mrs. Steven Ames
Mr. and Mrs. Howard R. Berlin
Elizabeth B.Blake
Ruth Bowman
Mr. and Mrs. James Brice
Melva Bucksbaum
Mrs. B. Gerald Cantor
Constance R. Caplan
Mr. and Mrs. Donald M. Cox
David L. Davies and John D. Weeden
Mr. and Mrs. Kenneth N. Dayton
Mr. and Mrs. C. Douglas Dillon
Mr. and Mrs. John A. Friede
Mrs. Melville W. Hall
Mr. and Mrs. Lee Hills
Mr. and Mrs. Theodore S. Hochstim
Harry Kahn
Mr. and Mrs. Gilbert H. Kinney
Mr. and Mrs. Richard S. Lane
Barbara Fish Lee
Mr. and Mrs. Robert E. Linton
Mr. and Mrs. Henry Luce III
Jeanne Lang Mathews
Mr. and Mrs. Frederick R. Mayer
Mrs. C. Blake McDowell, Jr.
Mr. and Mrs. Robert M. Meltzer
Barbara Babcock Millhouse
Roy R. Neuberger
Mr. and Mrs. Leon B. Polsky
Mr. and Mrs. Milton F. Rosenthal
Barbara Slifka
Ann C. Stephens
Mr. and Mrs. John W. Straus
Mr. and Mrs. David J. Supino
Mrs. George W. Ullman
Mr. and Mrs. Martin S. Weinberg
Mrs. Keith S. Wellin
Mr. and Mrs. Dave H. Williams